THE JAZZ IMAGE

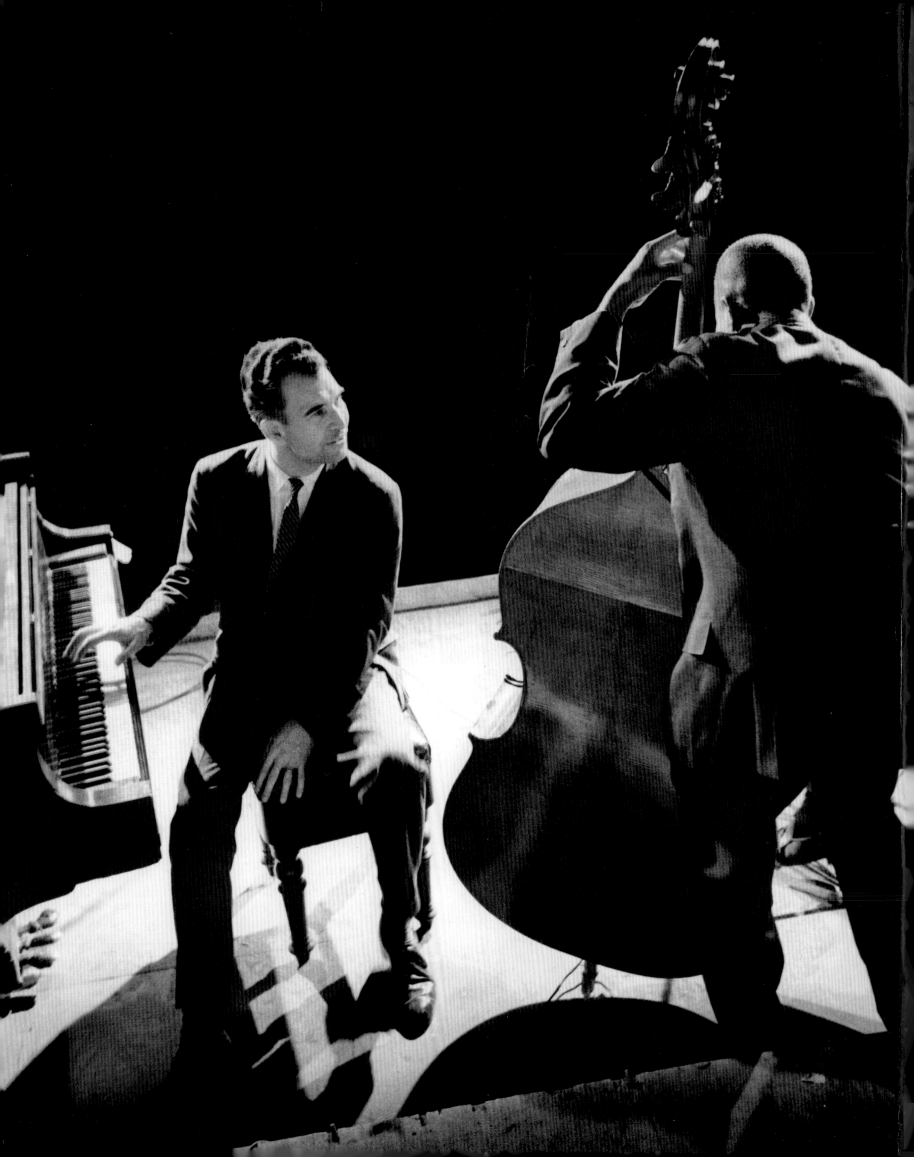

THE JAZZ IMAGE

MASTERS OF JAZZ PHOTOGRAPHY

LEE TANNER

INTRODUCTION BY NAT HENTOFF

ABRAMS, NEW YORK

Editors: Charles Kochman and Nikki Columbus
Designer: Gary Tooth / Empire Design Studio
Production Manager: Anet Sirna-Bruder

Library of Congress Cataloging-in-Publication Data

Tanner, L. E. (Lee E.)
 The jazz image: masters of jazz photography / by Lee Tanner ;
 introduction by Nat Hentoff ; afterword by Peter Fetterman.
 p. cm.
 ISBN 978-0-8109-5749-7
 1. Jazz musicians—Pictorial works. I. Title.
 ML3506.T35 2006
 779'.978165—dc22

 2006012016

Text and compilation copyright © Lee Tanner
Photography credits appear on page 175.

Printed and bound in China
10 9 8 7 6

Abrams books are available at special discounts when purchased in quantity
for premiums and promotions as well as fundraising or educational use.
Special editions can also be created to specification. For details, contact
specialsales@abramsbooks.com or the address below.

THE ART OF BOOKS SINCE 1949

155 West 18th Street
New York, NY 10011
www.abramsbooks.com

FRONT ENDPAPER:
Punch Miller returns home in
the morning, New Orleans, 1958.
Photograph by Dennis Stock

BACK ENDPAPER:
**A Saturday night dance in
Rochester, New York, 1958.**
Photograph by Paul Hoeffler

PAGE 1:
Cootie Williams, a star in Duke Ellington's
band, at Connelly's, Boston, 1959.

Photograph by Lee Tanner

PAGE 2:
Dave Brubeck listens to
Eugene Wright solo at the
Monterey Jazz Festival, 1959.
Photograph by Jerry Stoll

DEDICATION

The Jazz Image is a celebration of all the musicians who have given us a lifetime of their glorious music. To quote the Duke, "We Love You Madly." This book is especially dedicated to the Judge: Milt Hinton, the Dean of Bassists. He lived to ninety, and worked with just about everybody in music, inspiring all to the heights of their abilities. Milt has received countless prestigious awards for his accomplishments and humanitarian efforts. On top of all this, he was, in my opinion, the Cartier-Bresson of jazz photography. Starting in the 1930s with an Argus C-3, Milt Hinton documented the heart and soul of the music world from the inside. His images are loving portraits—a gift to all who are totally enthralled with jazz.

ACKNOWLEDGMENTS

The Jazz Image has been a project-in-process for more than five years, and many individuals have given encouragement and support. My deepest thanks go to the photographers and their agents who had faith in me and trusted me with their prints over this long period. Thanks to Kati Meister who has been my constant encourager and supporter since the first publisher gave up on the project. Ever since, we have been in a continuous state of "beating the bushes" to enlist a new publisher, until recently when Eric Himmel of Harry N. Abrams brought *The Jazz Image* on board. The book has been moved swimmingly through design and editing under the expert direction of editor Charles Kochman. My overwhelming appreciation and thanks also go to designer Gary Tooth, who has created a most striking presentation of all the work, and to Nikki Columbus, who has kept the text in remarkably organized shape.

Now to a list of organizations and individuals who played a part leading up to publication. First and foremost is the American Jazz Institute and the Gould Center for Humanistic Studies at Claremont McKenna College, whose support allowed all the images to be included and presented as I originally visualized. This musicological and academic association, directed by composer-arranger Mark Masters, Professor Ron Teeples, and David Hetz, is collecting an oral history of jazz, holds free concerts open to the public, and records new music. Help was also received from the Manchester Craftsmen's Guild. Others who have lent support are Ken Burns (Florentine Films), Lee Mergner (*Jazz Times*), Frank Alkyer (*Down Beat*), Nat Hentoff, Gary Giddens, John Turner, Bruce Lundvall (Blue Note Records), Dan Morgenstern (Institute for Jazz Studies), Peter Fetterman, Ben Sidran, Kathleen Sims, Ben Cawthra, and Bob Wilson.

And to my wife, Linda . . . thank you for your love, support, and inspiration.

Support for publication of *The Jazz Image* was contributed by the American Jazz Institute and the Gould Center for Humanistic Studies at Claremont McKenna College.

INTRODUCTION By Nat Hentoff

In 1957 I was fortunate to be involved in *The Sound of Jazz* on CBS-TV, which included many of the jazz legends shown in this unprecedented collection of illuminating photographs—talents such as Ben Webster, Lester Young, Count Basie, Thelonious Monk, and Billie Holiday. After the program, a viewer wrote to CBS to express her exhilaration at "seeing these players so joyously, so intently immersed in doing what they most want to do. It's rare that many of us have found our life's vocation."

In *The Jazz Image* Lee Tanner has assembled the pantheon of jazz photographers—of which he himself is an eminent representative—who demonstrate how these musicians have answered Duke Ellington's song, "What Am I Here For?" The players knew their calling, and so did the photographers who created an enduring visual history of this musical life force.

No one has described the essence of making jazz as powerfully as Oscar Peterson in his autobiography, *A Jazz Odyssey*. He writes of the "will to perfection" that characterizes jazz musicians and the "daredevil enterprise" of improvising individually and collectively in front of an audience.

Peterson explains, "It draws on everything about you, not just your musical talent. It requires you to collect all your senses, emotions, physical strength, and mental power, and focus them totally on the performance. . . . [Playing jazz] is so uniquely exciting that once it's bitten you, you never get rid of it. Nor do you want to: for you come to believe that if you get it all right, you will be capable of virtually anything."

Throughout this book you will see what drives Peterson and all the musicians in this book. There's Dennis Stock's shot of Earl Hines in a state of creative exhilaration (pages 64–65), and Hugh Bell's image of Duke Ellington on fire, urging his musicians to go beyond what they thought they could do (page 40).

There are other distillations of the jazz life in this unparalleled compilation: Lee Tanner's photo of one of the most sensuous, infectiously lyrical soloists in all of jazz—Johnny Hodges (page 126). Ellington once told me, "When Johnny Hodges plays a ballad, sometimes a sigh from someone in the audience reaches us, and that sigh becomes part of our music."

In a book I wrote nearly fifty years ago, *The Jazz Life*, I quoted W. H. Auden's description of music: "It can be made anywhere, is invisible, and does not smell." As much as I admire the penetrating wit and worldly wisdom of Auden, he couldn't have been more wrong.

"Music," I answered him, "is made by men (and women) who are insistently *visible*, especially as in jazz when the players *are* their music." Charlie Parker said it crisply and clearly: "Music is your own experience, your thoughts, your wisdom. If you don't live it, it won't come out of your horn."

The magically multi-dimensional drummer, Jo Jones—"the man who plays like the wind"—added his chorus to Charlie Parker's: "All jazz musicians, through their instruments, express the types of persons they are, the experiences they've had during the day, during the night before, during their lives. There's no way they can subterfuge their feelings."

On page after page of *The Jazz Image*, the life experiences that have created the distinctive temperaments of each musician—and therefore his music—reveal themselves not only in the very act of playing but also in vibrant off-the-stand reactions. Look at the photo in which Louis Armstrong looks so pleased at giving pleasure (page 109); or the urbane, subtly ironic, but also incurably romantic Paul Desmond (page 89).

And there's the instantly identifiable Billie Holiday, "Lady Day" (pages 48–49). She could say "hello" to me on the street or in a studio, and that was music. Roy Eldridge said of her (and this is an obbligato to seeing her in this book), "Billie must have come from another world because nobody had the effect on people she had. She could really get to people. I've seen her make them cry and make them happy."

Particularly intriguing in this assembly of jazz masters is the scope of the book—its range of eras, styles, and personalities. Coming off the page is the robust brilliance of James P. Johnson (page 27), the father of Harlem stride piano and a major influence on Thomas "Fats" Waller and Duke Ellington.

Seeing Fats Waller (page 28) here reminded me of when I, a nineteen-year-old cub reporter on my college paper, asked him for an interview, and he took me to a sumptuous dinner at the hotel where he was playing, exemplifying the generosity of spirit of jazz musicians.

Seeing them here makes me hear, in memory, their music again. One night, at the Savoy Café in Boston, Oran "Hot Lips" Page, sitting in after midnight, played and sang the blues

for well over an hour without pausing as he stopped all conversation in the room. In Douglas Henry Daniels's *One O'Clock Jump: The Unforgettable History of the Oklahoma City Blue Devils*, trumpeter Max Kaminsky is quoted on Page's temperament, also revealing the context in which many of these black players lived: When both these players were in Artie Shaw's band, "One night after the show (in the deep south), a cracker came up to the bandstand and said he thought Lips played so great that he wanted to meet him. After shaking Lips' hand, the Southerner said, 'and Ah want you to know this is the first time Ah ever shook the hand of a colored man.' Kaminsky recalled how his friend 'flashed one of his wide, happy grins and said in his wonderfully pleasing way, 'Well, buddy, it didn't hurt, now did it?'"

Seeing Duke Ellington in these pages I recalled our conversation about those times, when black musicians were only allowed to stay in hotels in the black sections of the cities they played. And I am again impressed by the resilient spirit of Ellington and all the other musicians in this book who survived racism.

"From 1934 to 1936, when we toured deep into the South," Duke said, "we commanded respect without the benefit of federal judges. We didn't travel by bus. Instead, we had two Pullman cars and a seventy-foot baggage car. We parked them in each station and lived in them. We had our own water, food, electricity, and sanitary facilities. The natives would come by, and say, 'What's that?' 'Well,' we'd say, 'that's the way the President travels.'"

There's a wonderful photograph here of the serenity, warmth, and depth of Jack Teagarden (page 37). It led me to look at psychiatrist Kay Redfield Jamison's book, *Exuberance: The Passion for Life*, in which she discusses the life force of this music, whose players encompass all races, genders, and countries of origin. Jamison writes: "The trombonist Jack Teagarden described the first time he heard the great Louis Armstrong play: 'The (river) boat was still far off. But in the bow I could see a Negro standing in the wind, holding a trumpet high and sending out the most brilliant notes I had ever heard. It was jazz . . . it was Louis Armstrong descending from the sky like a god.'"

As the music of jazz became an international language, that man who descended from the sky went on a tour of Africa and booked into the Belgian Congo, which was in the midst of a fierce civil war. Hearing that Louis was coming, the two sides declared a truce because they wanted to hear those brilliant notes.

In July 2005 the International Association of Schools of Jazz (based in The Hague, the Netherlands) held its fifteenth annual meeting in Krakow, Poland. Thirty-six schools of jazz were represented from more than twenty-five countries. The musicians, including students, who jammed through the night, know the names and the sounds of Louis Armstrong and the other jazz originals in this book; and if they see these photographs, they will be even more inspired.

What binds the musicians in *The Jazz Image* with those who gathered in Krakow and all the other jazz makers throughout the world is what Charles Mingus described as the very essence of the jazz impulse: "I'm trying to play the truth of what I am. The reason it's difficult is that I'm changing all the time." That belief in possibility becomes part of the listening experience because the immediacy and the direct honesty of this music is a continually regenerative force, whether or not you yourself can play a note. It energizes your own life experiences—losses, triumphs, and continuing desires.

One of Ellington's sidemen told me of him, "He's found the way to stay young. Watch him some night in the wings. Those bags under his eyes are huge, and he looks beat and kind of lonely. But then we begin to play, he strides out on the stand, the audience turn their faces to him, and the cat is a new man!"

Look again at the photograph of Duke here lifting his band and his sidemen, and that thrust of life may enter your own being as well.

PREFACE Lee Tanner

In 1943, when I was twelve, I came across a *Life* magazine article entitled "Jam Session" that documented an informal jazz party held in photographer Gjon Mili's New York City studio. It had a profound effect on me. I had been listening to jazz on the radio since I was seven, and I now could put faces to the sounds I had learned to love. Here they were on the page, musicians captured while playing rather than stiffly posed for publicity shots. Mili's photographs plunged me into a world where I could observe the artists at work. It gave me a sense of being present as the creative process unfolded. More exactly, the photographer made me the eye of the camera. It reminds me today of an earlier childhood memory. While still in a crib, I spent many hours in my father's studio watching him draw and paint. It is rare to be able to observe an artist at work as something new is developed. One most often sees or hears their perfected creation: the painted canvas, the published book, the music, dance, or theatrical presentation. Jazz in live performance is invariably something new as it is created.

The jazz scholar Nat Hentoff observed not long ago that "recordings are not enough to provide a full understanding of a jazz musician's work. There is an added physical and emotional impact in seeing the musician play. The music is so personal that with the best players, their instruments have become extensions of themselves." An avid listener may not always be able to be present for a performance, and certainly not for those of the past. However, the gap in emotional connection can be minimized by viewing the vast body of images that a select group of photographers have built over nearly three-quarters of a century. Jazz and photography, art forms whose only similarity may be that of improvisation, have developed a magnificent synergism.

My love of jazz and my love of the photography of jazz have been lifelong passions. Through the years I have joyfully practiced my photographic avocation and have followed the work of my colleagues with great admiration. We looked forward to our annual visits to Newport and Monterey: hearing the music, shooting the scene, and building lifelong friendships.

The Jean Goldkette Orchestra, 1927,
with saxophonist Frankie Trumbauer
(top row, third from left) and cornetist
Bix Beiderbecke (fourth from right).

Duncan Schiedt Collection

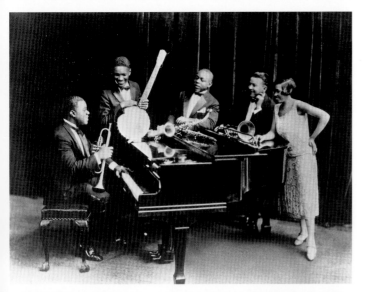

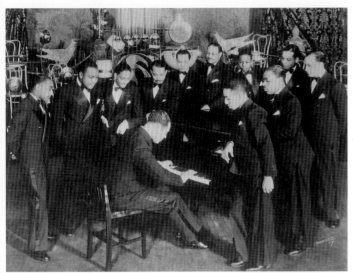

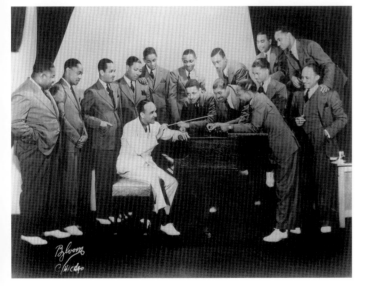

With time I came to realize that jazz photography has not been afforded the exposure and appreciation that it fully deserves. In the early 1990s, when I retired from a career in science, I began to curate and produce group exhibitions, first in the San Francisco Bay Area and then across the country. One of them was a celebration of Dizzy Gillespie, and this led to the publication of my first book, comprising the work of twenty photographers. Then in 1995 I took over a new project for *Jazz Times* magazine, a series called "Indelible Images—Classic Jazz Photography," which had been initiated to give exposure to the work of six photographers each year. This was a marvelous experience, and it led to my desire to put this book together.

It may seem oddly arbitrary to the reader that the earliest photographs in *The Jazz Image* are from the mid-1930s. After all, the beginning of jazz goes back to the turn of the century, and photography predates that by some seventy years. However, the limitations imposed by state-of-the-art technology made candid pictures taken on the scene effectively impossible for those first three decades. Photoflash bulbs were not invented until 1931, and available-light photography in low-lit situations was not really developed as a technique for another fifteen years, requiring further scientific advances in lens design and film sensitivity. The early photographs of musicians were often taken outdoors, such as this image of Jean Goldkette's musicians in 1927 (opposite). Pictures taken indoors required artificial lighting accomplished by igniting a dangerously explosive mixture of fine powders. Two examples are the charming although still rather formal shots of Louis Armstrong's Hot Five in 1925 (top) and the Duke Ellington Orchestra in 1929 (middle). On the other hand, the studio posed shot of the Fletcher Henderson Orchestra in 1936 (bottom) was quite likely illuminated with intense electric or flashbulb lighting units.

Photoflash and camera shutter synchronizers ushered in the era of modern photojournalism and an emphasis on rapid news reporting as well as entertainment events, such as this ballroom performance of the Count Basie Band with Lester Young from 1940 (page 10). Photographers were also going into the recording studios. The next photo on that page shows Count Basie and Benny Goodman along with their sidemen in a special session for producer John Hammond's *Spirituals to Swing* series in 1939. In the same year, Charles Peterson captured Billie Holiday recording her famous rendition of "Strange Fruit" (page 11). Holiday is also seen here in a truly cheerful moment with a young, handsome Ben Webster, taken several years earlier by Danish fan Timme Rosenkrantz.

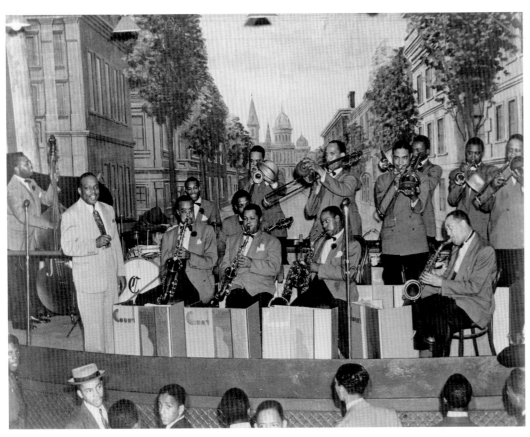

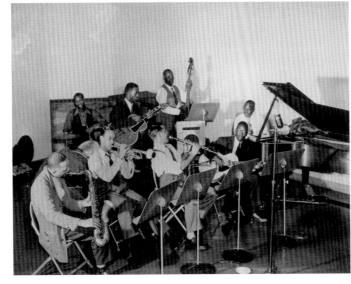

In the mid-1940s, the journalist and photographer Bill Gottlieb got many newsworthy shots. Three included here (page 12) are New York City's 52nd Street at night, a musician get-together at Mary Lou Williams's apartment, and Thelonious Monk with confrères in front of the famous Minton's Playhouse in Harlem. Another three pictures (page 13) show perhaps the tail end of this type of journalistic publicity photography. Popsie Randolph took the only pictures of the historic Miles Davis recordings for Capitol Records in 1949; Robert Parent captured a remarkable quartet of Bird, Monk, Mingus, and Roy Haynes at Greenwich Village's Open Door Café in 1953; Irving Kaufman shot Billy Eckstine and his band on their way to the recording studio.

In the late 1930s and even more so after World War II, photographers experienced an available-light revolution. The field blossomed with the advent of small cameras with lenses and films that had increased capability to capture light. One could now readily obtain pictures of performances in the low-lit ambiance of jazz clubs without auxiliary lighting. Coincidentally, jazz, too, was experiencing a transformation: The established swing style was giving way to more modern forms, and small groups featuring strong individual soloists provided dramatic subjects for photographers.

Recording technology changed the presentation of music after the war as well. New LP (long-playing) records greatly increased the amount of music that could be stored on a single record, and these ten- and twelve-inch discs required packaging for sale. Designing the LP jacket now became a powerful marketing medium. The small independent jazz companies quickly broke from conventional graphic approaches by using candid performance shots. Several labels gained unique and vivid visual identities based on their photographers' styles. Two

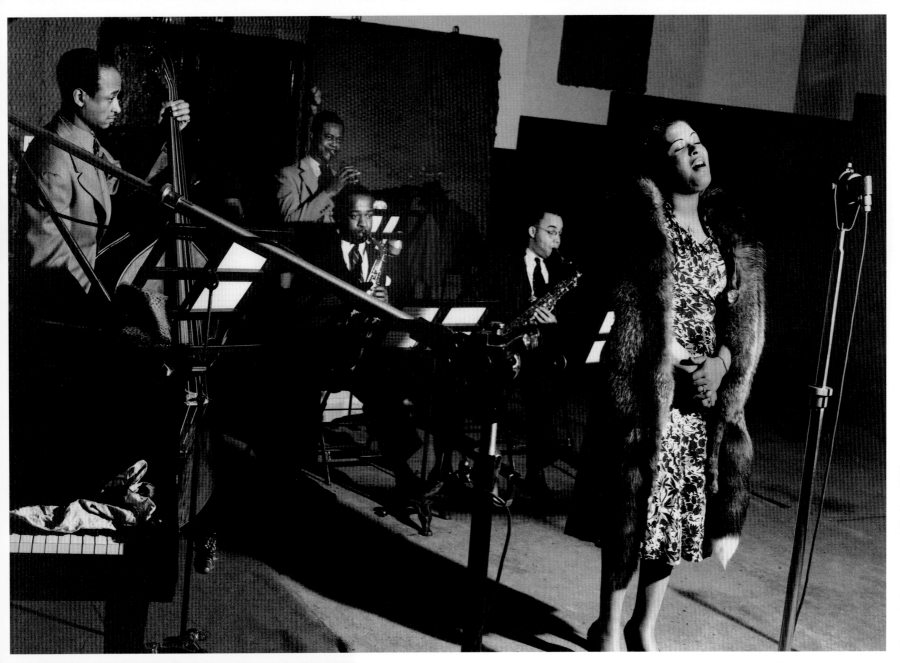

ABOVE:

Billie Holiday records "Strange Fruit"
for Commodore Records, New York, 1939.

Photograph by Charles Peterson

LEFT:

Billie Holiday with **Ben Webster,
Johnny Russell, Ram Ramirez,** and
unknown guitarist in Harlem, 1935.

Photograph by Timme Rosenkrantz
Duncan Schiedt Collection

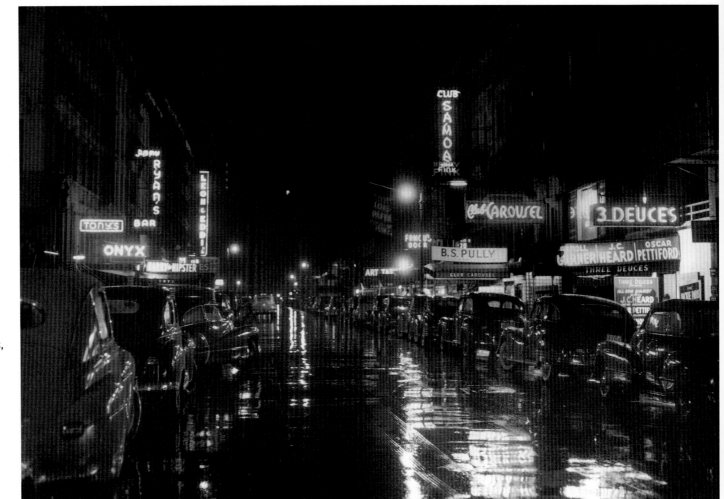

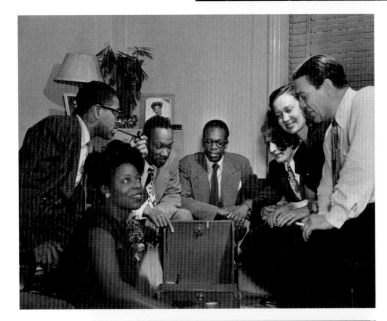

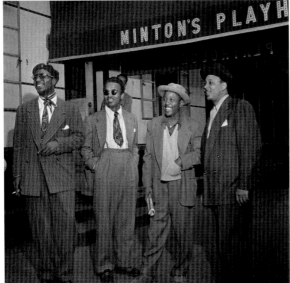

excellent examples are Frank Wolff's images for Blue Note and Bill Claxton's work for Pacific Jazz. These jacket photographs were presented with little or no frills, preserving each artist's personal vision. Soon, all the recording industry followed this lead, to the great benefit of many working photographers as well as the buying public.

The photographers included here all began shooting jazz during the period from 1935 into the 1970s. We are quite a diverse lot, coming from many different backgrounds and places of origin. Our most common link is that many of us were jazz fans from an early age. We were children of the traditional and swing eras who heard live music on late-night radio, on records, and sometimes even in person. Many were trained in the fine arts before starting careers in photography; others were musicians or in the music business. Gjon Mili, Bob Parent, and I were the only ones formally trained in science or engineering. One might see an association here as well: Science, visual art, and music are all aspects of jazz photography. During a Yousuf Karsh photo session with Albert Einstein in 1948, Karsh's assistant at the time, the young photographer Herman Leonard, asked Einstein (who was also a fine violinist) what the connection was between a great musician and a mathematician. Einstein responded, "Why, it's the same thing—improvisation!"

BELOW:

The Miles Davis Nonet, Capitol Records, New York, 1949:
Junior Collins, French horn; Bill Barber, tuba; Kai Winding,
trombone; Gerry Mulligan, baritone sax; Davis, trumpet;
Al Haig, piano; Lee Konitz, alto sax; Joe Shulman, bass.

Photograph by Popsie Randolph
Frank Driggs Collection

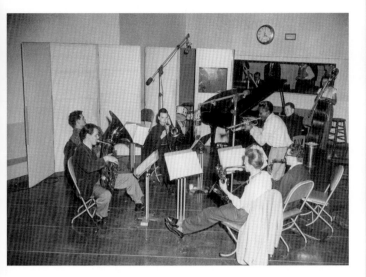

I present some of the best work of many of these
photographers in the following pages. All the artists,
or their representatives, have been marvelously coopera-
tive in working within the scope of my vision, and they
have my deeply felt thanks. My primary desire was to
collect examples of their best art, but I also wanted this
to be a book that would have a historical dimension,
with photographs of the most important innovators of
jazz into the 1990s.

"No music has been more adored by the camera,"
wrote Barry Singer in the *New York Times*. "Something
about the faces in jazz, and the ephemeral improvised
moment, have infatuated photographers . . . inspiring
viewfinder variations as eloquent as the most transcen-
dent jazz solos."

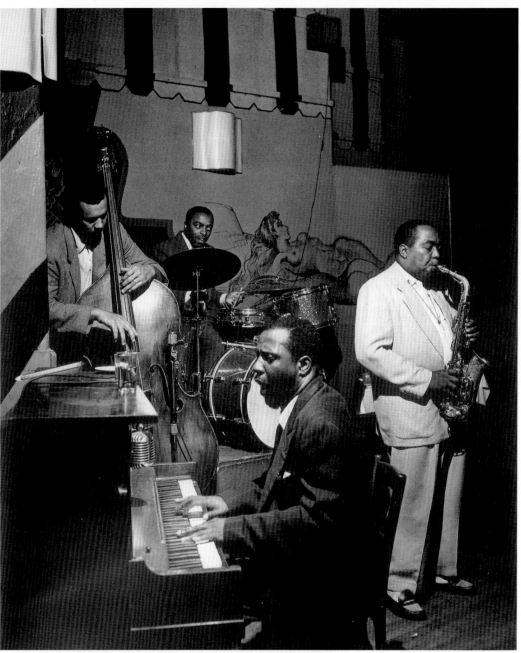

ABOVE:

Monk and Bird at the Open Door Café,
New York, 1953: **Charles Mingus,** bass;
Roy Haynes, drums; **Thelonious Monk,**
piano; **Charlie Parker,** alto sax.

Photograph by Robert Parent

LEFT:

Singer **Billy Eckstine and his Bebop
Big Band** head to a recording
session at National Records, New
York, May 1948: Art Blakey, drums;
Tommy Potter, bass; Budd Johnson,
tenor sax, arranger; Robert "Junior"
Williams, alto sax; Fats Navarro,
trumpet; Eckstine; Chippie Outcalt,
trombone, arranger; Gene Ammons,
tenor sax.

Photograph by Irving Kaufman
Frank Driggs Collection

13

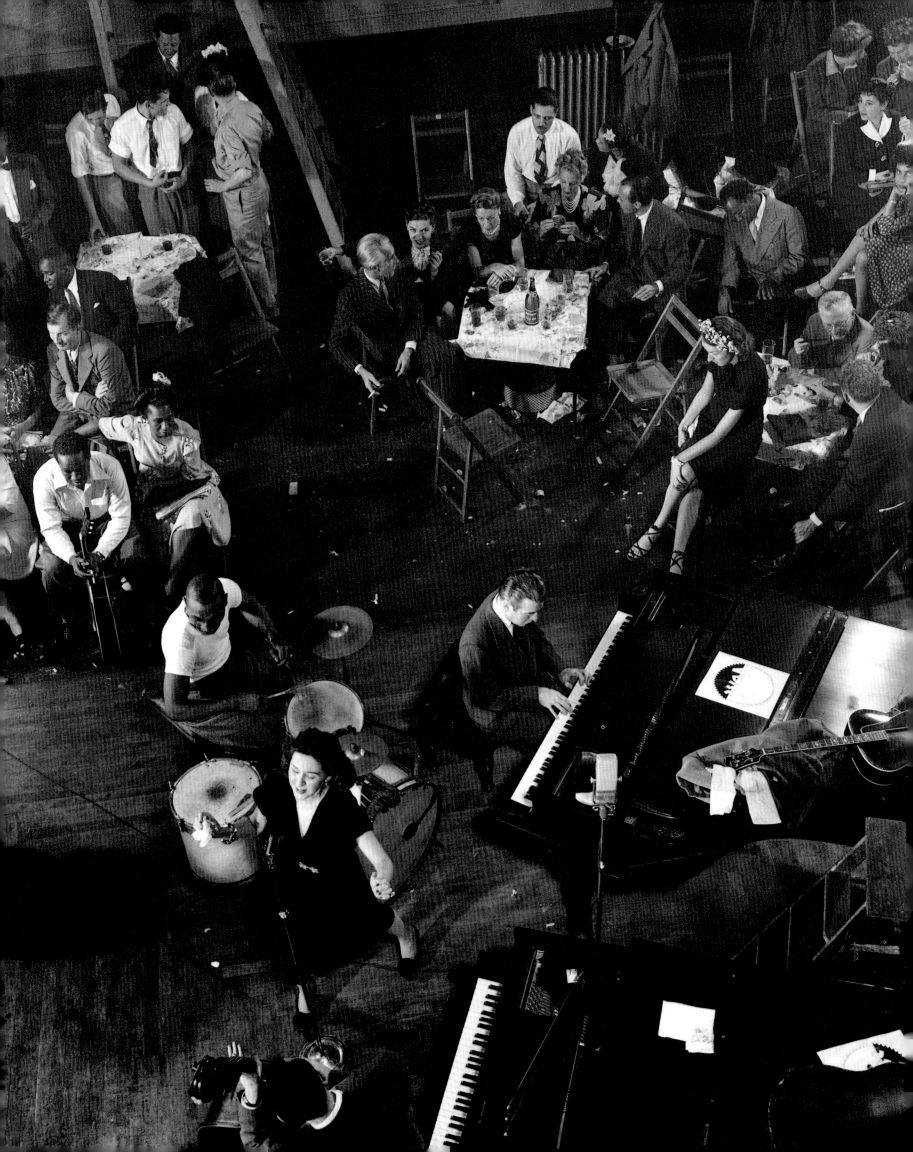

1935–1945

Singer **Lee Wiley** with **Cozy Cole** on drums and **Jess Stacy** on piano at a jam session in Gjon Mili's New York studio, 1943.

Photograph by Gjon Mili

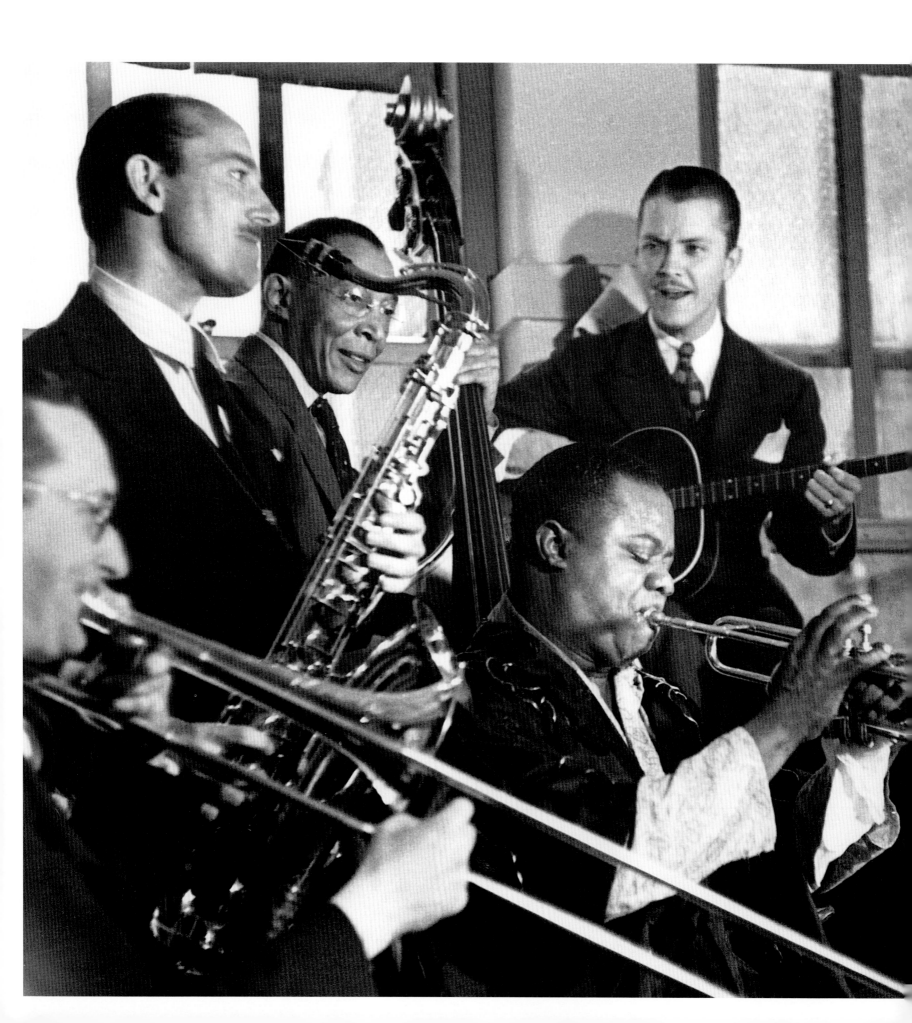

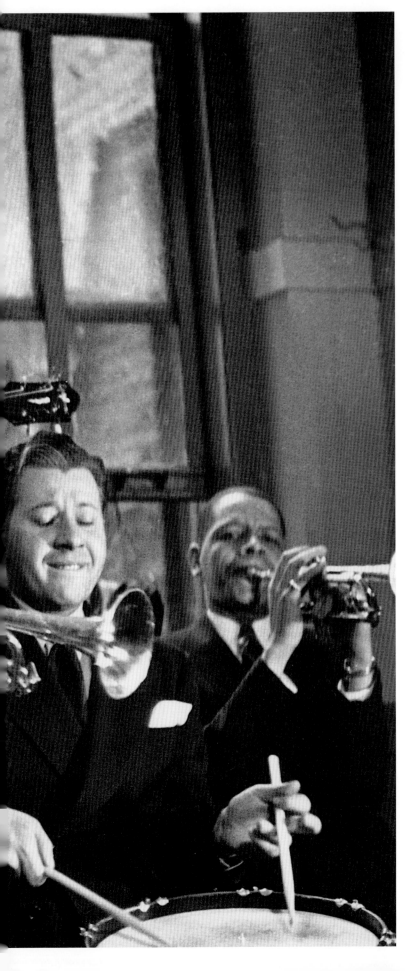

Louis Armstrong plays backstage with **Tommy Dorsey, Bud Freeman, Eddie Condon, Pops Foster, George Wettling,** and **Red Allen,** at the Paramount Theater, New York, 1937.
Photograph by Charles Peterson

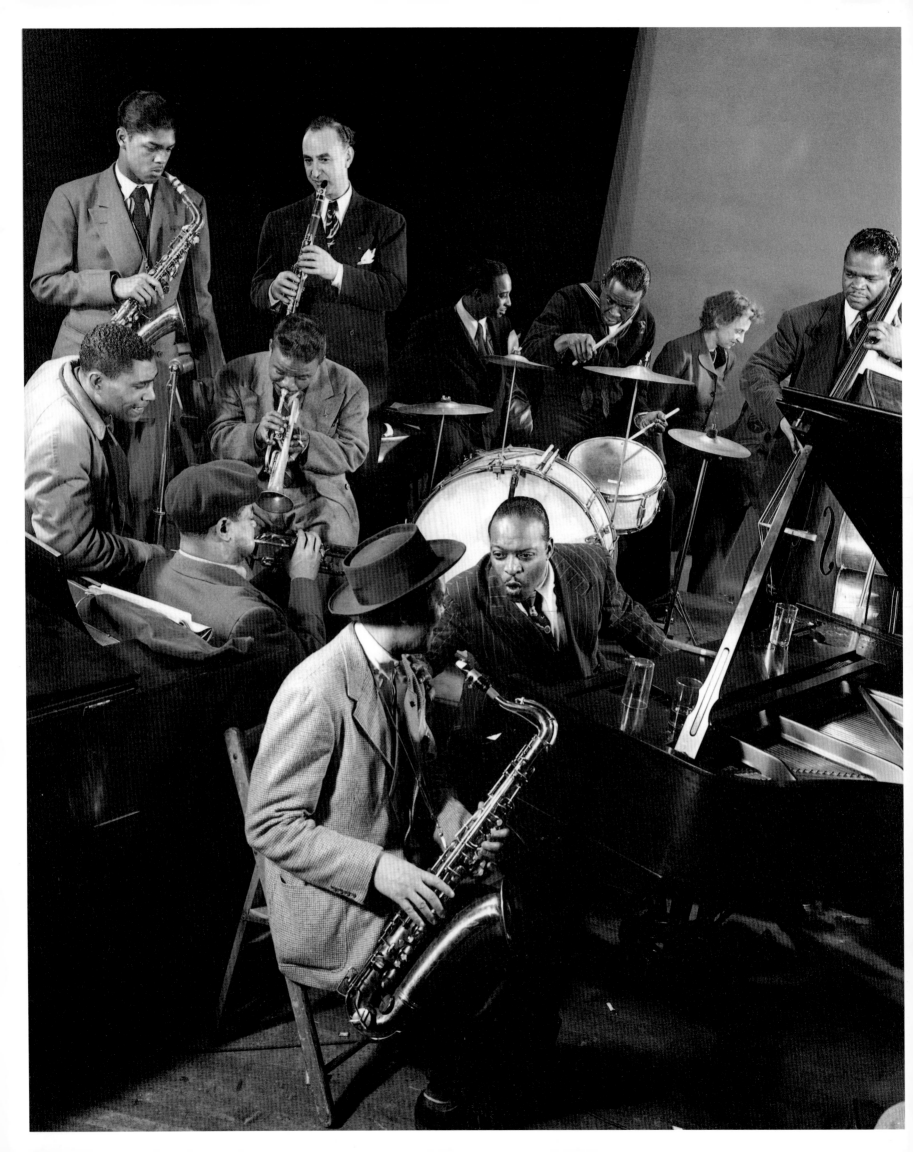

Lester Young and **Count Basie**
in conversation while **Dizzy Gillespie**
and others play at a jam session in
Gjon Mili's New York studio, 1943.
Photograph by Gjon Mili

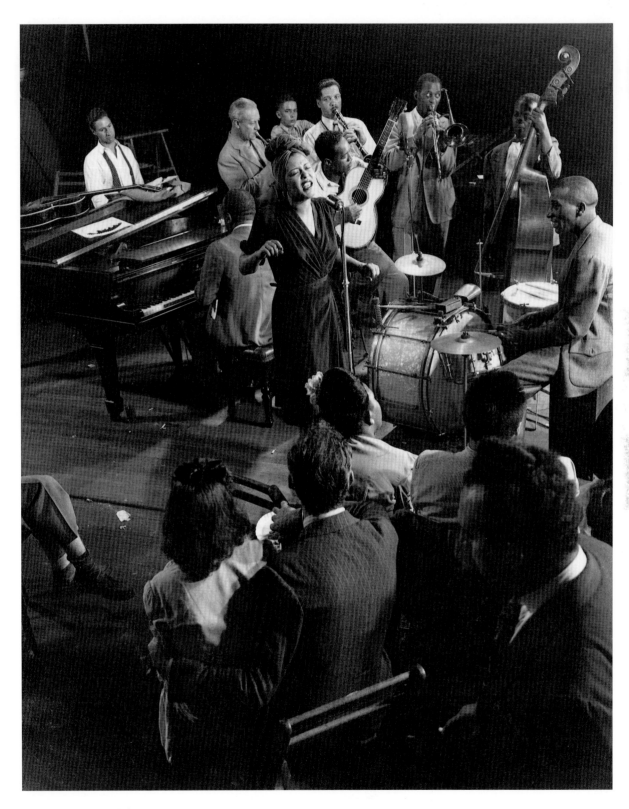

Billie Holiday and drummer
Cozy Cole, jam session in
Mili's New York studio, 1943.
Photograph by Gjon Mili

Soprano saxophonist **Sidney Bechet** and **Hot Lips Page** at Jimmy Ryan's, New York, 1942.

Photograph by Charles Peterson

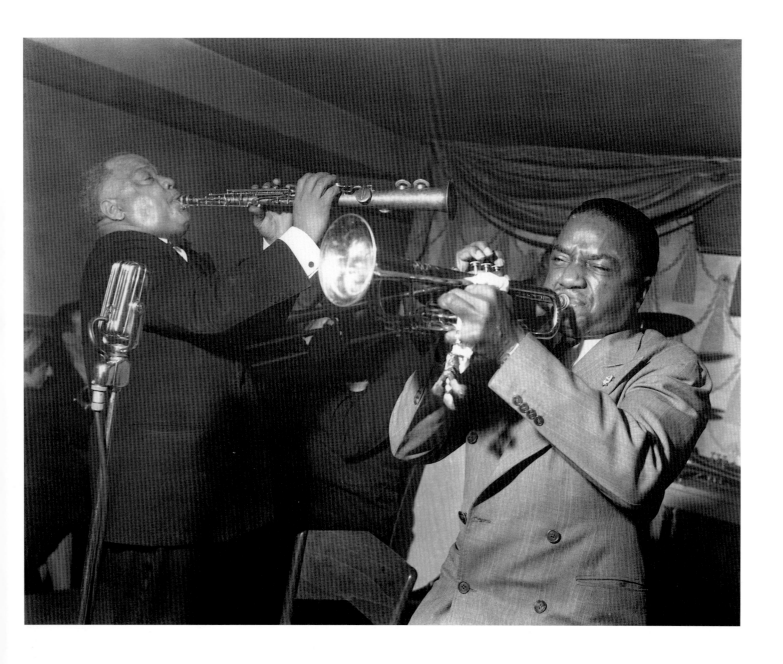

Drummer **Gene Krupa** sits in
with **Eddie Condon, Lou McGarity,**
and **Wild Bill Davison** at Condon's,
New York, 1945.
Photograph by Charles Peterson

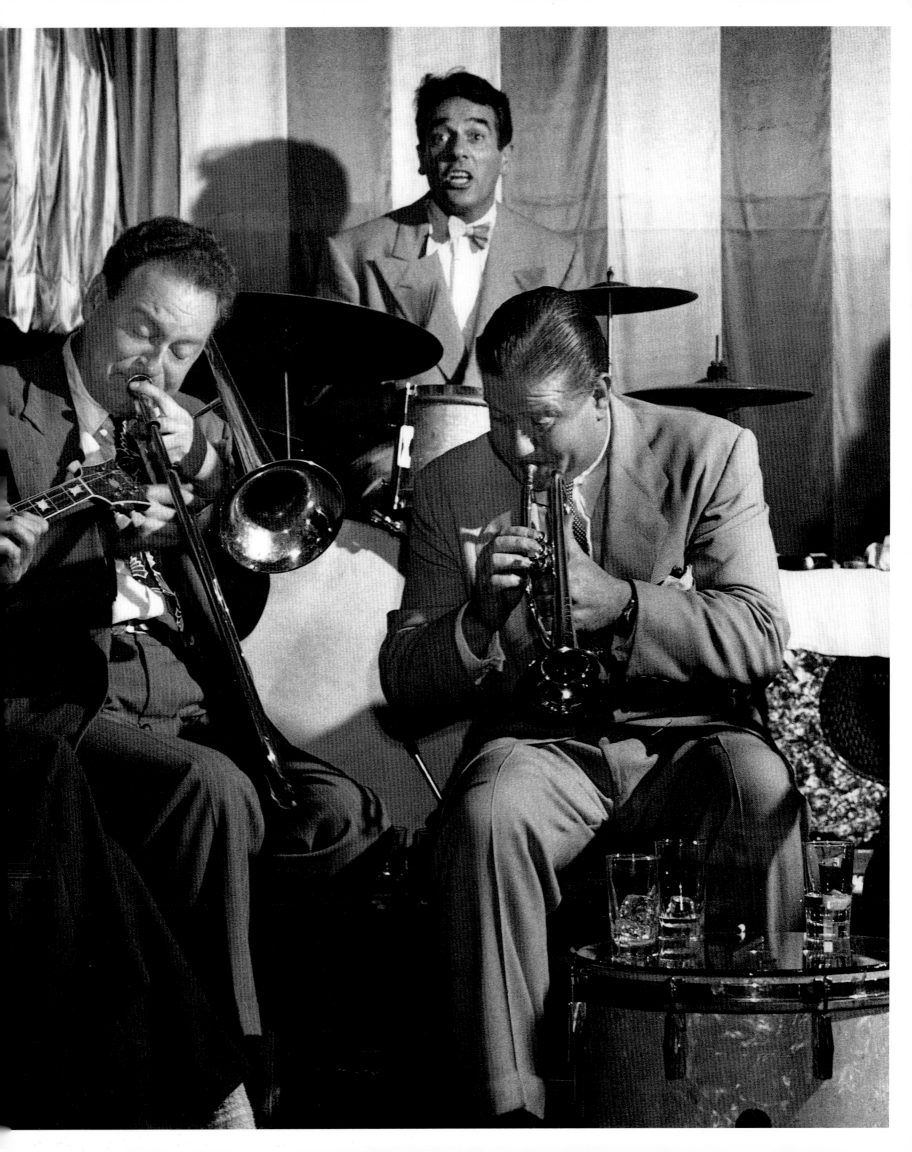

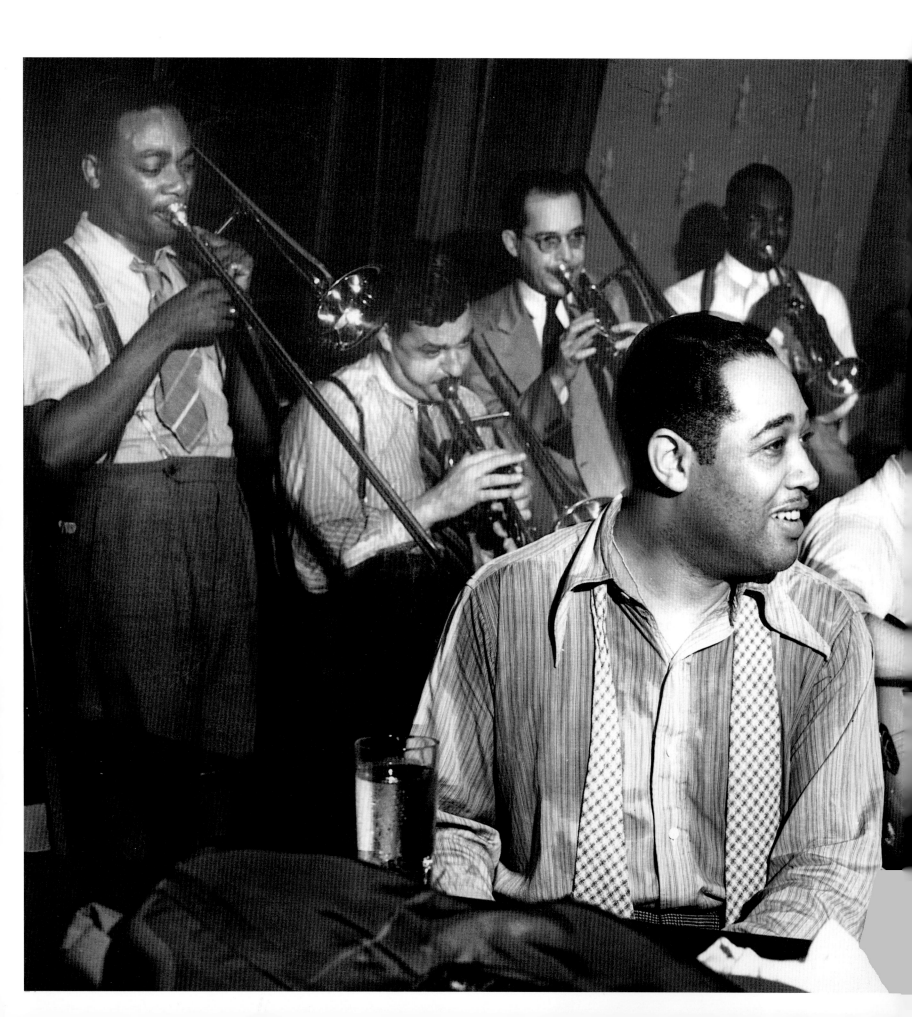

Duke Ellington at a jam session photographed for *Life*, produced by Harry Lim of Keynote Records, New York, 1940.

Photograph by Charles Peterson

Lester Young listens as **Joe Sullivan** plays
at the Village Vanguard, New York, 1940.
Photograph by Charles Peterson

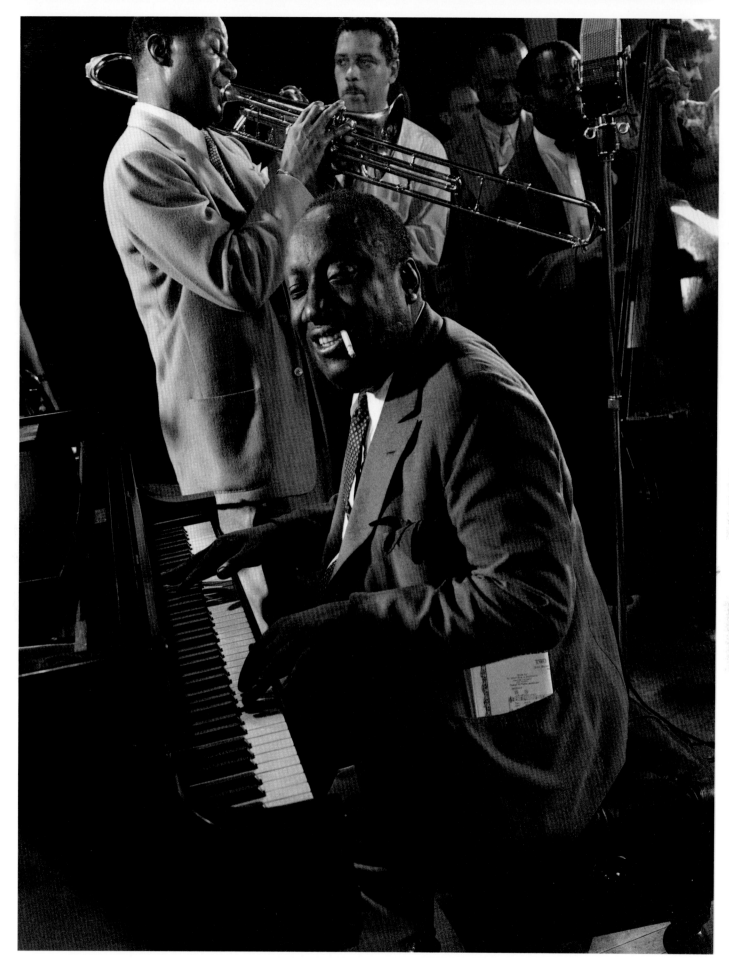

Pianist **James P. Johnson**
at a jam session in Mili's
New York studio, 1943.
Photograph by Gjon Mili

Fats Waller gets a quick lunch
before going to the Apollo Theater
in Harlem, New York, 1937.

Photograph by Charles Peterson

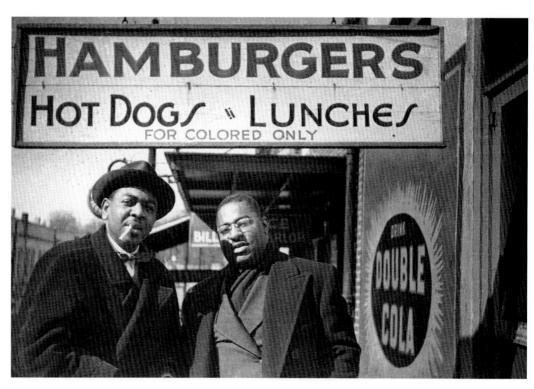

Trombonist **Tyree Glenn** and saxist **Chu Berry** on tour with Cab Calloway in the Jim Crow South, Fort Bragg, North Carolina, 1940.

Photograph by Milt Hinton

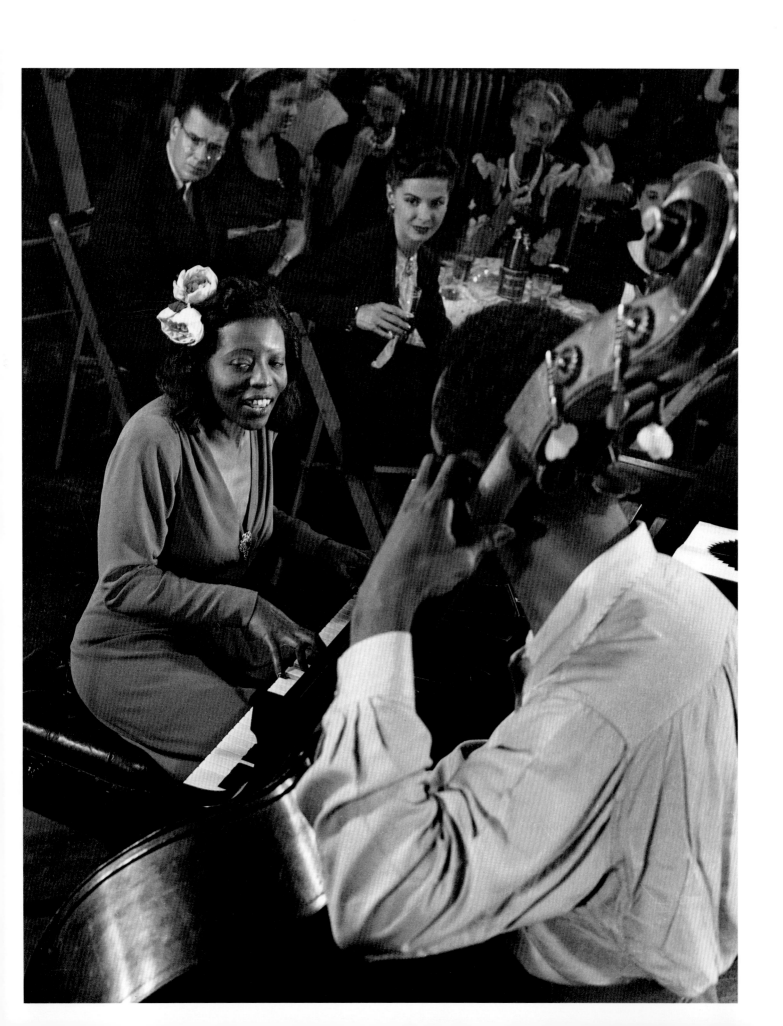

"Mary Lou Williams had been modern since shortly after she became a professional pianist, composer, and arranger many years ago. As she absorbed each new jazz style, she contributed to it."
Nat Hentoff

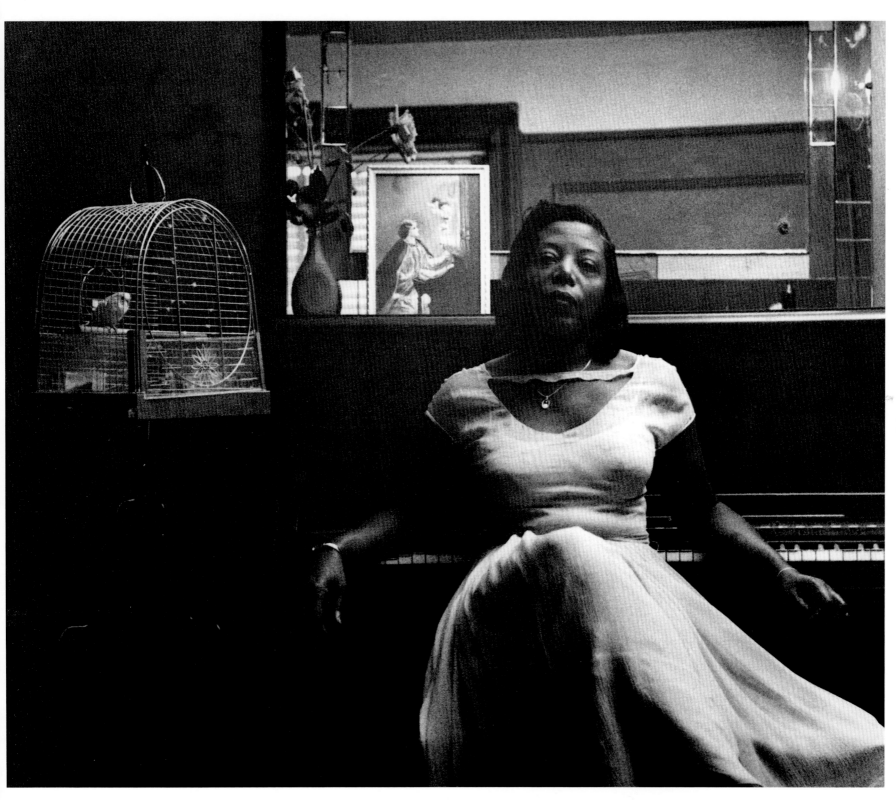

Mary Lou Williams in New York, 1955. In later life Williams taught and practiced her faith.
Photograph by Dennis Stock

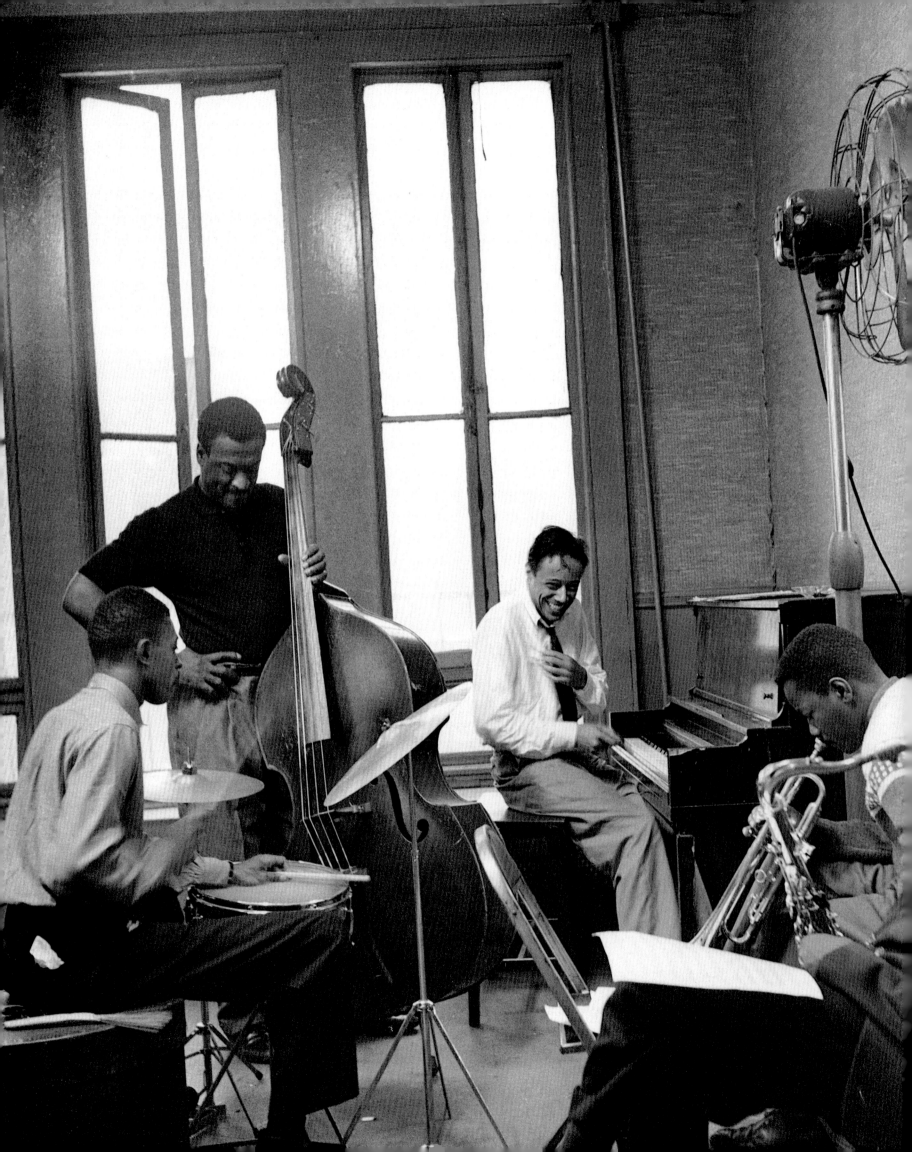

1946—
1960

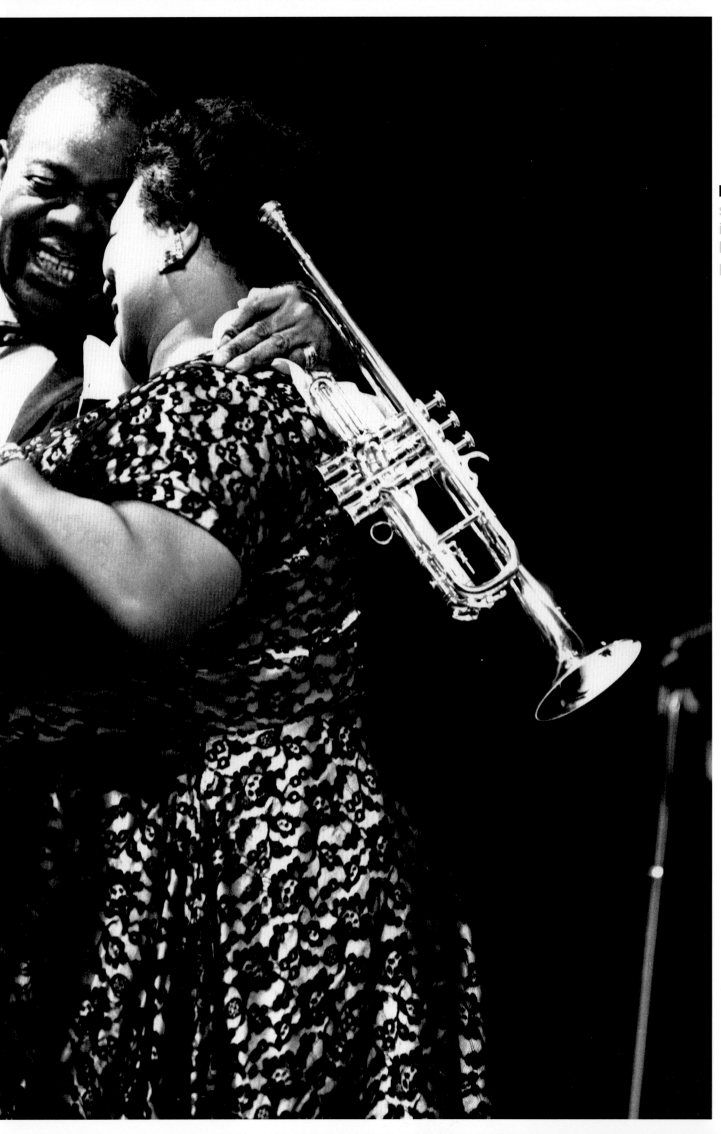

"When I pick up that horn, that's all!
The world's behind me, and I don't
concentrate on nothing but that horn."
Louis Armstrong

Louis Armstrong on the set
of the movie *High Society*,
Los Angeles, 1956.

Photograph by Bob Willoughby

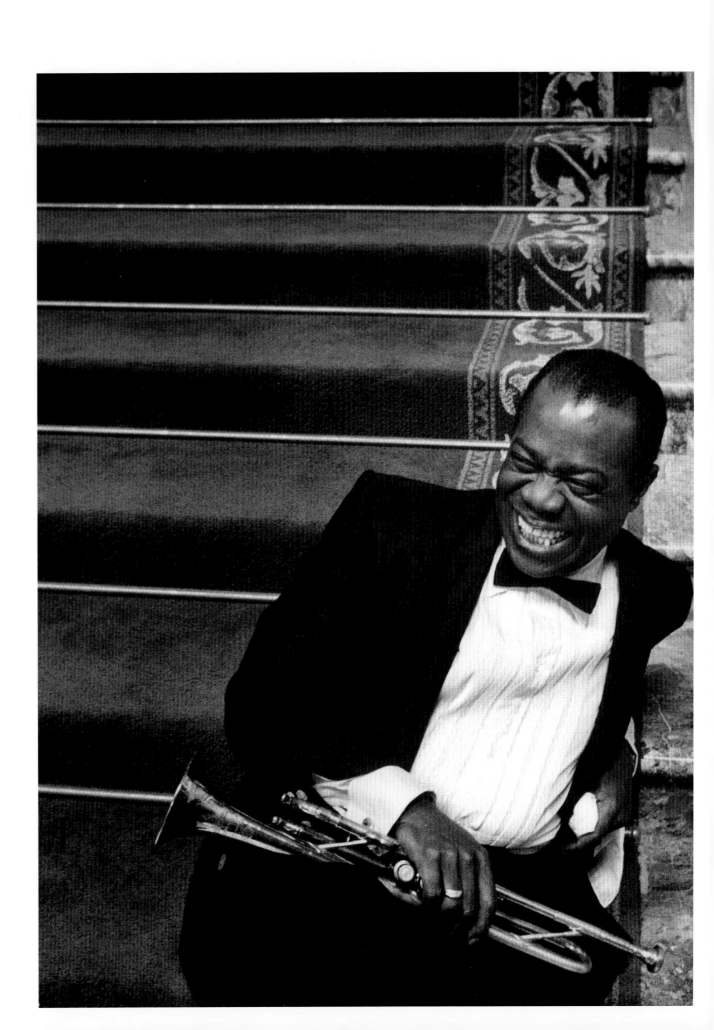

Louis Armstrong in his typical backstage attire, New York, 1954.

Photograph by Carole Reiff

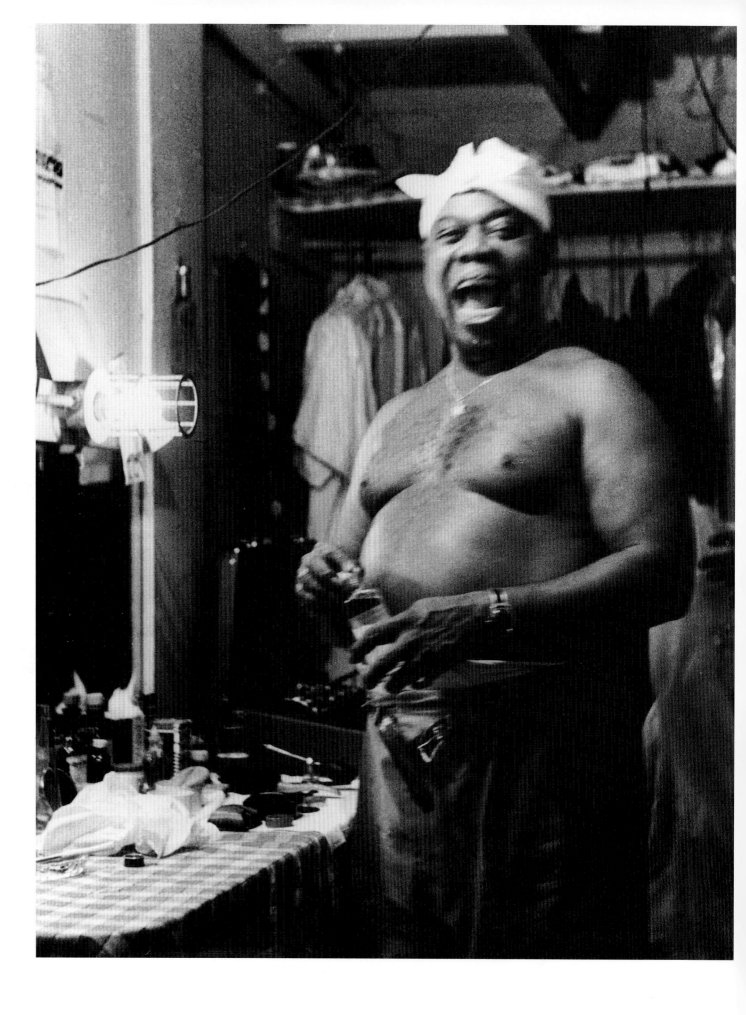

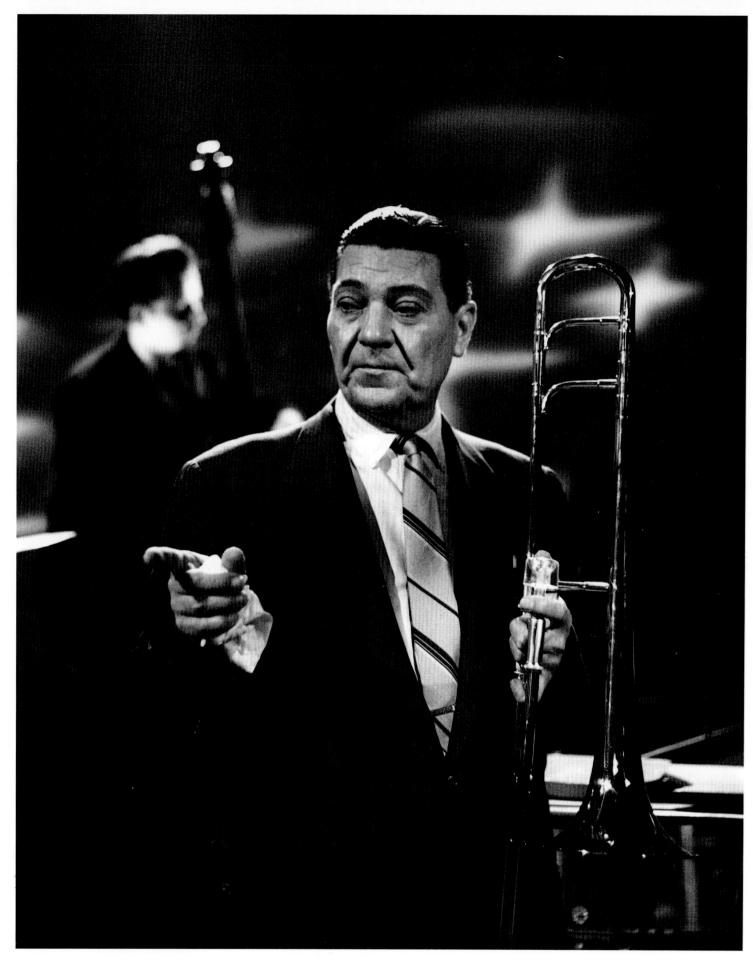

The legendary **Jack Teagarden**
on the *Stars of Jazz* TV show,
Los Angeles, 1958.

Photograph by Ray Avery

Lionel Hampton, vibraphonist, two-fingered pianist, and drummer, in New York, 1948.

Photograph by William Gottlieb

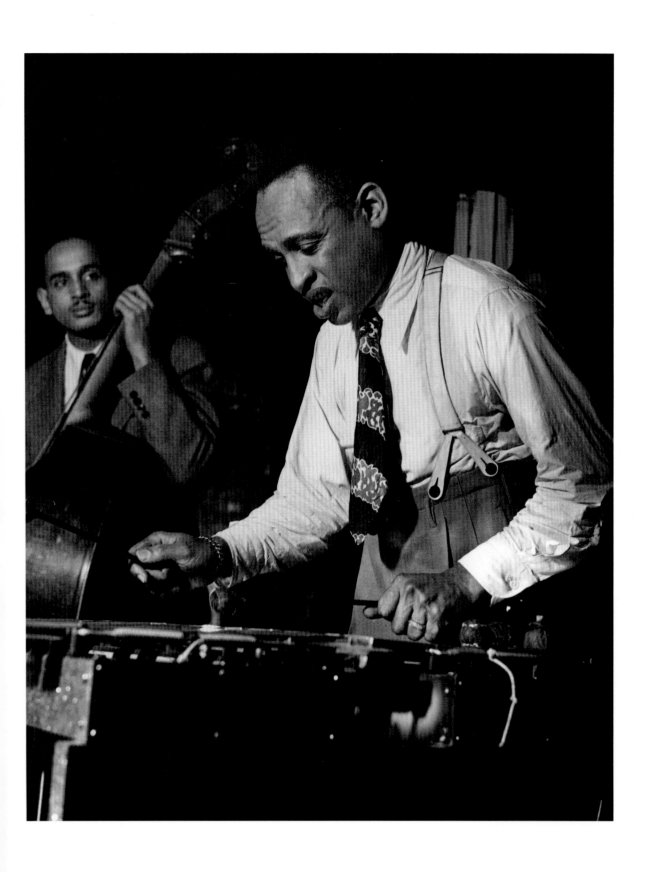

"If you're a certain age, Benny Goodman brings back the swing style dancing in ballrooms and dancing in theaters. He was a leader, and through him seventy years ago was created the first mass audience for jazz."
Nat Hentoff

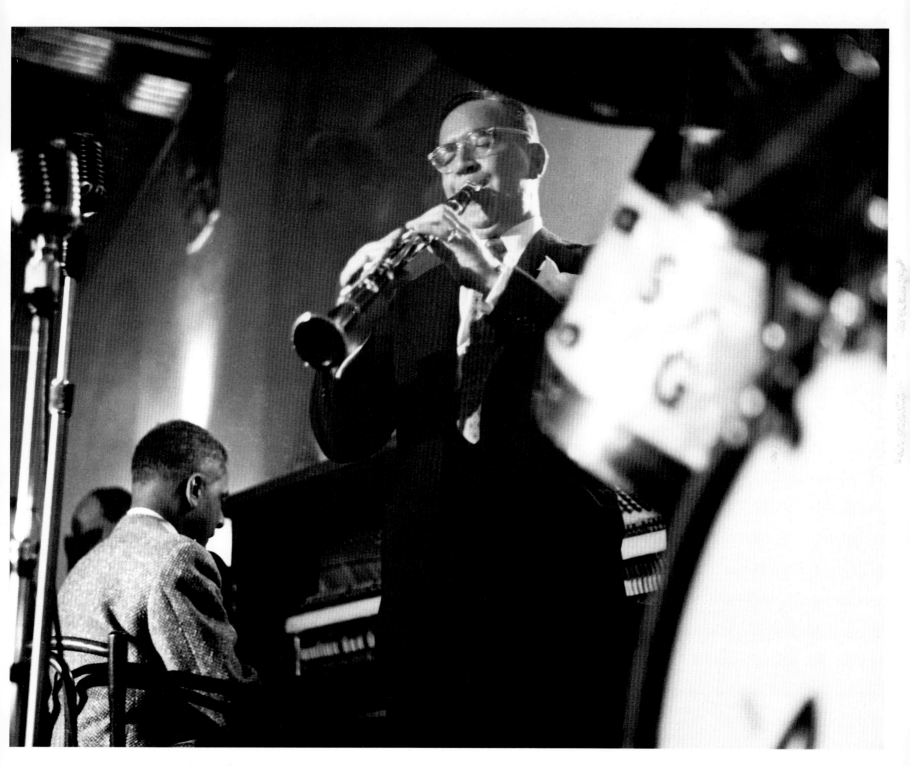

Benny Goodman with pianist **Teddy Wilson** in New York, 1956.
Photograph by Robert Parent

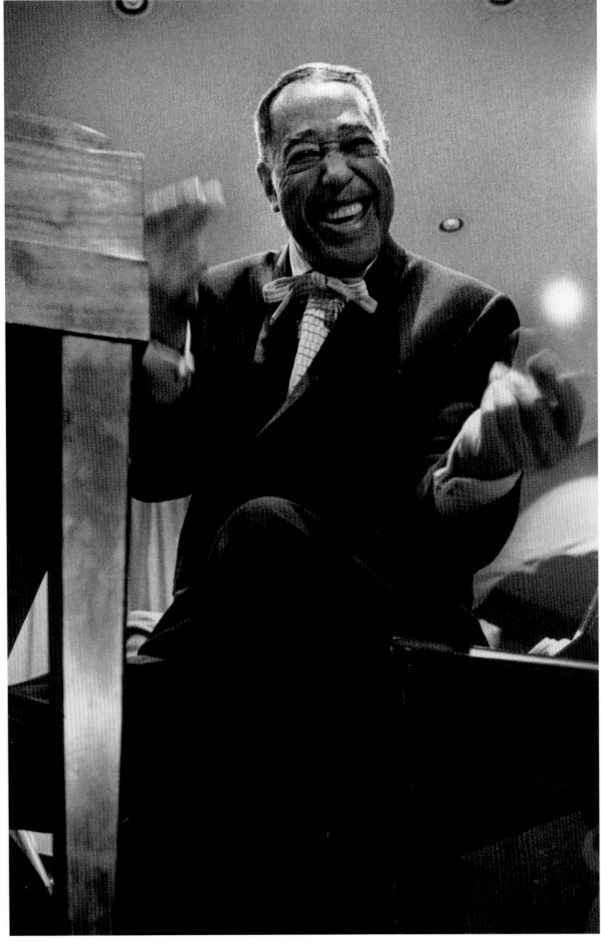

"I'm a piano player, a rehearsal piano player, a jive-time conductor, bandleader, and sometimes I just do nothing but take bows... and I have fun. My, my, my. My thing is having fun."
Duke Ellington

Duke Ellington on tour in Tennessee, 1952.

Photograph by Hugh Bell

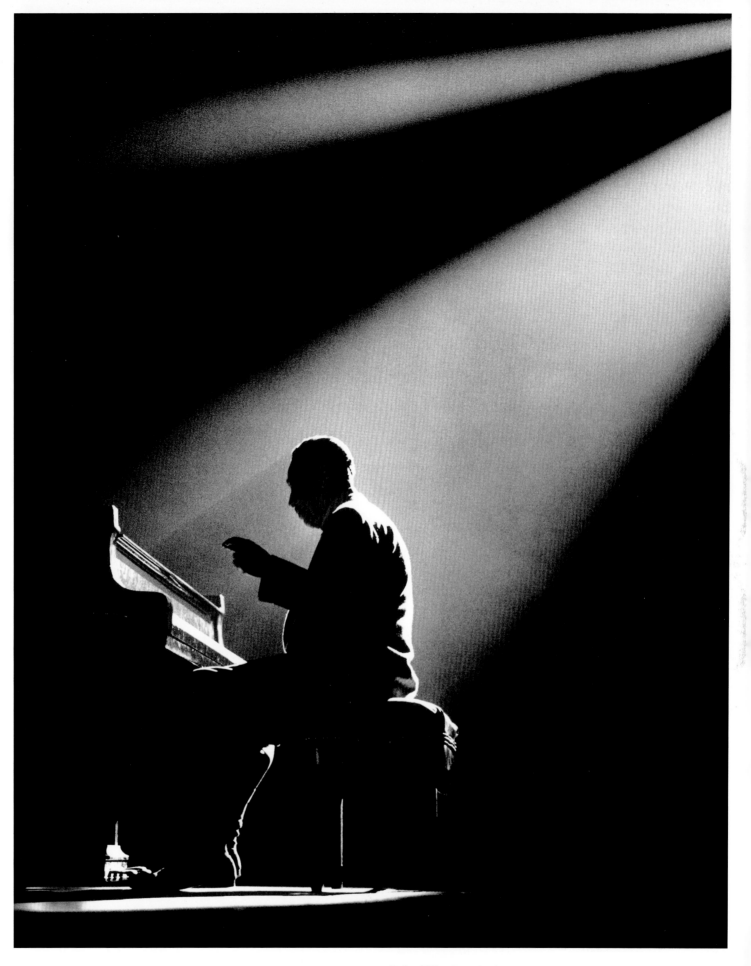

Duke Ellington performs
in Paris, 1958.
Photograph by Herman Leonard

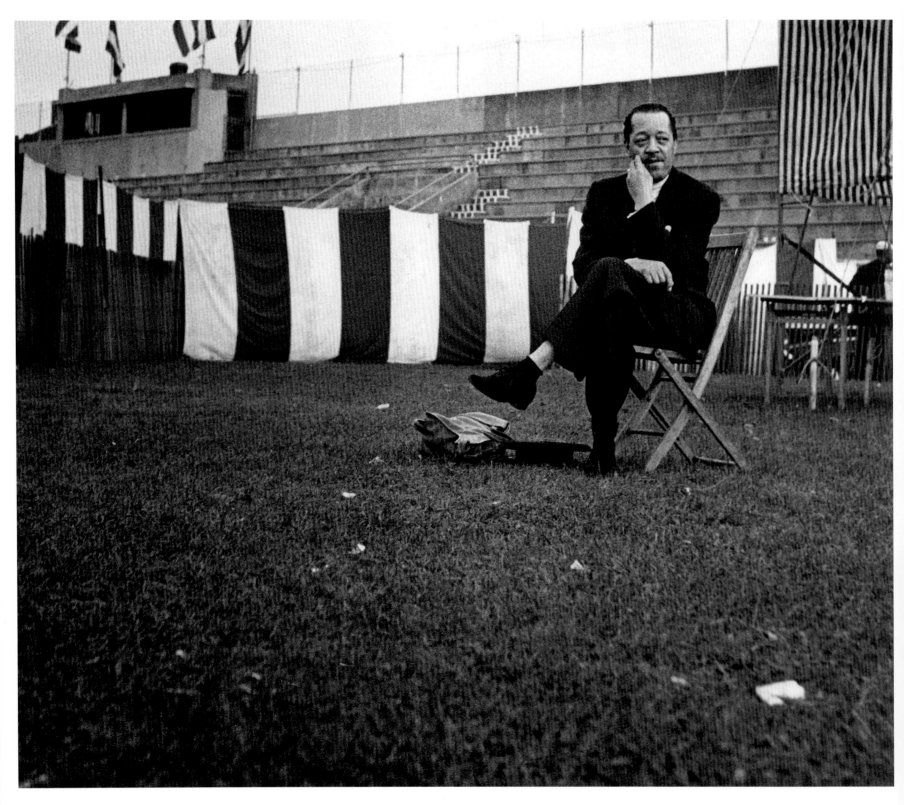

Lester Young at the
Newport Jazz Festival, 1958.

Photograph by Robert Parent

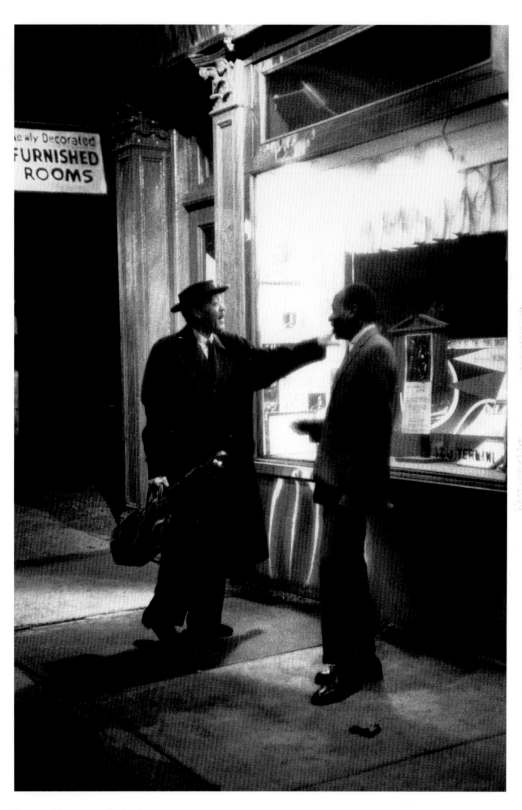

Lester Young and pianist
Hank Jones outside the
Half Note, New York, 1958.
Photograph by Herb Snitzer

Dexter Gordon with drummer
Kenny Clarke at the Royal Roost,
New York, 1948.
Photograph by Herman Leonard

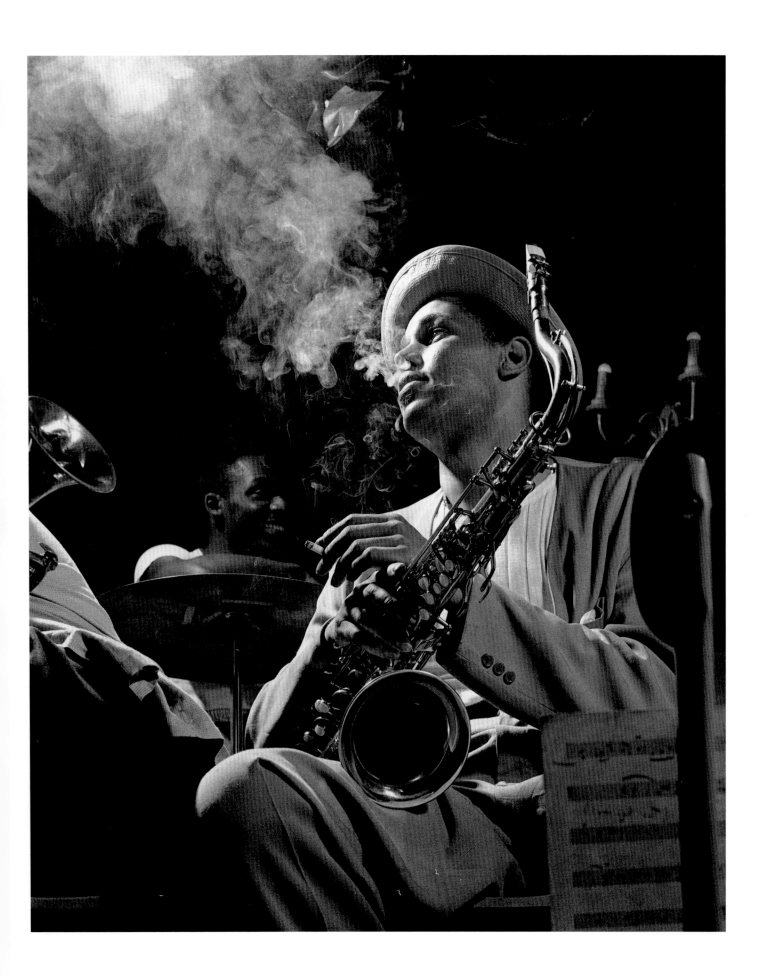

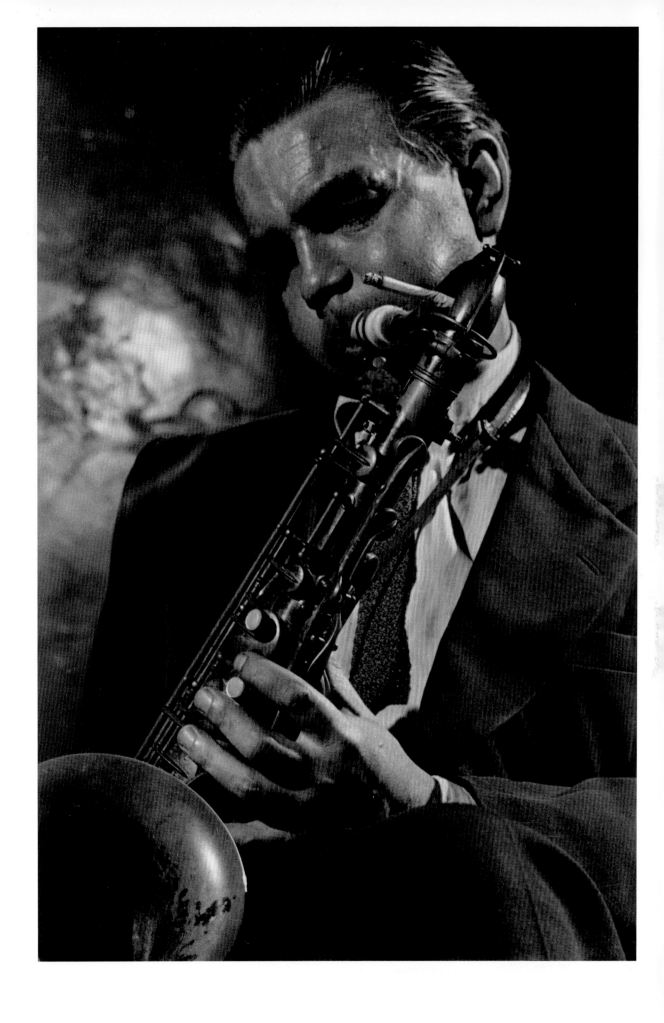

45

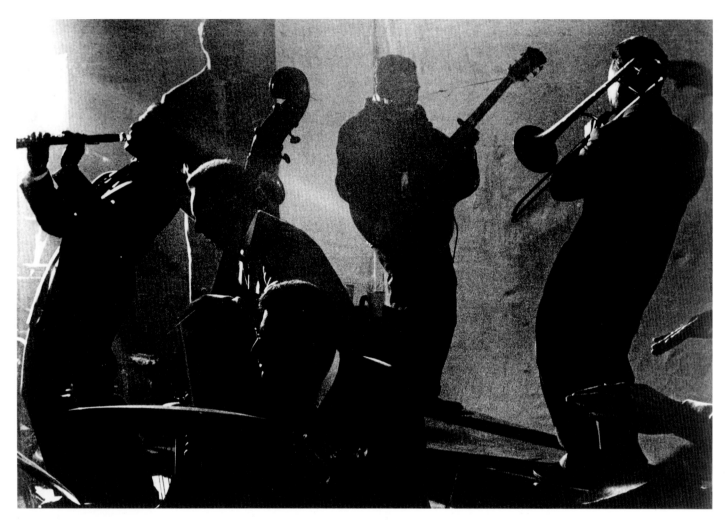

Clarinetist **Tony Scott's**
group at the Village Gate,
New York, 1952.

Photograph by Hugh Bell

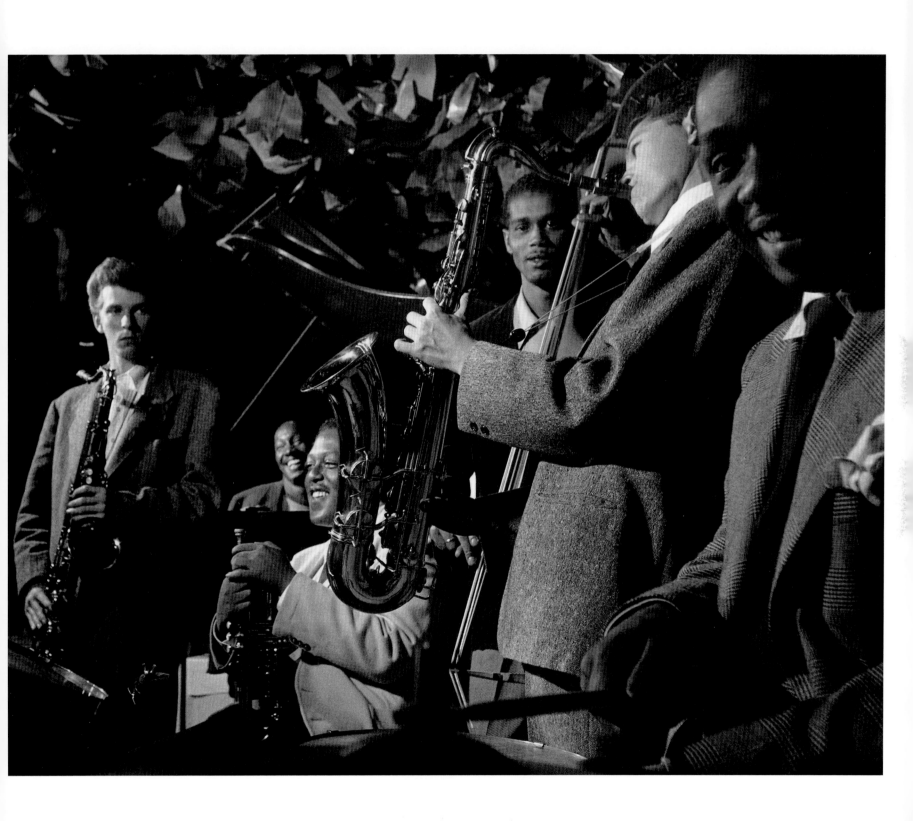

Pianist **Tadd Dameron's** group:
**Jimmy Ford, Dameron, Fats
Navarro, Curley Russell, Allen
Eager,** and **Kenny Clarke** at the
Royal Roost, New York, 1948.
Photograph by Herman Leonard

47

"Among musicians, Billie Holiday
was the jazz singer who said
more to them than anyone else."
Nat Hentoff

Billie Holiday performs at the
Tiffany Club, Los Angeles, 1951.
Photograph by Bob Willoughby

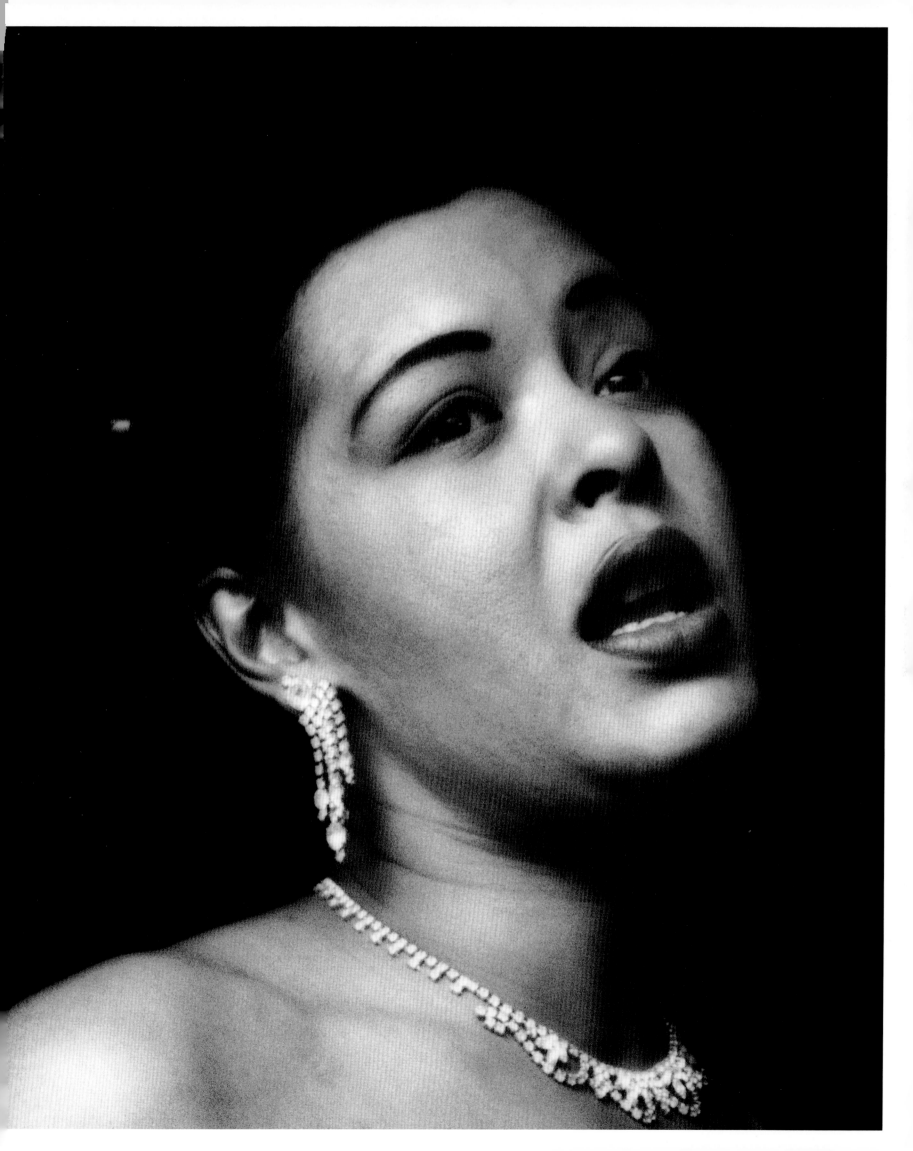

"A singer has to work doubly hard to emit those random notes in scat singing with perfect intonation. Well, I should say all singers except Ella. Her notes float out in perfect pitch, effortless, and most important of all, swinging."
Mel Torme

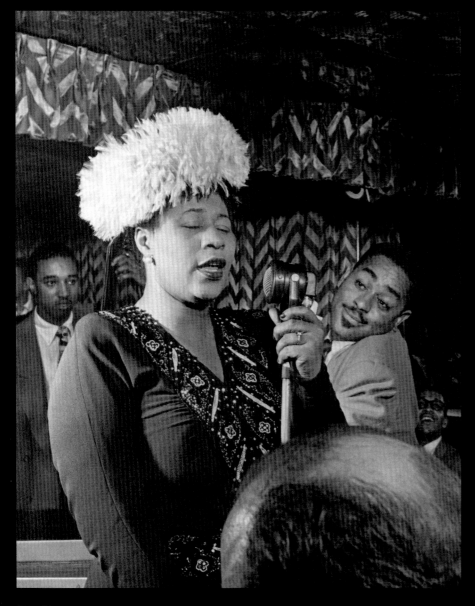

Ella Fitzgerald with **Dizzy Gillespie,** who taught her to sing scat, at a 52nd Street club, New York, 1948.
Photograph by William Gottlieb

Dinah Washington in Los Angeles, 1959.
Photograph by William Claxton

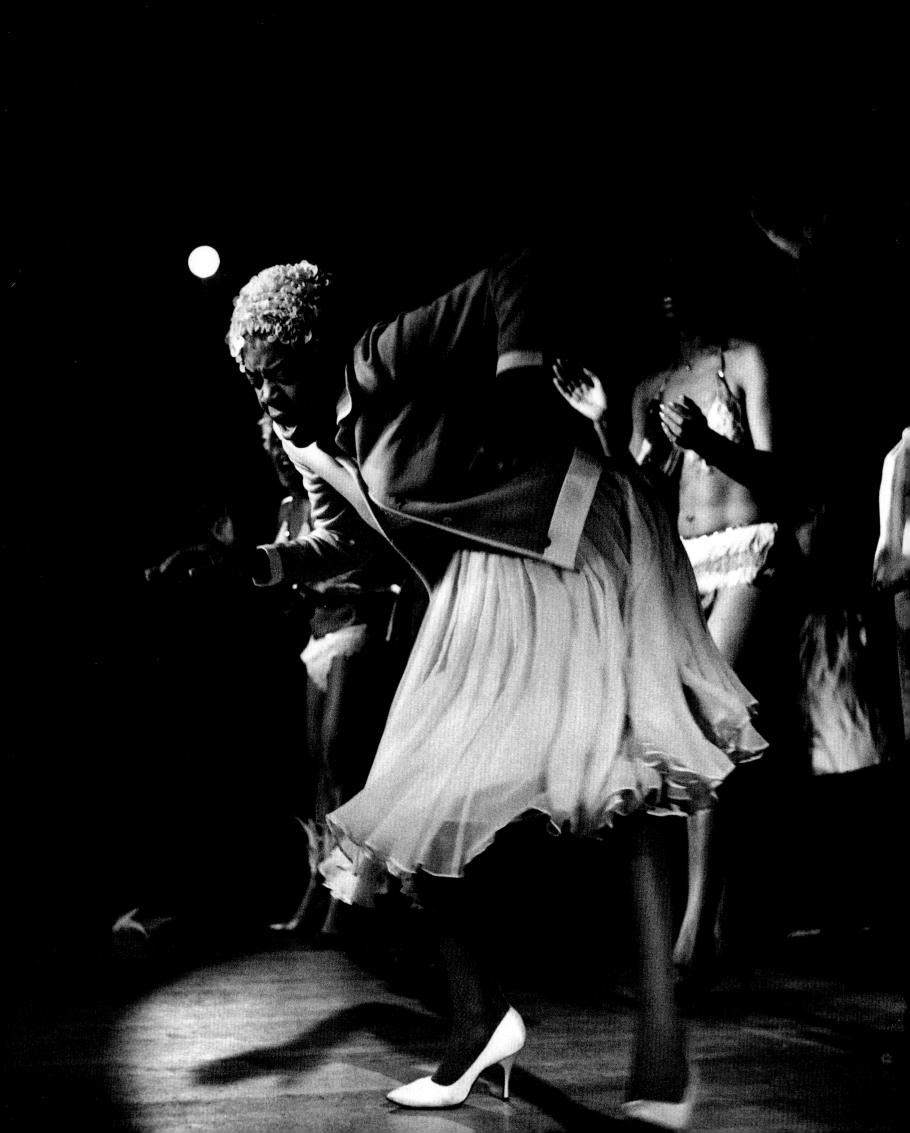

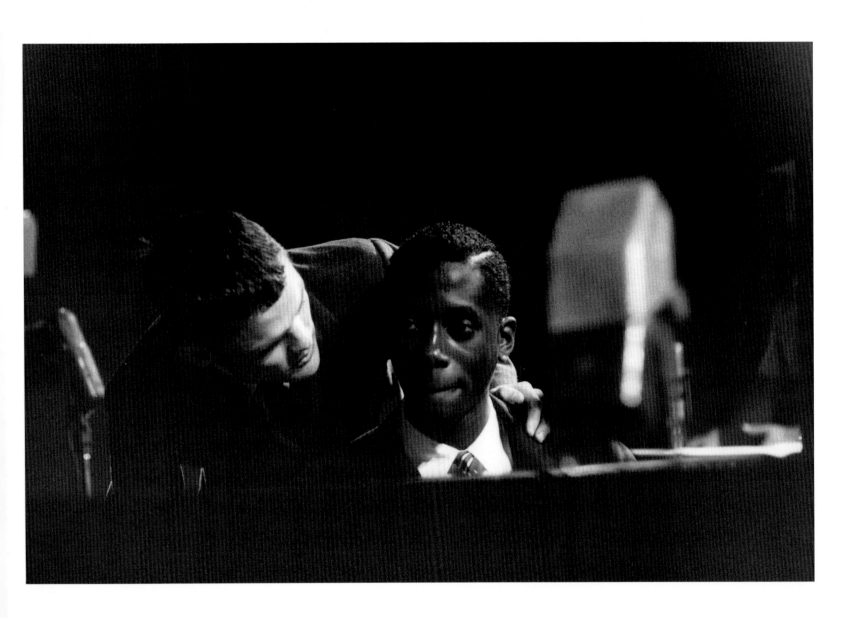

Chet Baker advises pianist
Bobby Timmons during
filming of the *Stars of Jazz*
TV show, Los Angeles, 1956.
Photograph by Ray Avery

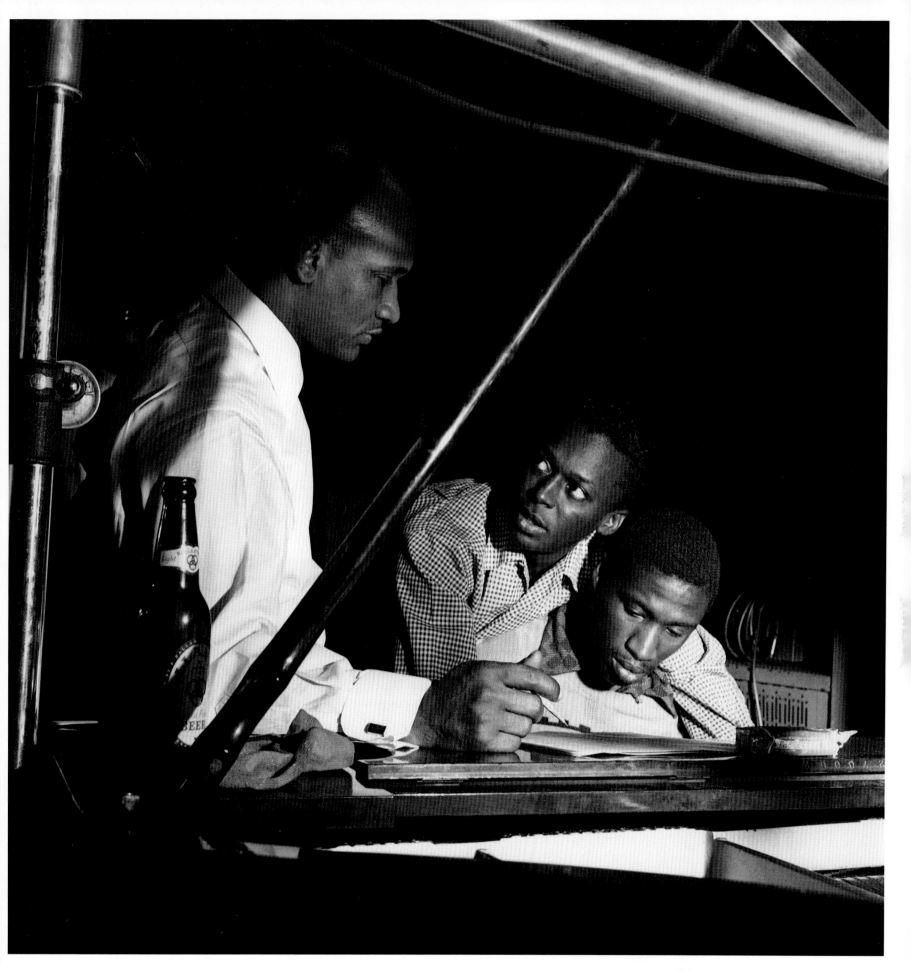

Bassist **Oscar Pettiford, Miles Davis,** and **Gil Coggins** at a Blue Note recording session, New York, 1952.

Photograph by Frank Wolff

Charlie Parker and **Red Rodney**
listen to Dizzy Gillespie at a
52nd Street club, New York, 1948.
Photograph by William Gottlieb

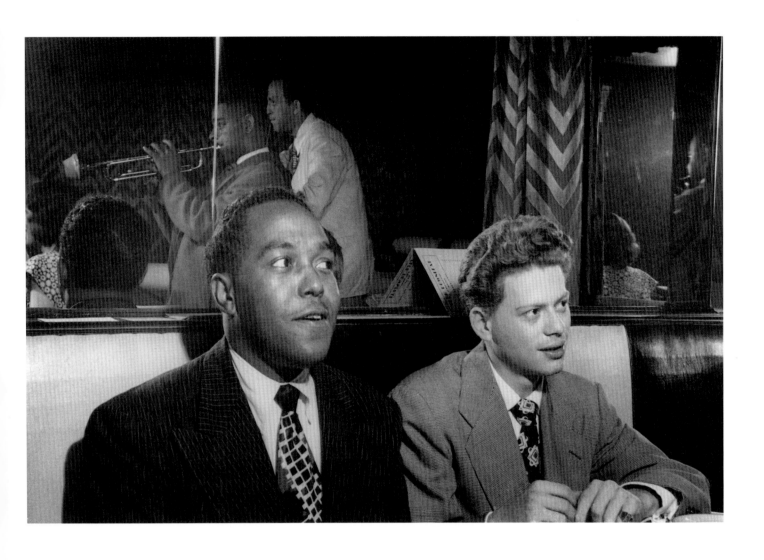

"Charlie Parker was the Louis Armstrong of his generation.
Every musician since his time is in his debt."
Nat Hentoff

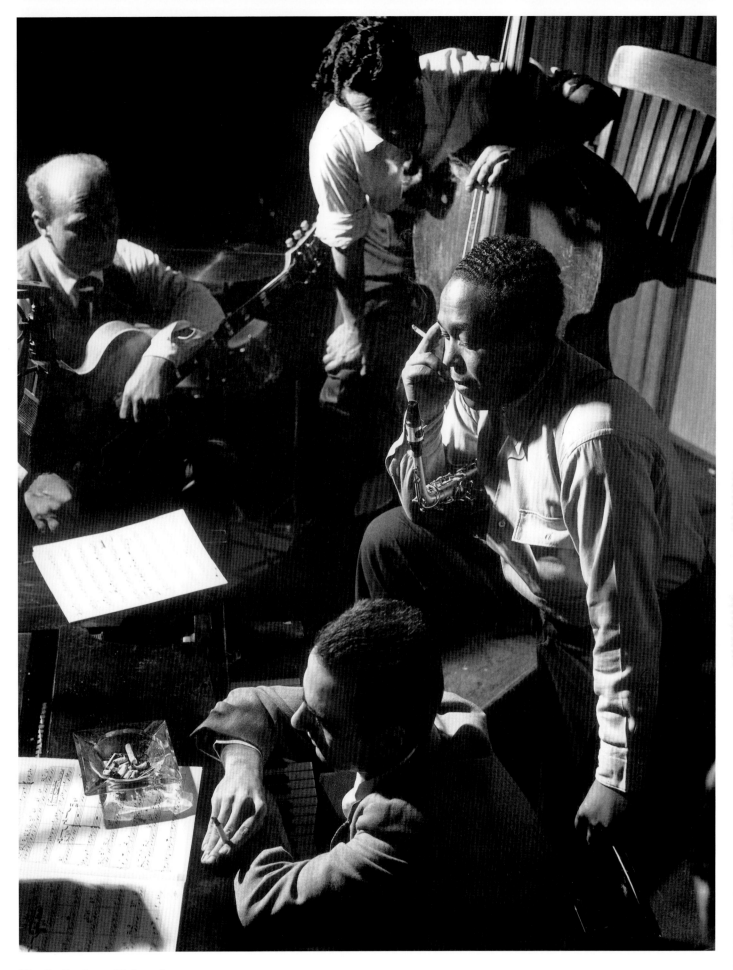

Charlie Parker with **Lennie Tristano** on piano, **Billy Bauer** on guitar, and **Eddie Safranski** on bass in New York, 1949.

Photograph by Herman Leonard

Singer **Sarah Vaughan** waits
to perform, New York, 1958.
Photograph by Carole Reiff

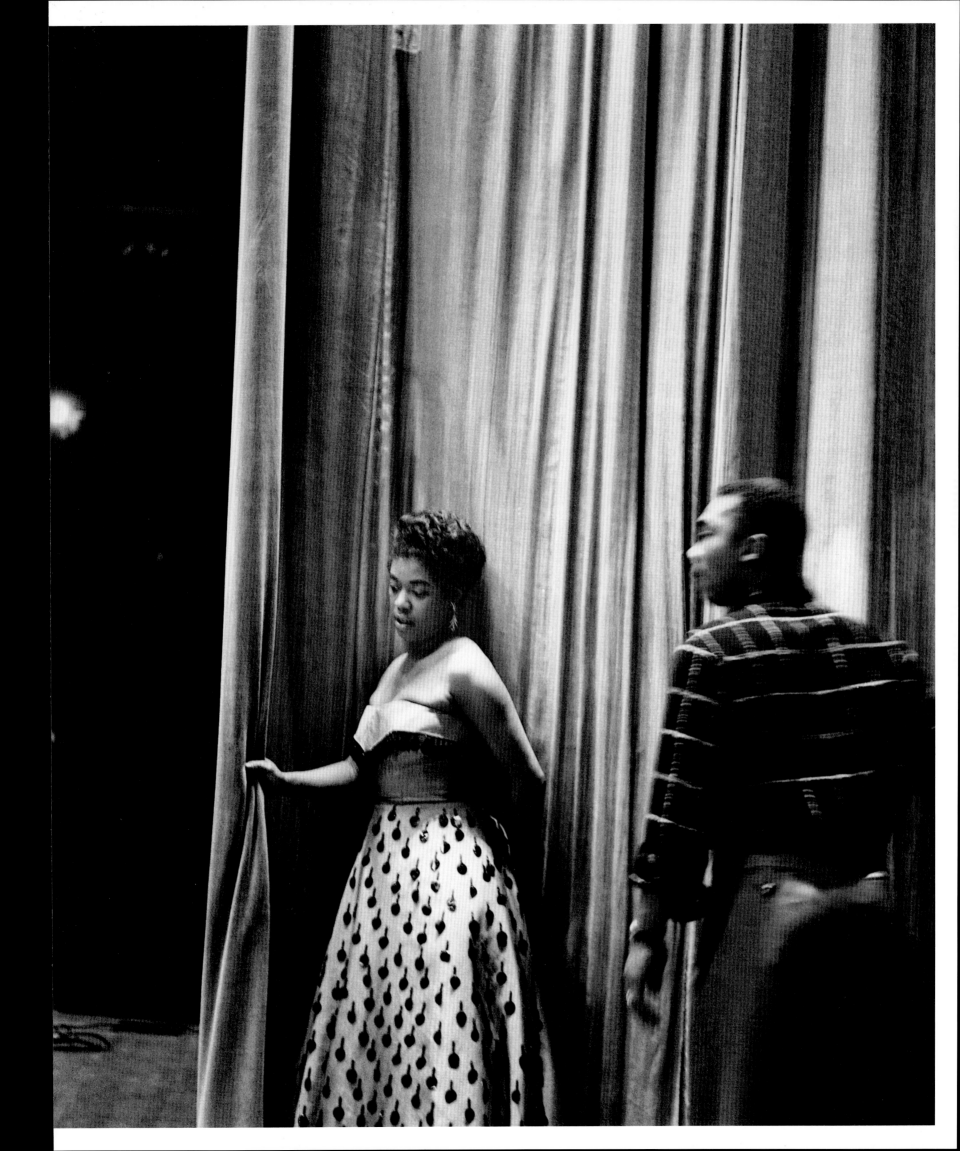

"Lester Young left a sound and a style that could penetrate and quicken the emotions more lastingly than any of his contemporaries, except Billie Holiday."
Nat Hentoff

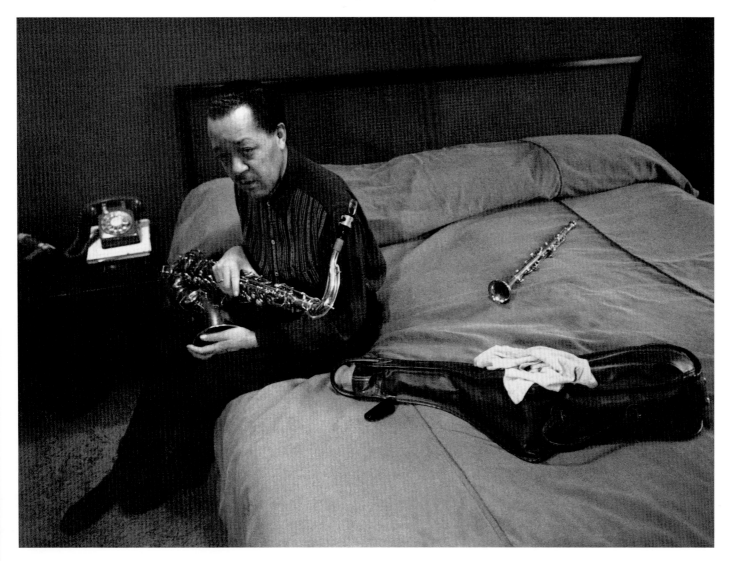

Lester Young in the last year
of his life, New York, 1958.

Photograph by Dennis Stock

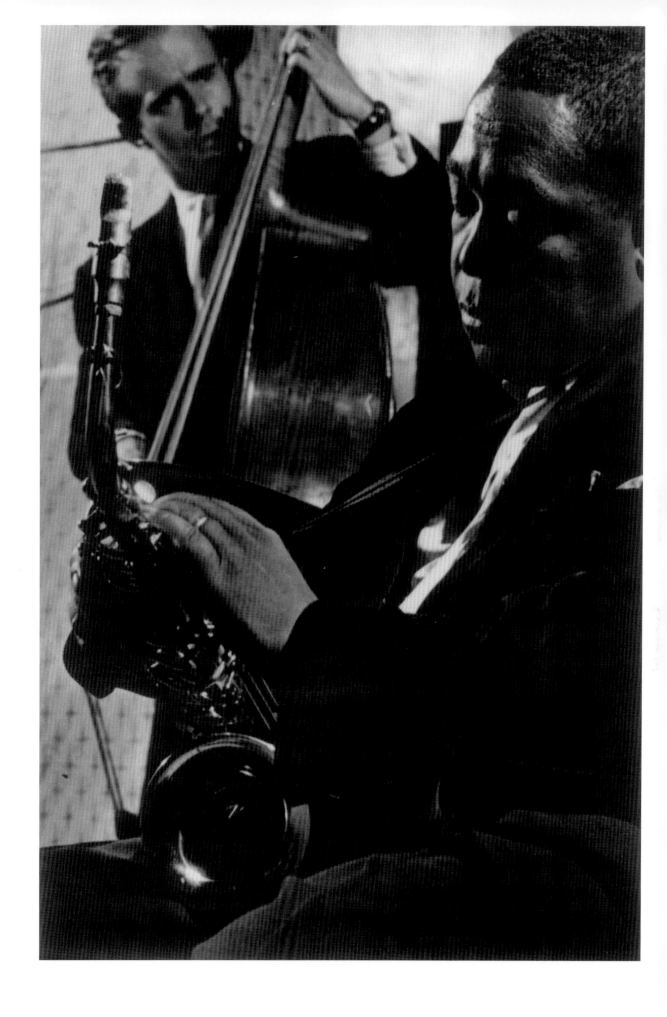

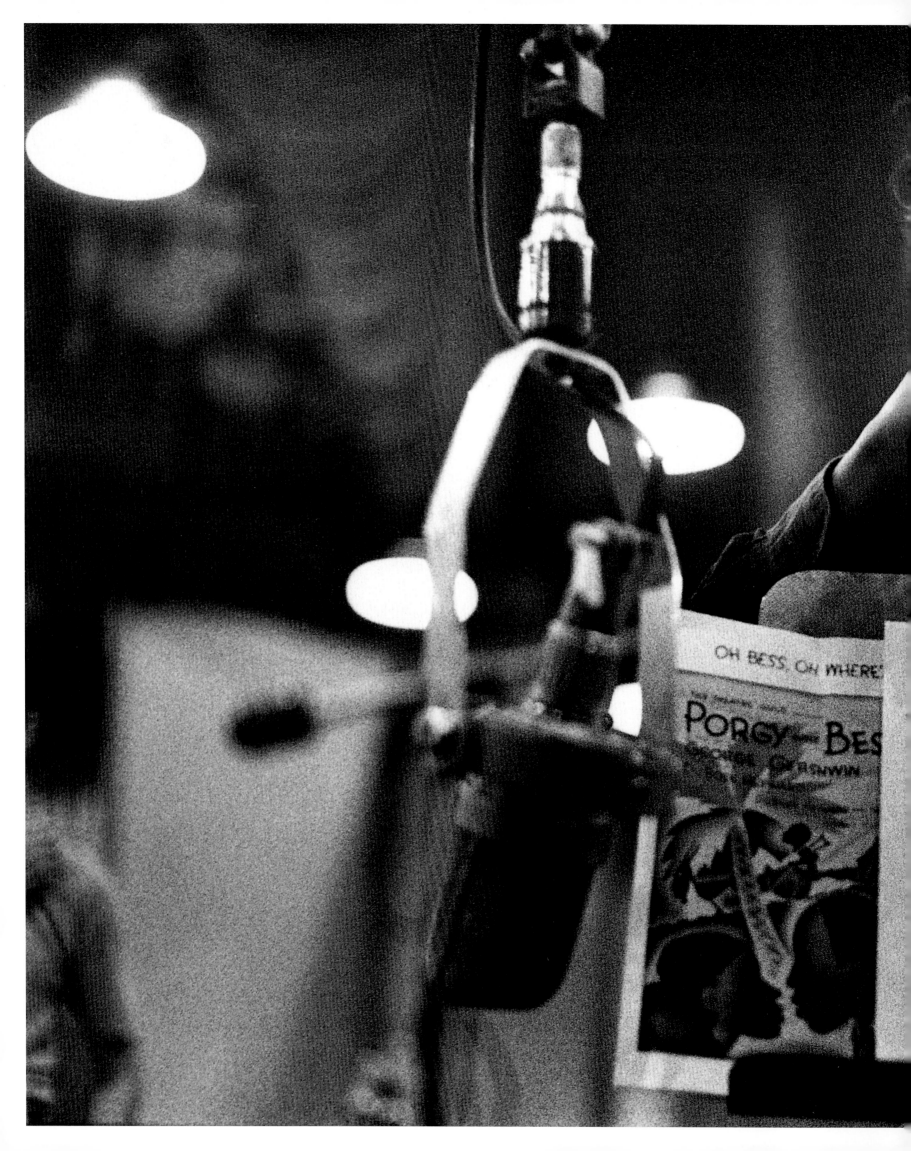

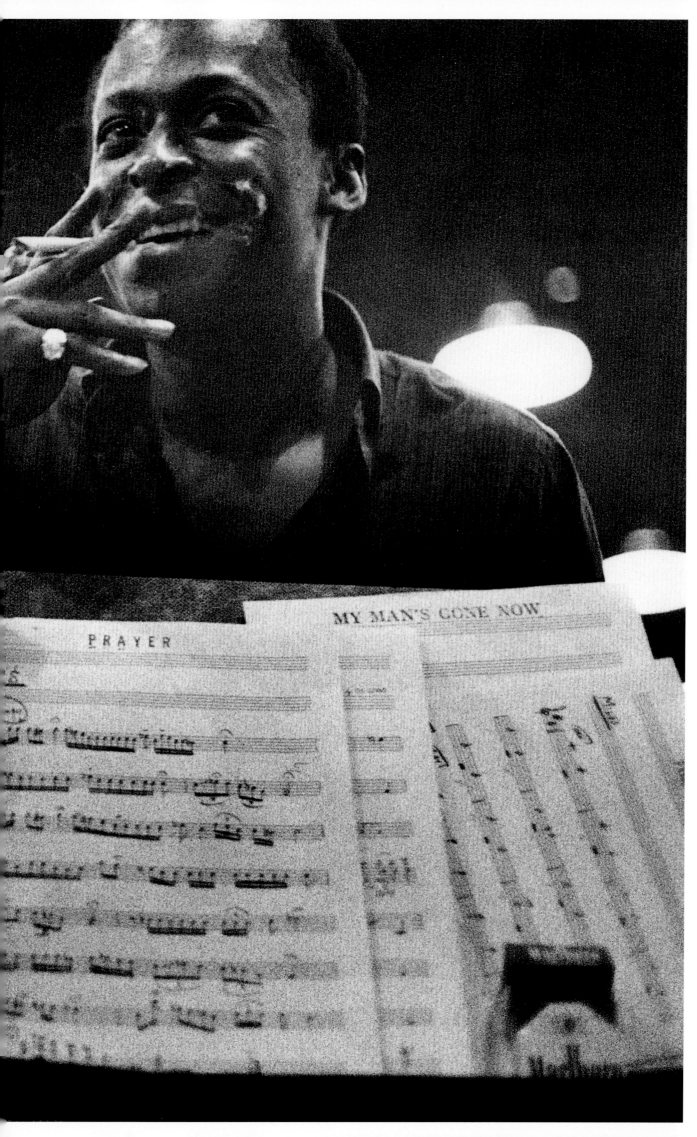

Gil Evans rehearses his *Porgy
and Bess* arrangements with
Miles Davis, New York, 1958.

Photograph by Don Hunstein

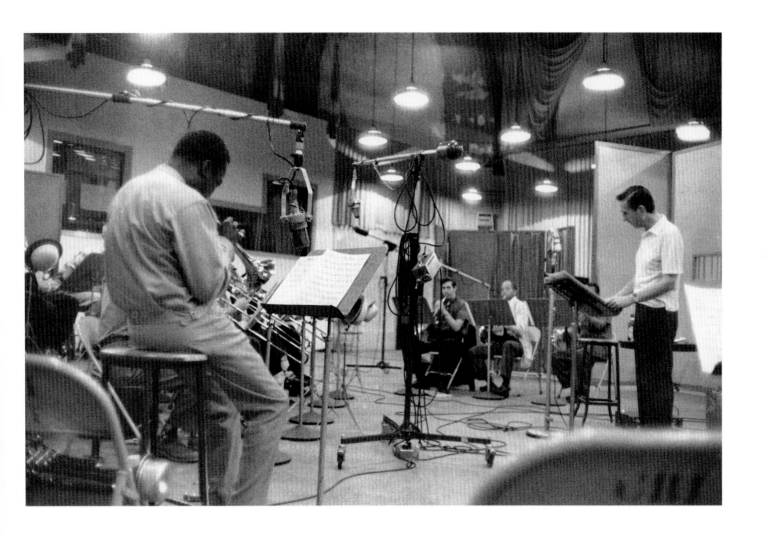

"Miles Davis was always what he felt like being.
He was uncompromising in music, swiftly
candid in conversation, and exceptionally alert.
His was the major lyrical talent of modern jazz."
Nat Hentoff

Legend **Earl Hines** plays in San
Francisco, 1958. He was remarkably
brilliant in his last years.
Photograph by Dennis Stock

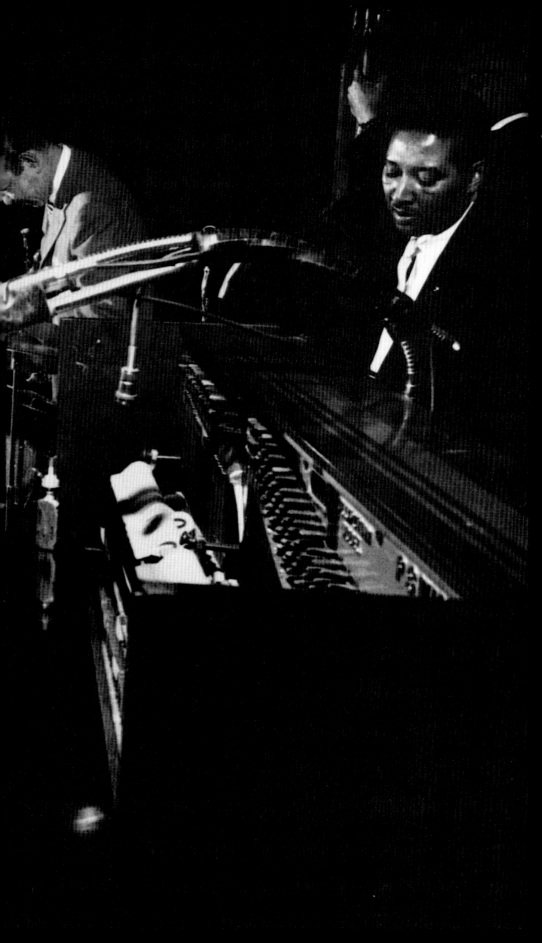

"Even Armstrong stopped developing long before he reached his seventies. But Earl Hines at seventy-four showed no sign of diminishing powers. . . . He could scare the hell out of you with his creativity."
Doug Ramsey

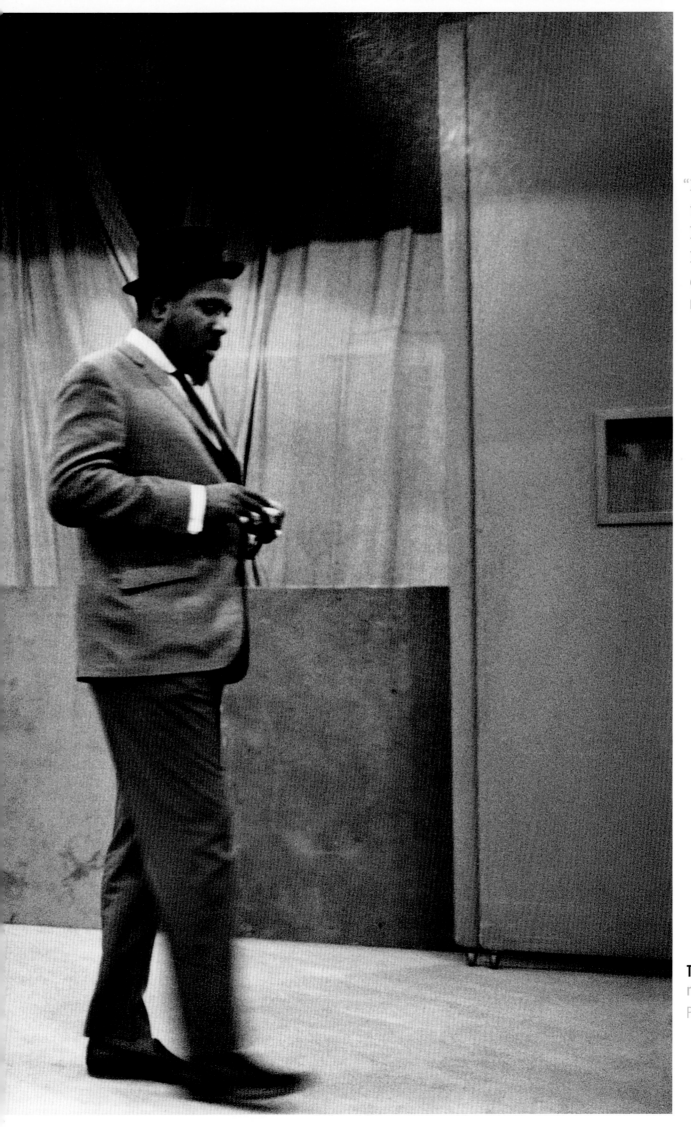

"Monk had no patience or time for embroidery, in his music or off the stand. He was considered a kind of jazz philosopher."
Nat Hentoff

Thelonious Monk between recording takes in New York, 1958.
Photograph by Don Hunstein

The night **Duke Ellington**
and his band were "reborn"
at the Newport Jazz Festival,
1956.

Photograph by Paul Hoeffler

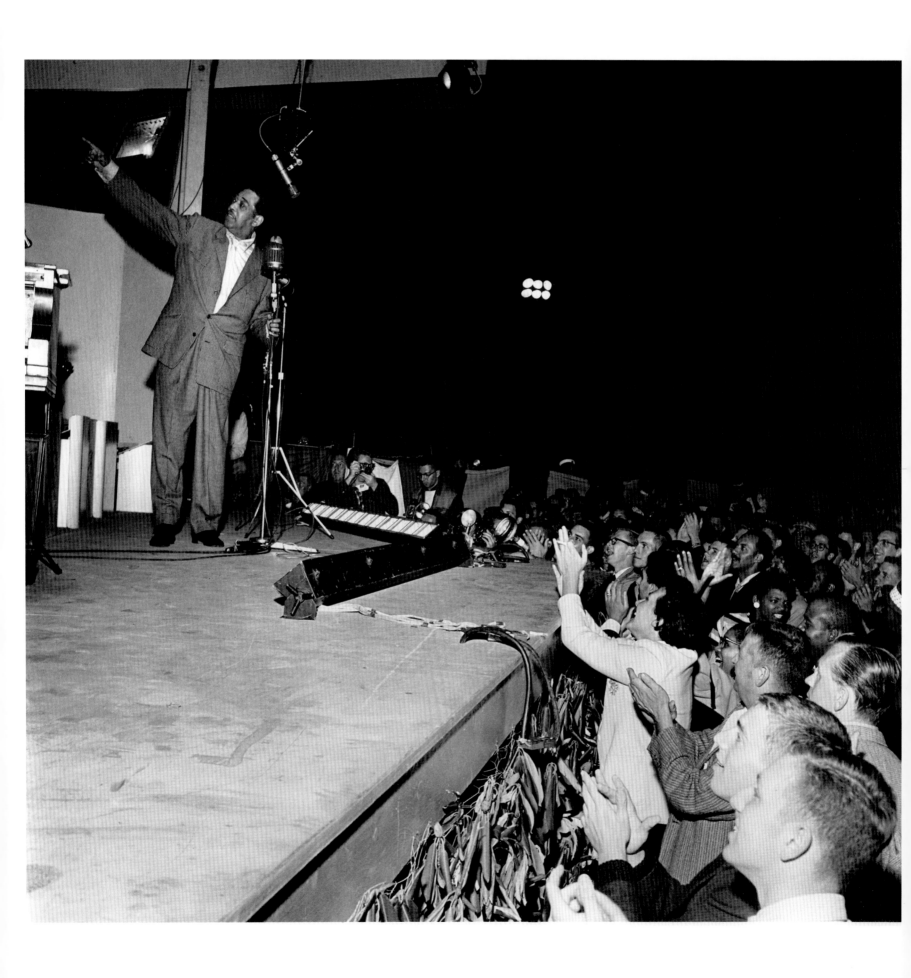

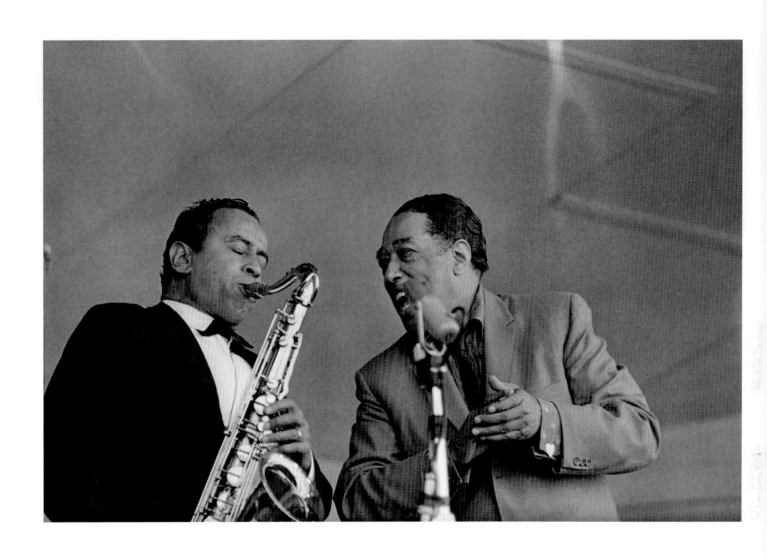

The Duke encourages **Paul Gonsalves** to replay his marathon solo from the 1956 Newport Jazz Festival at the Monterey Jazz Festival, 1960.

Photograph by Jim Marshall

Joe Williams and **Jimmy Jones**
discuss a vocal arrangement,
New York, 1959.
Photograph by Milt Hinton

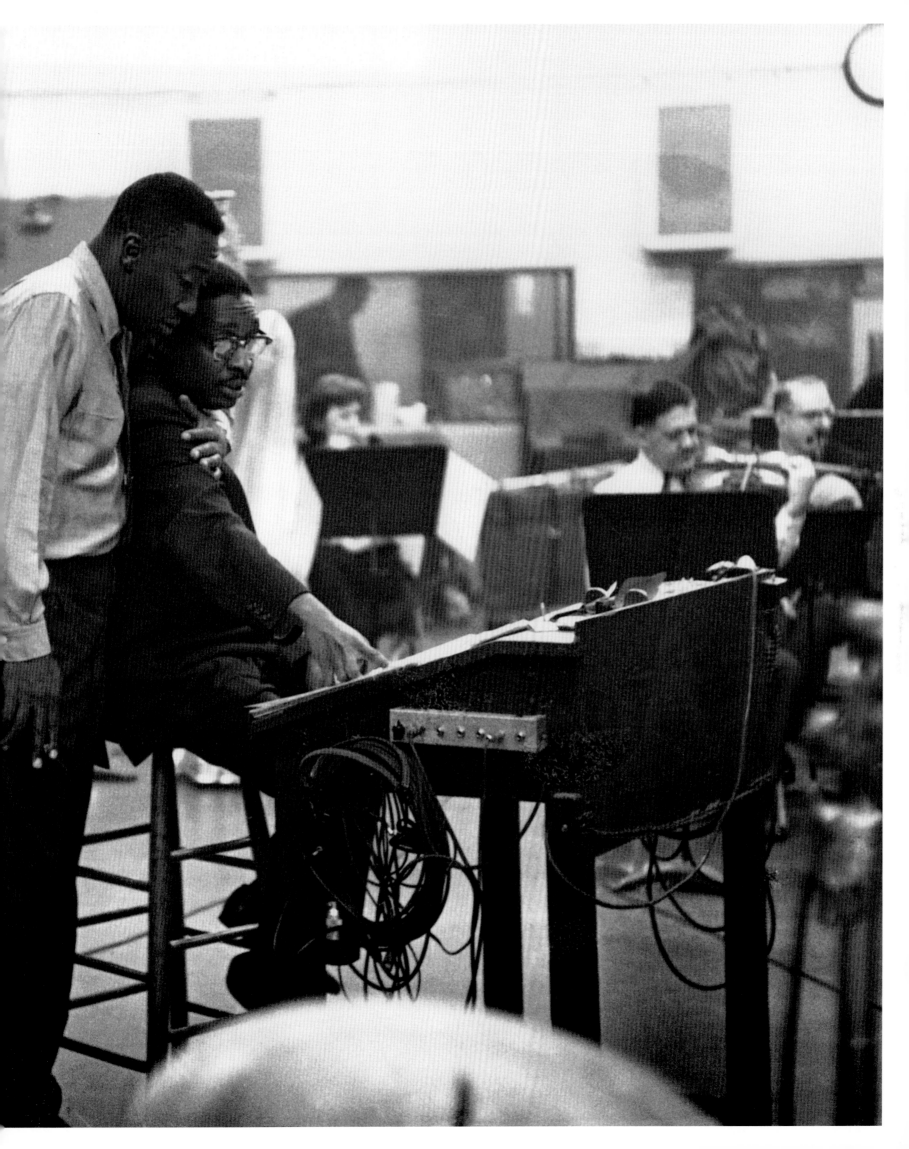

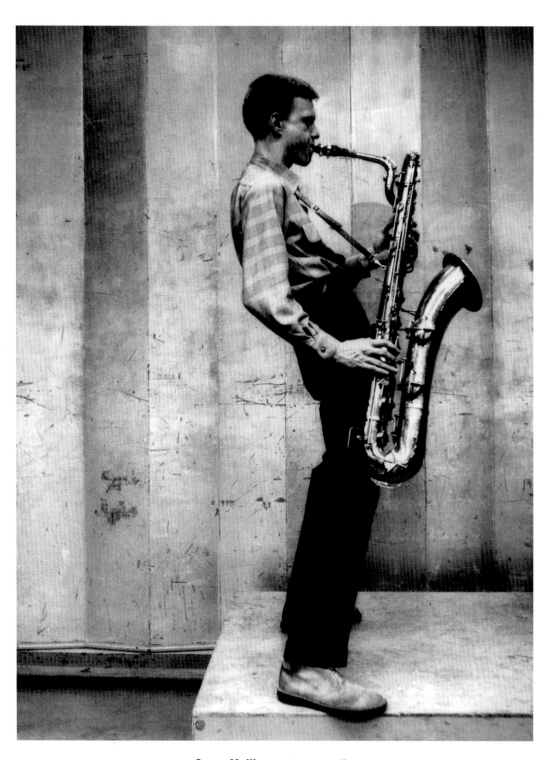

Gerry Mulligan at a recording
session in Los Angeles, 1953.

Photograph by Bob Willoughby

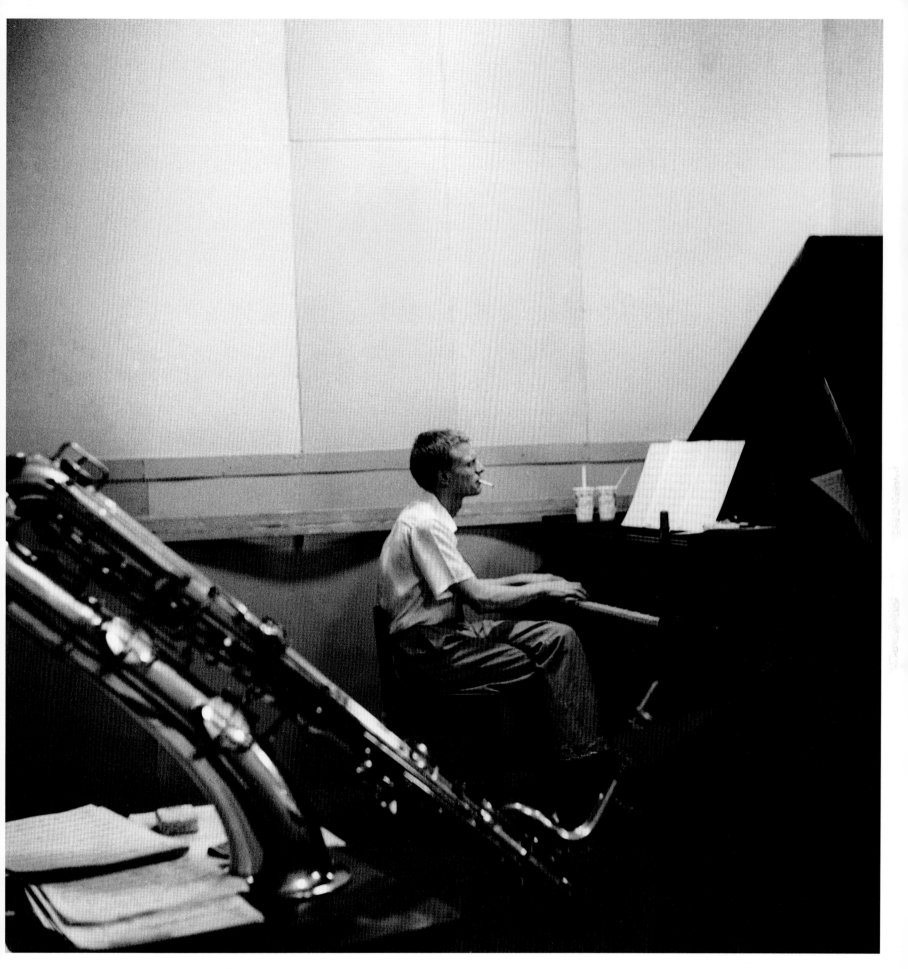

Gerry Mulligan works out an
arrangement, New York, 1955.
Photograph by Carole Reiff

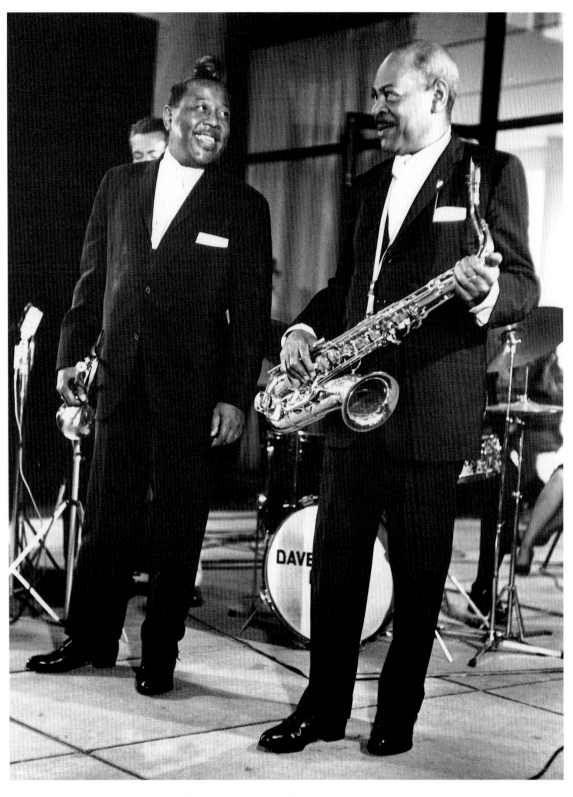

Roy Eldridge and **Coleman Hawkins,** musical partners for years, at the Museum of Modern Art, New York, 1960.
Photograph by Herb Snitzer

Coleman Hawkins and drummer
Osie Johnson at a recording session
in Hackensack, New Jersey, 1960.
Photograph by Esmond Edwards

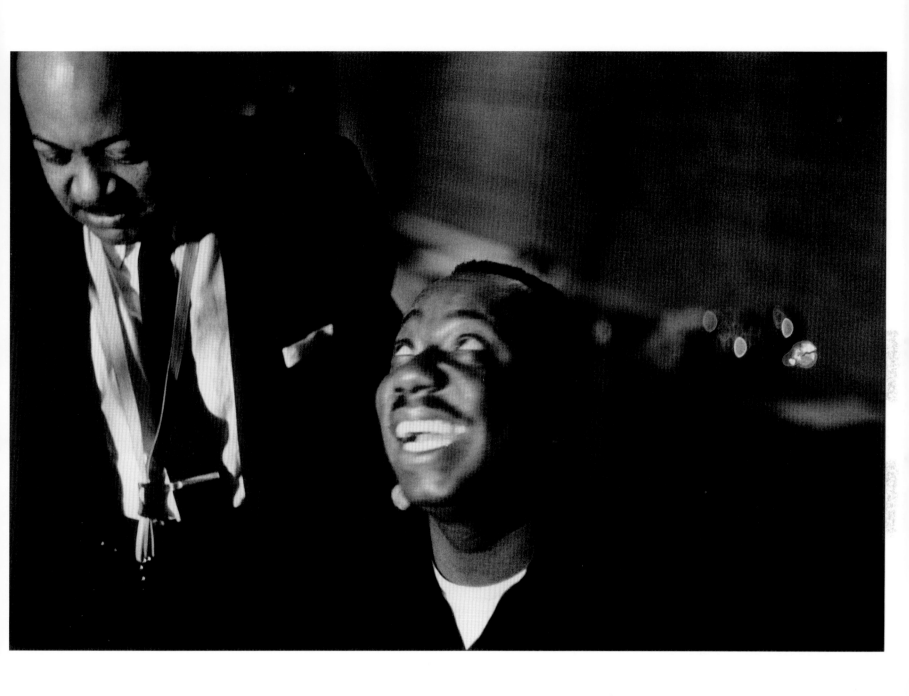

"Hawkins was the person who woke you up and
let you know there was a tenor saxophone."
Lester Young

Al Cohn, Zoot Sims, and **Tony Scott** record in New York, 1956.
Photograph by Carole Reiff

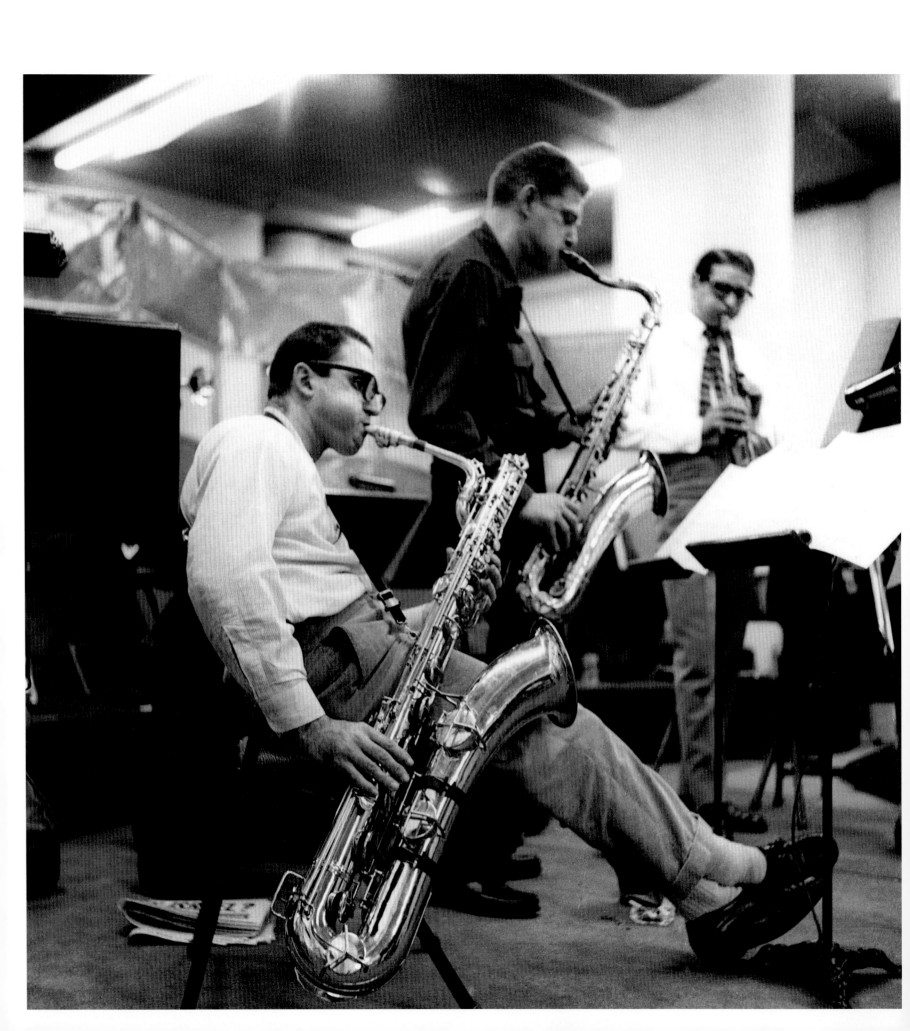

Al Cohn, Zoot Sims,
and **Tony Scott** record
in New York, 1956.
Photograph by Carole Reiff

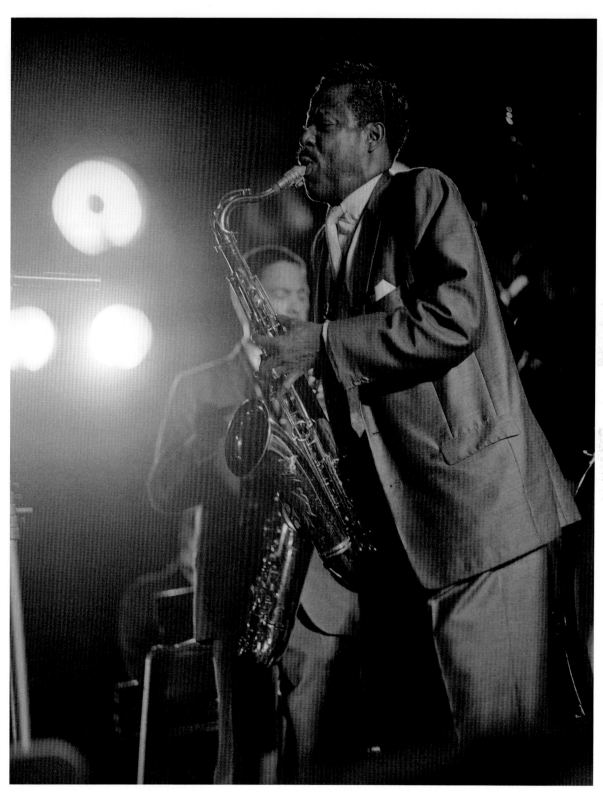

Lockjaw Davis and **Johnny Griffin,**
a swinging tenor team, in
New York, 1960.

Photograph by Chuck Stewart

Singer **Anita O'Day** at the
Village Vanguard,
New York, 1957.

Photograph by Robert Parent

Anita O'Day peeks out of
the Village Vanguard,
New York, 1958.

Photograph by Dennis Stock

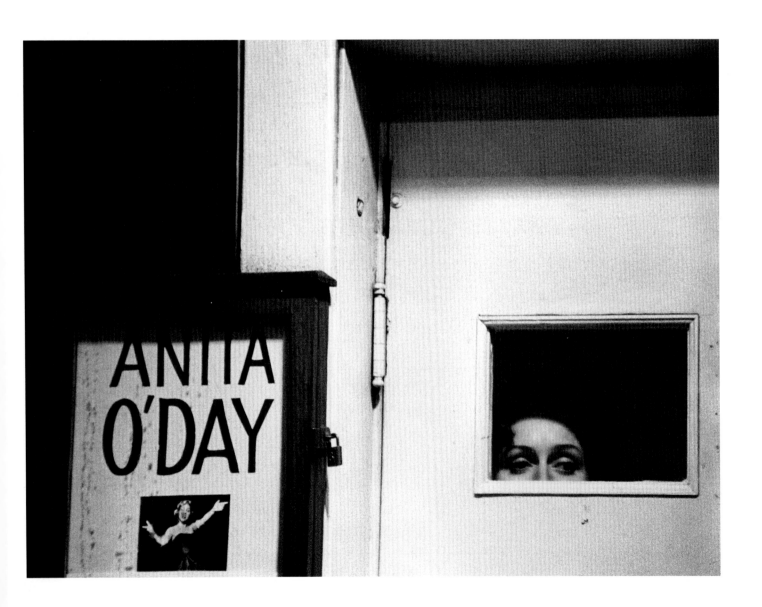

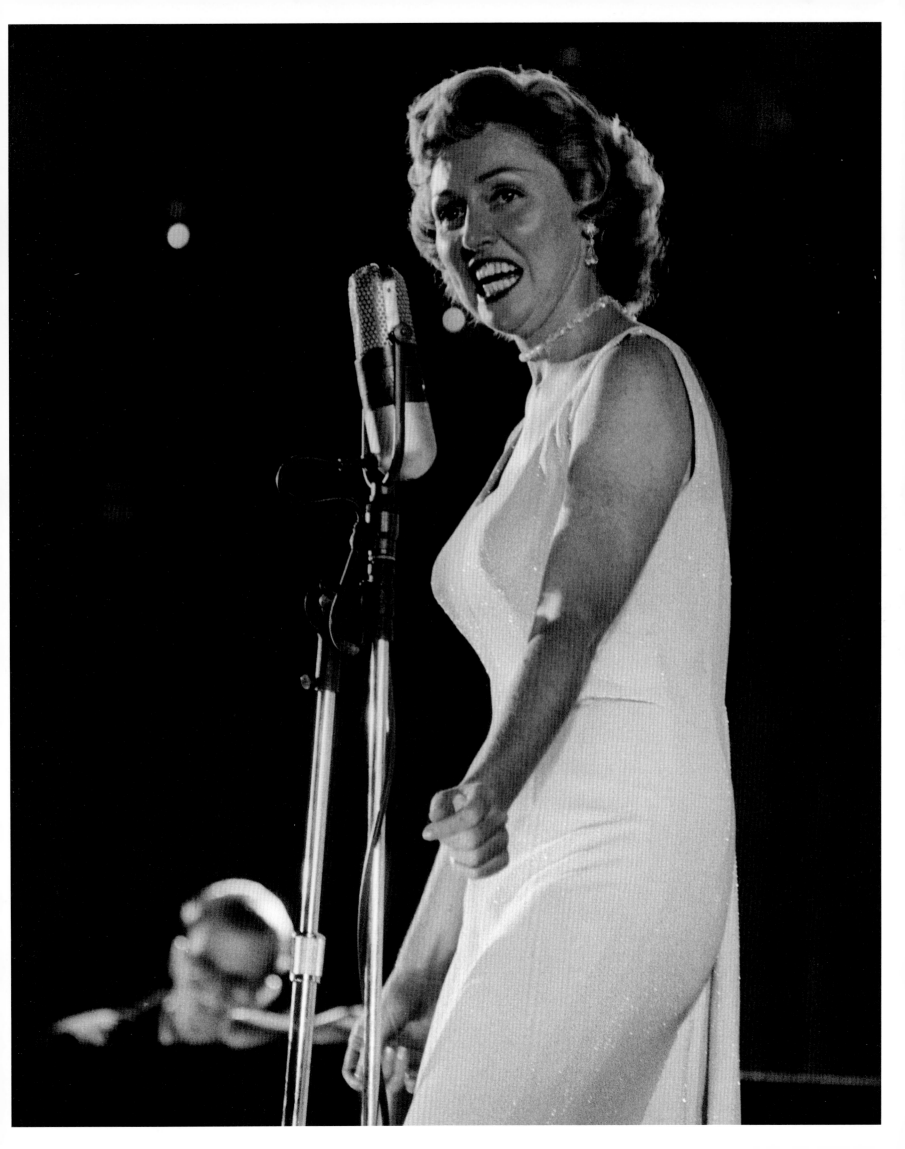

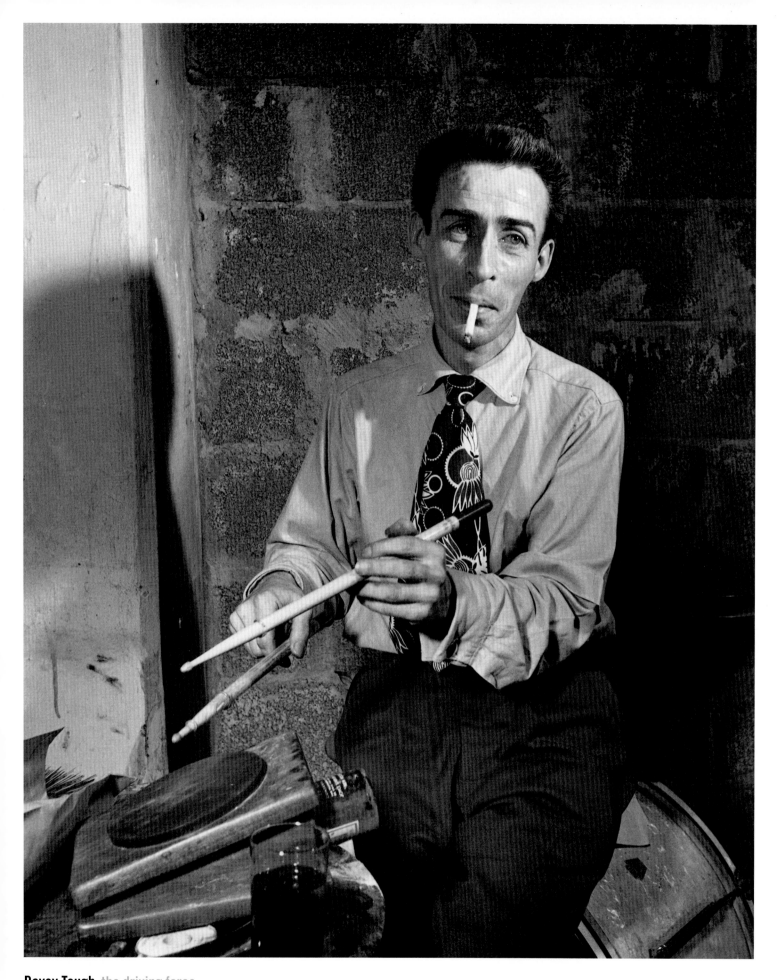

Davey Tough, the driving force
of Woody Herman's First Herd,
in New York, 1948.

Photograph by William Gottlieb

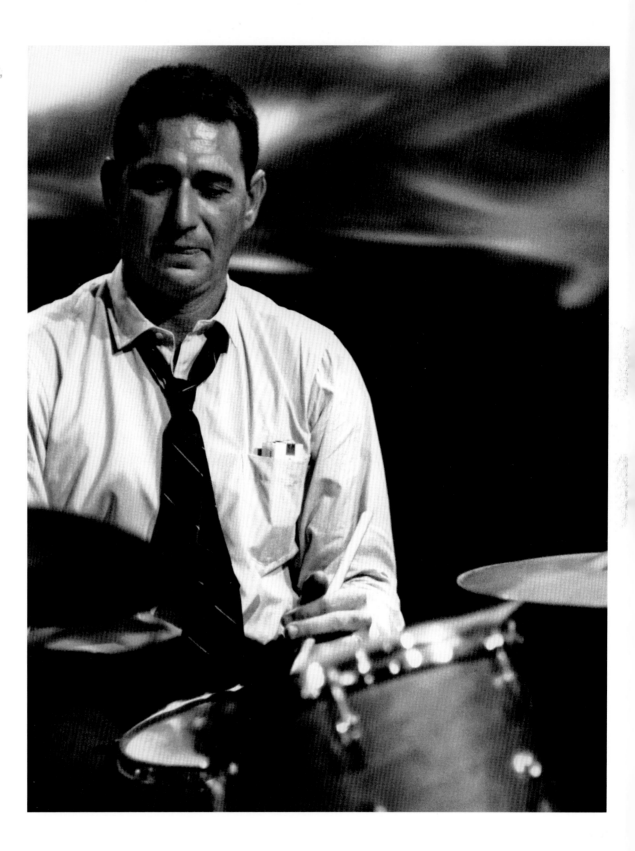

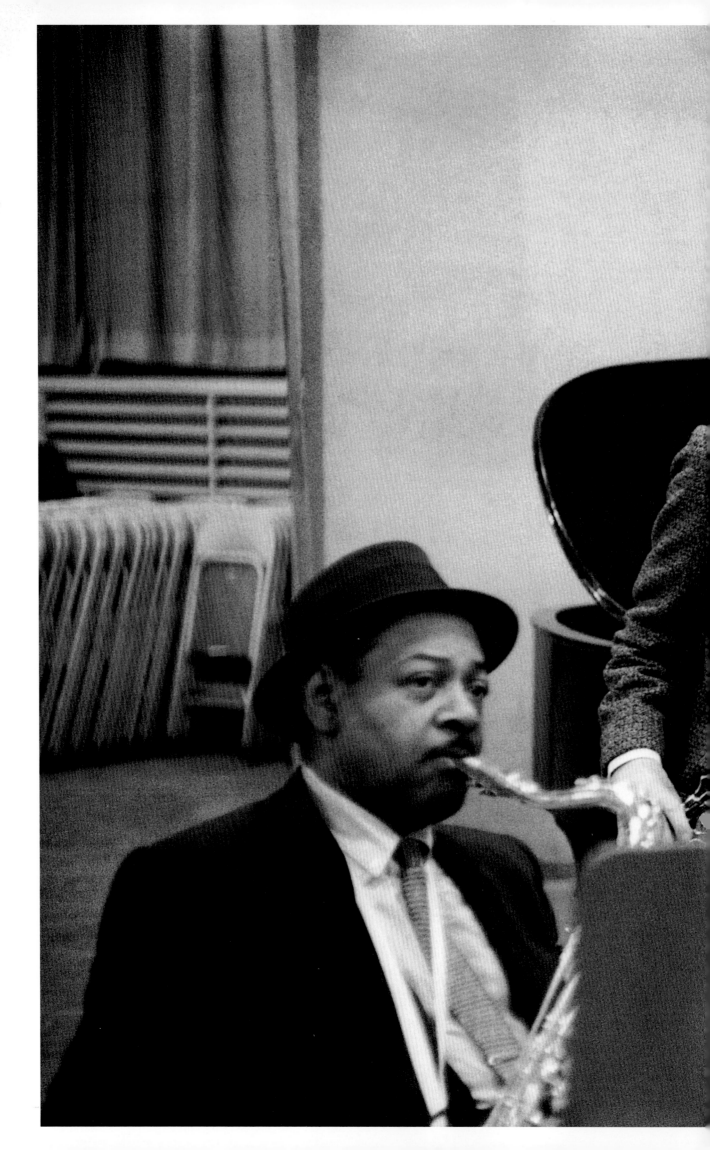

Tenor greats **Coleman Hawkins,
Lester Young,** and **Ben Webster**
at a recording session in
New York, 1957.
Photograph by Don Hunstein

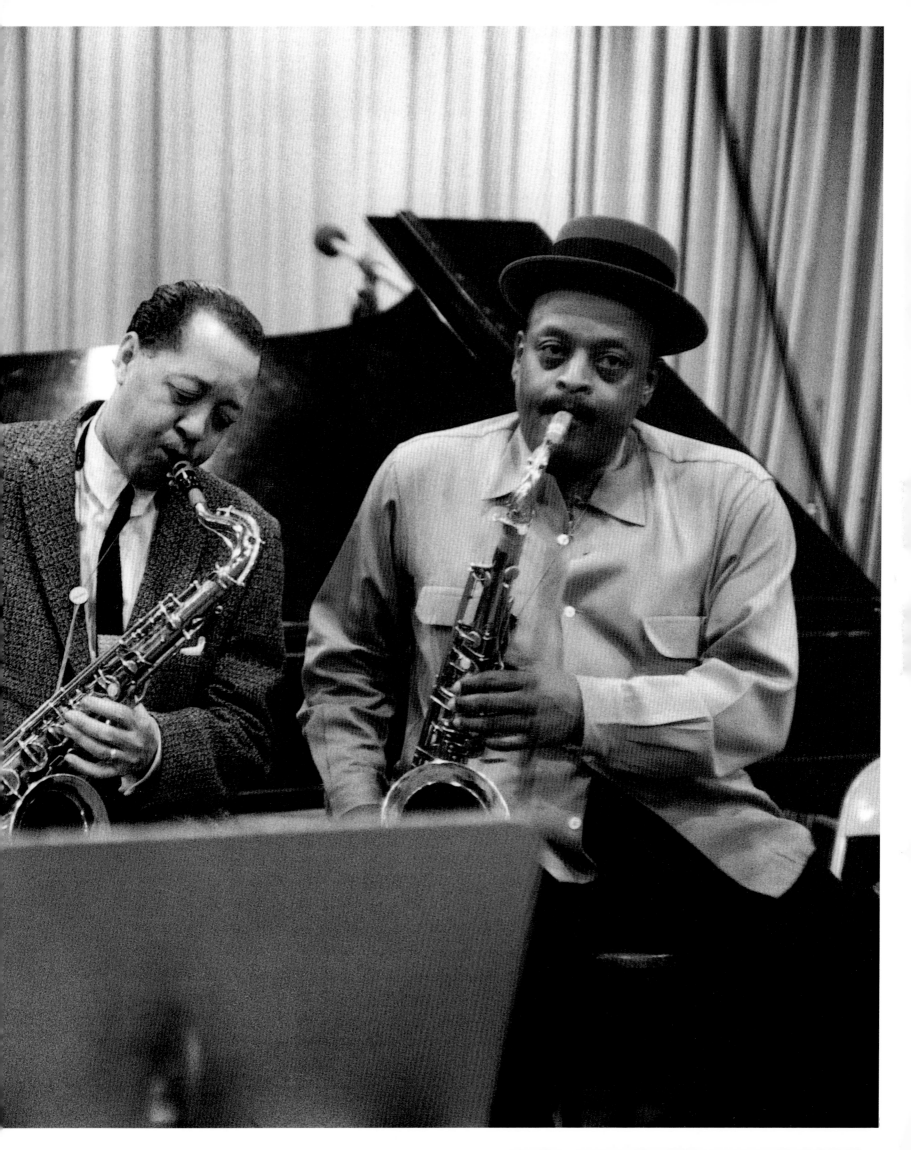

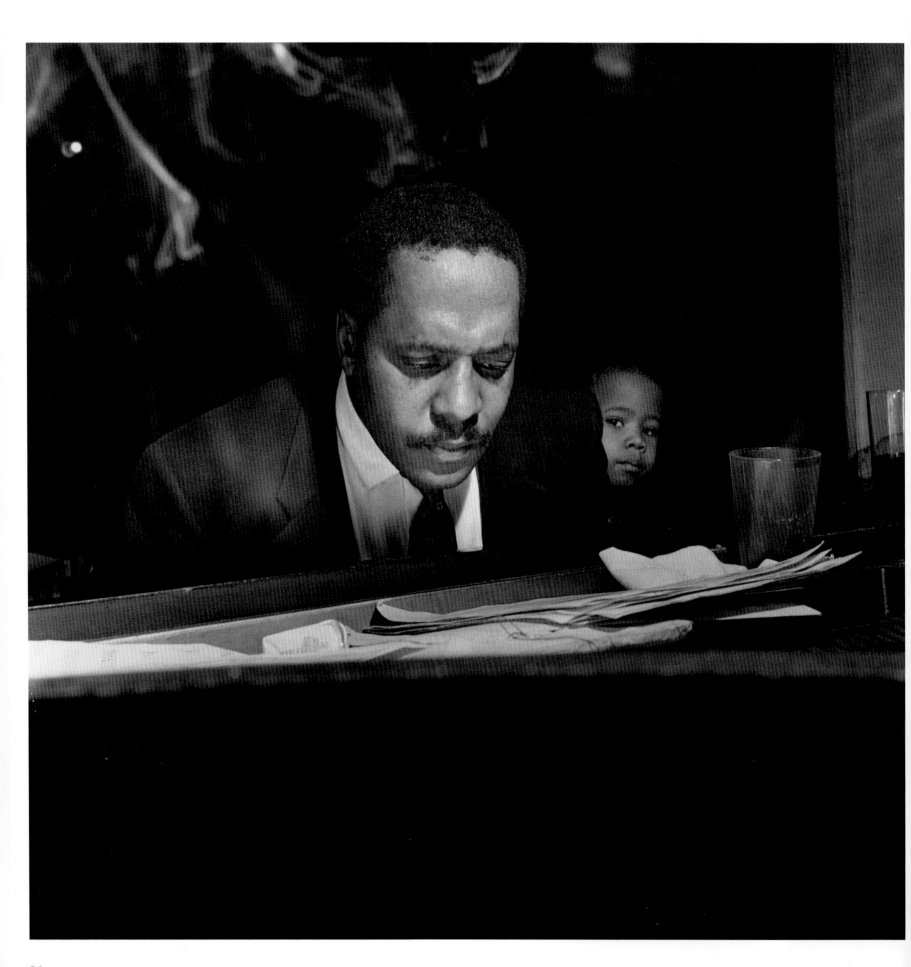

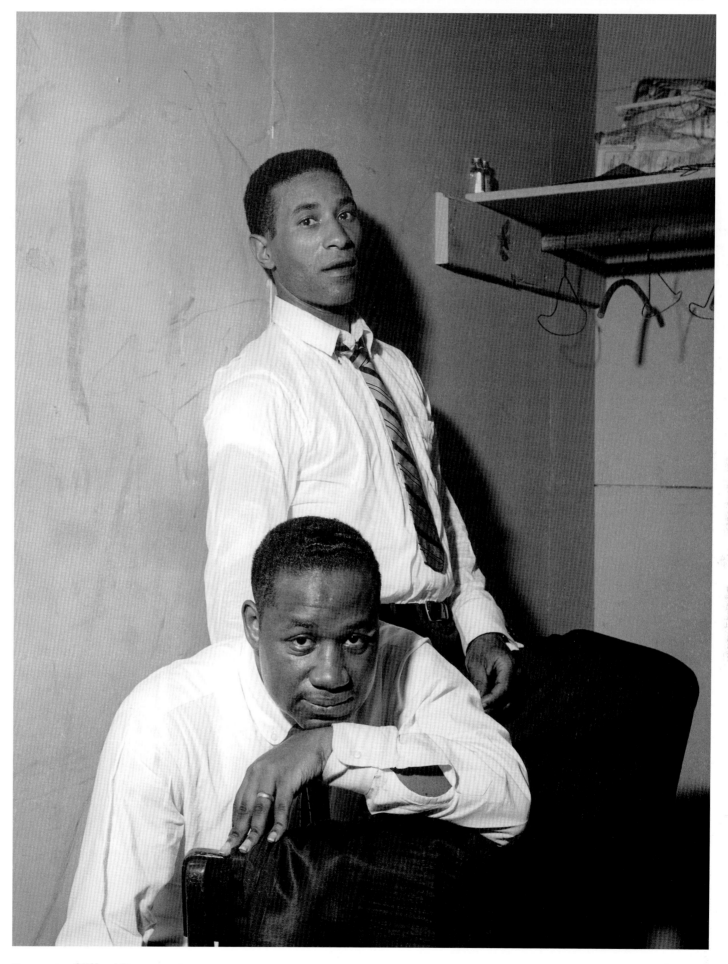

Trumpeter **Clifford Brown** and
drummer **Max Roach** in New York,
1953. The two were musical
partners until Brown's untimely
death in 1956.

Photograph by Herman Leonard

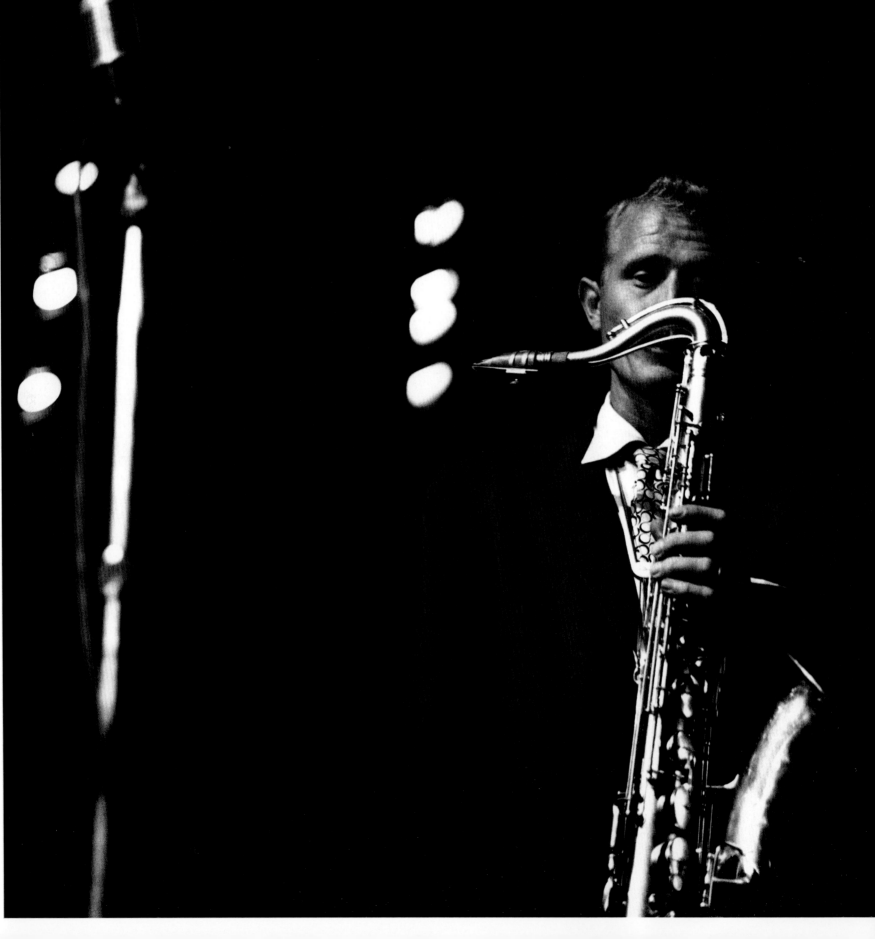

Jimmy Guiffre with guitarist
Jim Hall on the *Stars of Jazz*
TV show, Los Angeles, 1956.
Photograph by Ray Avery

Horace Silver, hard-bop pianist,
at Storeyville, Boston, 1958.
Photograph by Lee Tanner

"All good music has healing potential."
Horace Silver

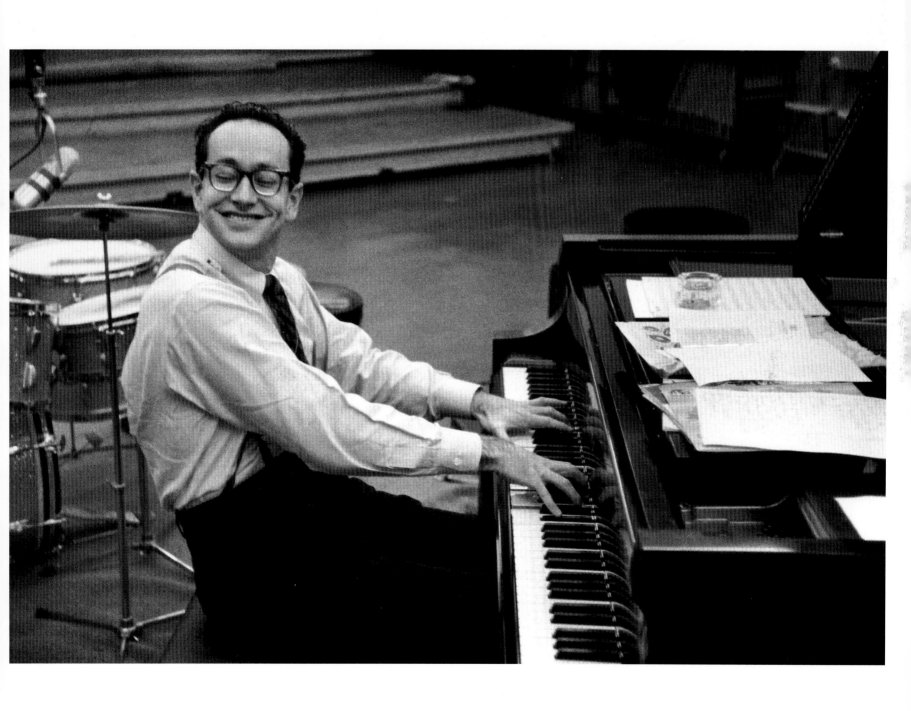

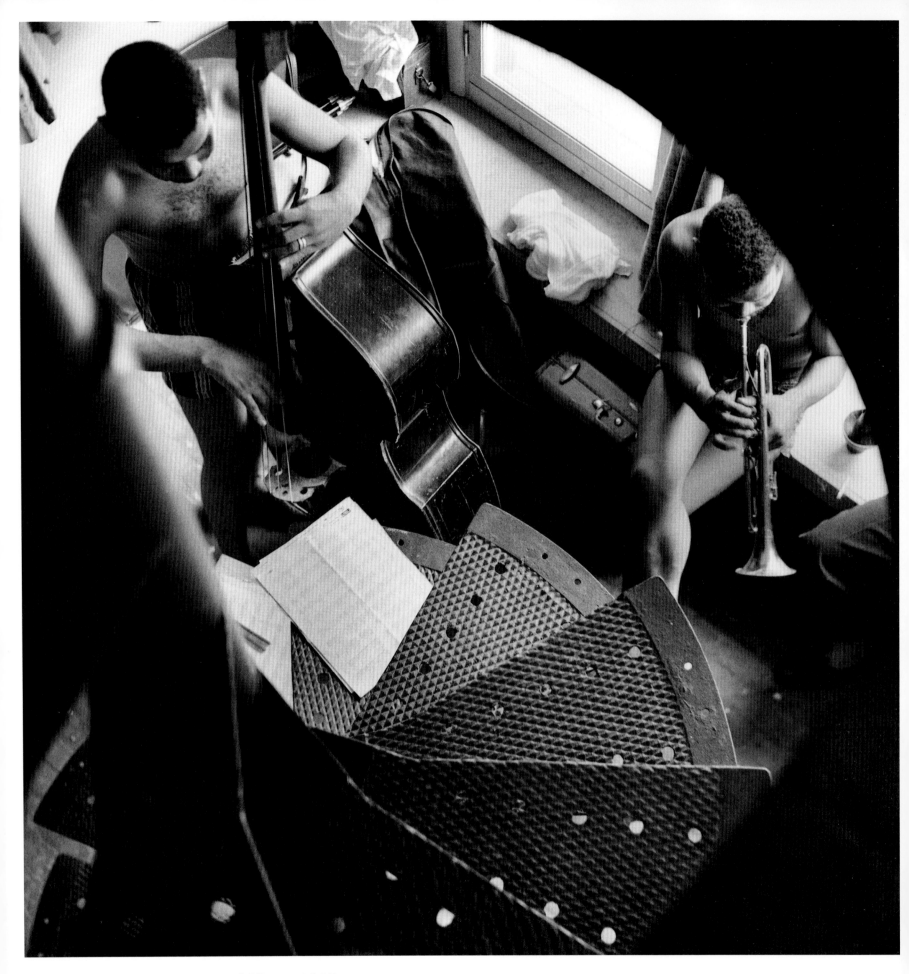

Twins **Addison** and **Art Farmer**
at the Music Inn, Lenox,
Massachusetts, 1955.
Photograph by Robert Parent

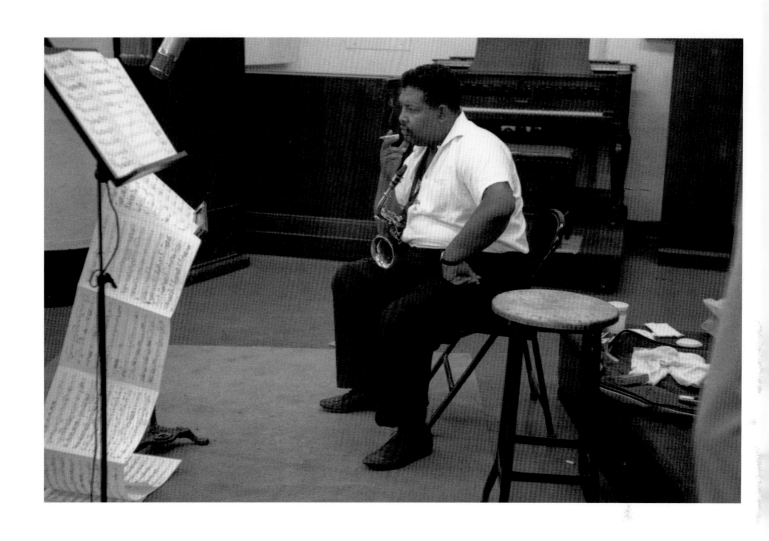

Cannonball Adderley
prepares to record in
New York, 1958.
Photograph by Milt Hinton

Clark Terry, star trumpeter with Ellington and Basie, records in New York, 1960.

Photograph by Esmond Edwards

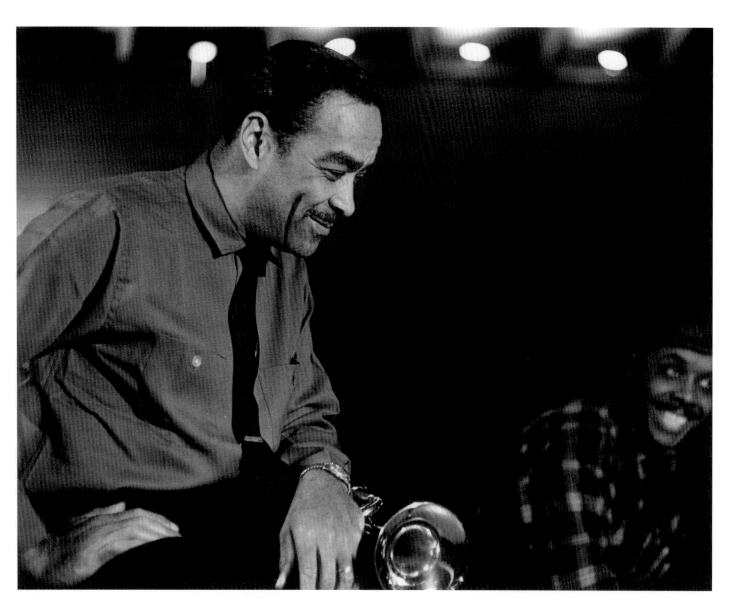

Two alumni from Basie's band, trumpeter **Buck Clayton** and saxist **Buddy Tate,** at a recording session in Hackensack, New Jersey, 1960.

Photograph by Esmond Edwards

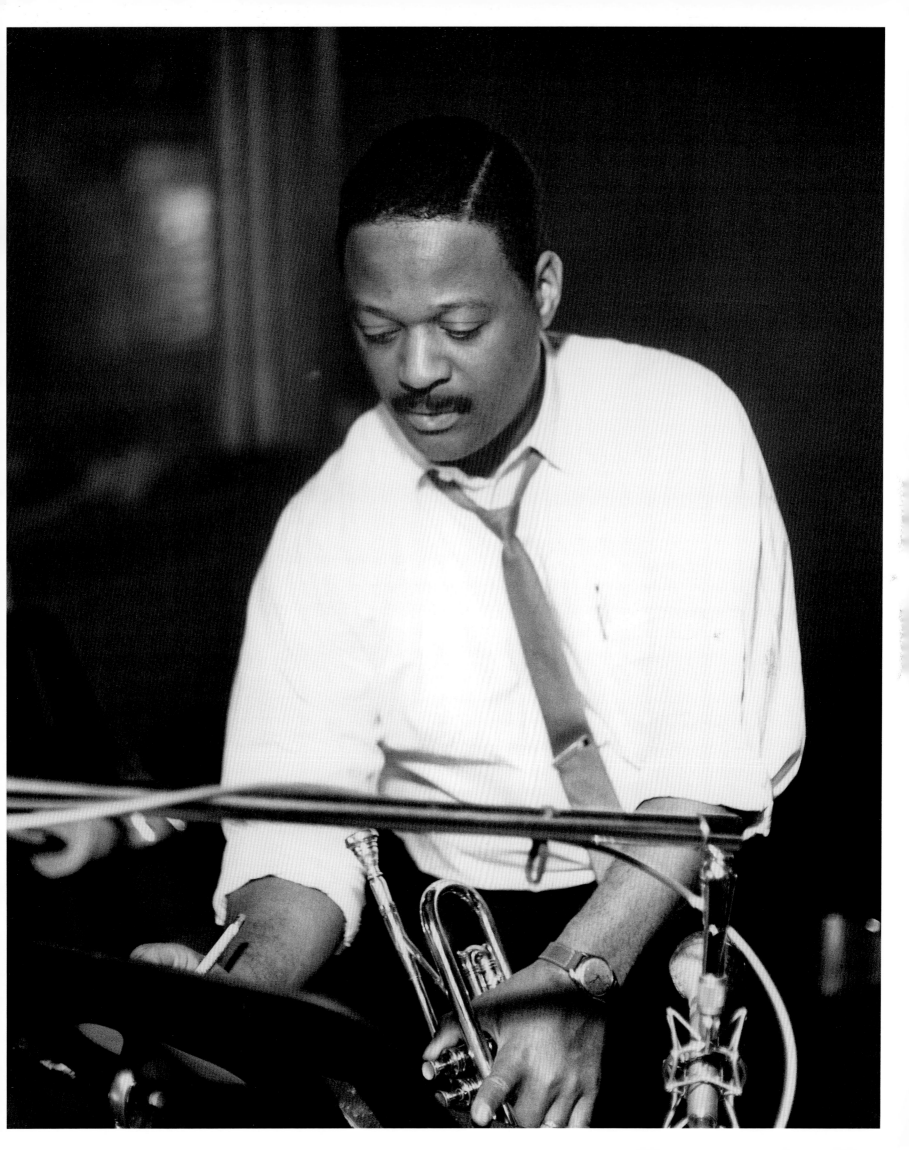

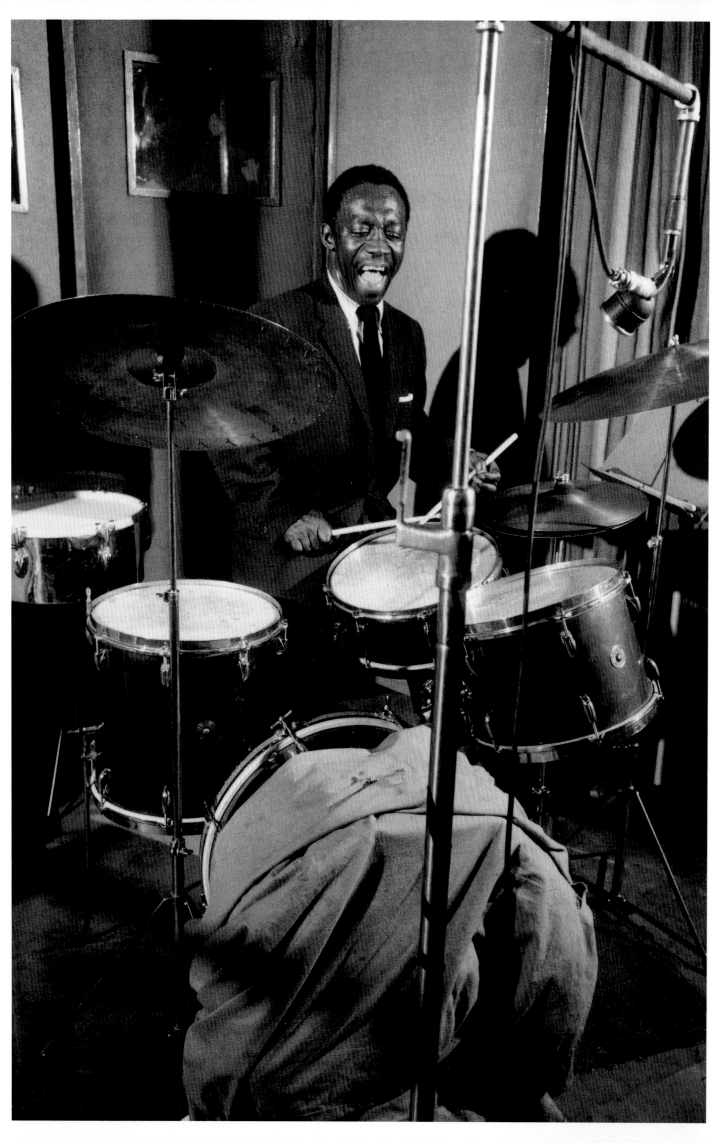

Art Blakey at a Jazz Messengers recording session in New York, 1958.
Photograph by Don Hunstein

More than fifty jazz musicians prepare for Art Kane's famous *Esquire* magazine photo shoot in Harlem, 1958. The drum section: **George Wettling** in front (facing camera); in the row above, **Papa Jo Jones, Gene Krupa,** and **Sonny Greer;** above them, **Zutty Singleton** and **Art Blakey.**

Photograph by Milt Hinton

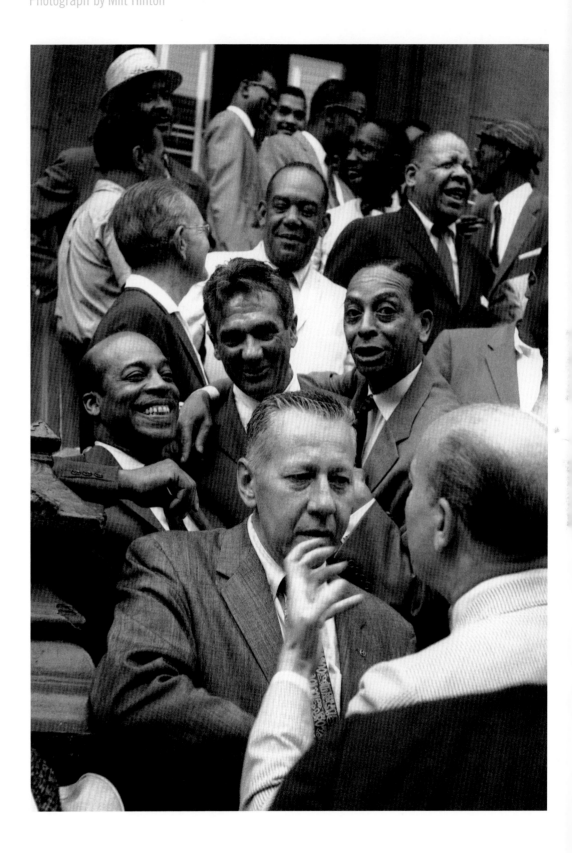

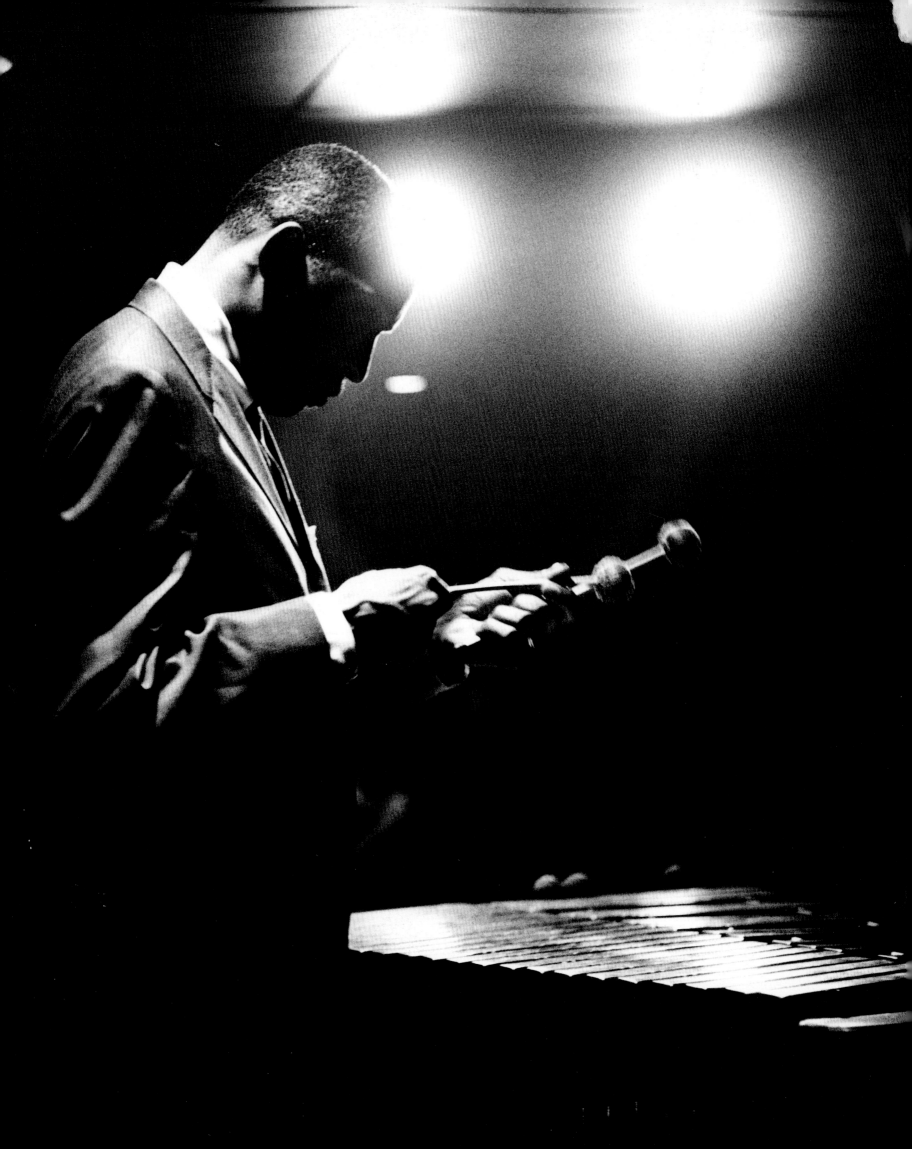

"Milt Jackson, whose background was church music . . .
brought the blues into every note he played."
Nat Hentoff

**1961–
1968**

Milt Jackson, soulful bebop
vibist, at the Jazz Workshop,
Boston, 1964.
Photograph by Lee Tanner

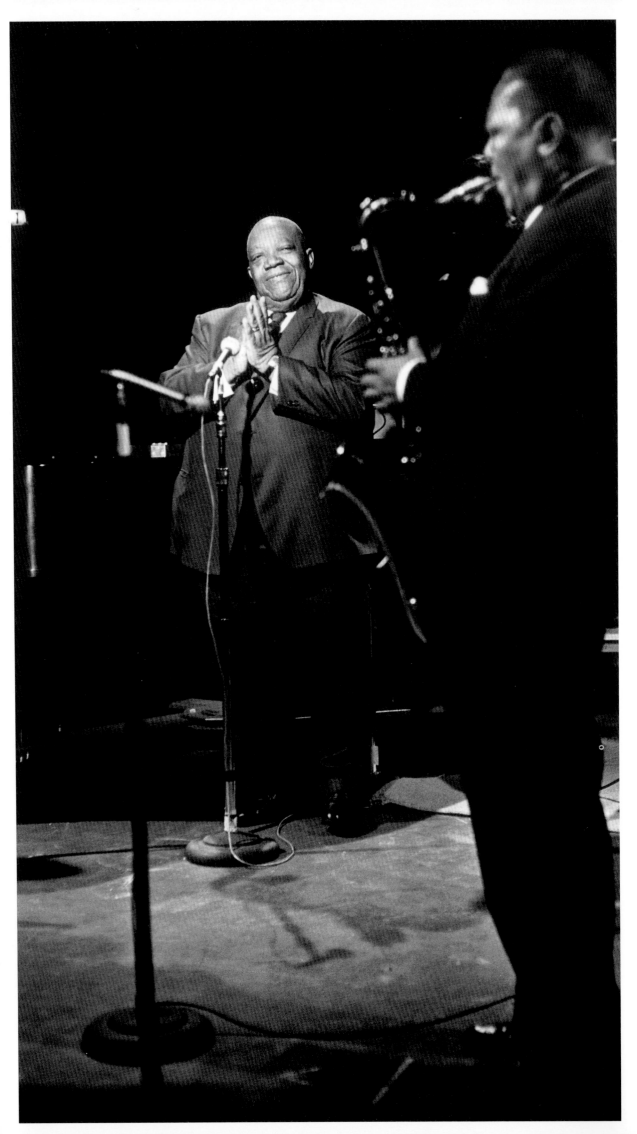

Singer **Jimmy Rushing** enjoys
a **Budd Johnson** solo at the
WGBH-TV studio in Boston, 1966.
Photograph by Lee Tanner

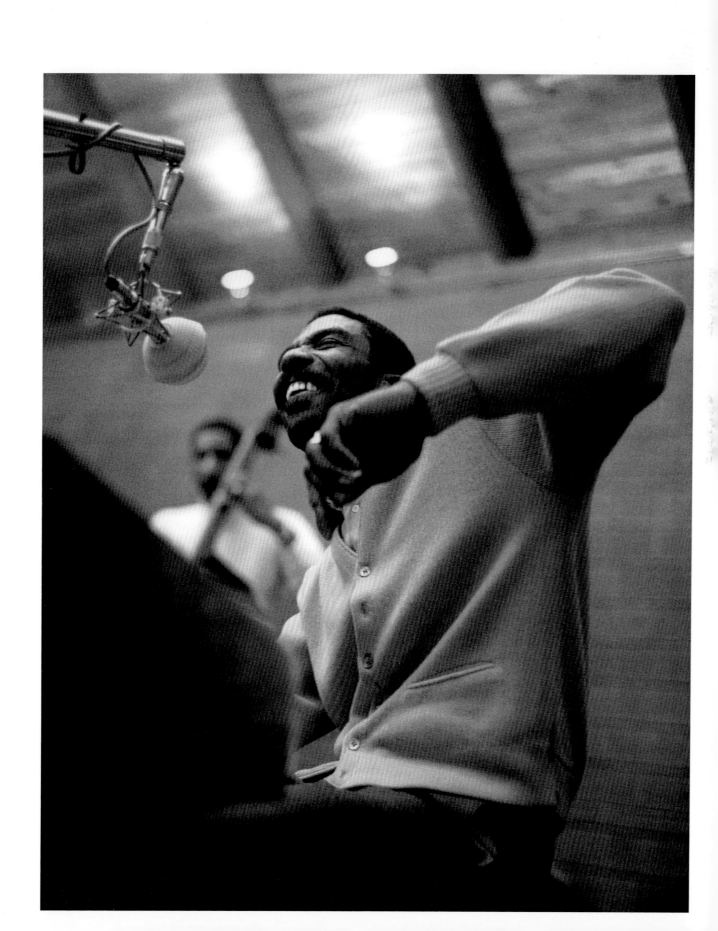

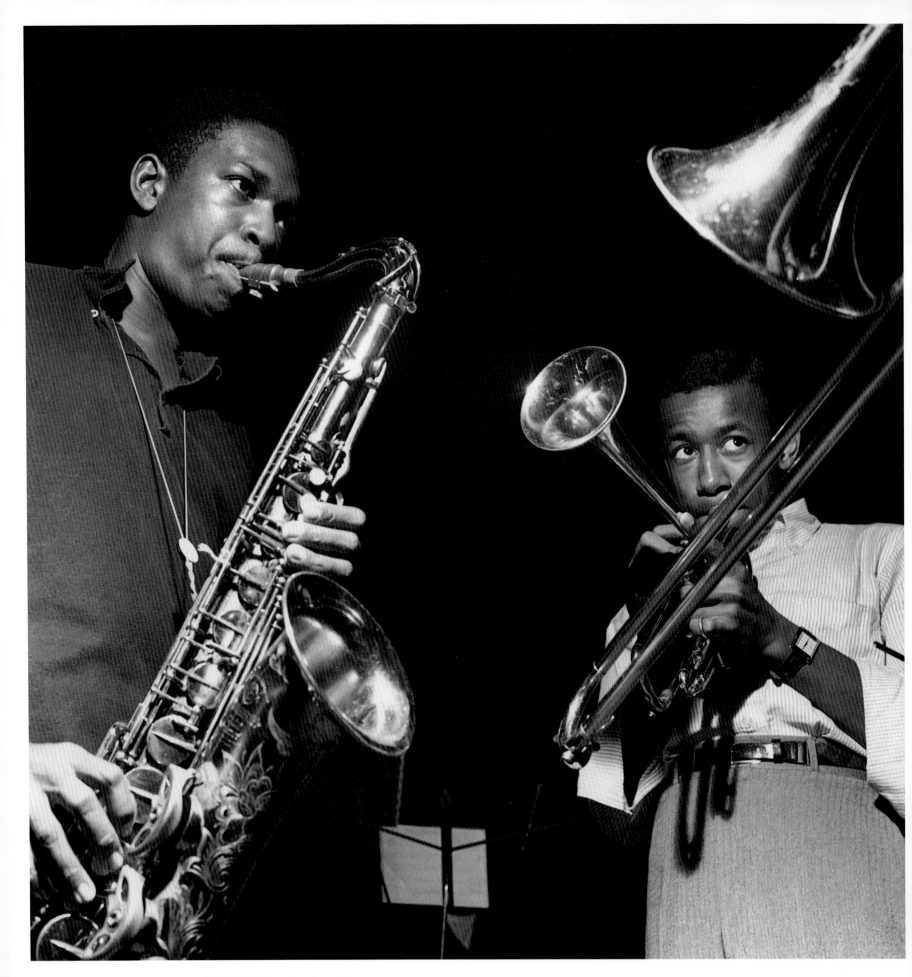

John Coltrane and **Lee Morgan**
at a Blue Note recording session
in Hackensack, New Jersey, 1957.

Photograph by Frank Wolff

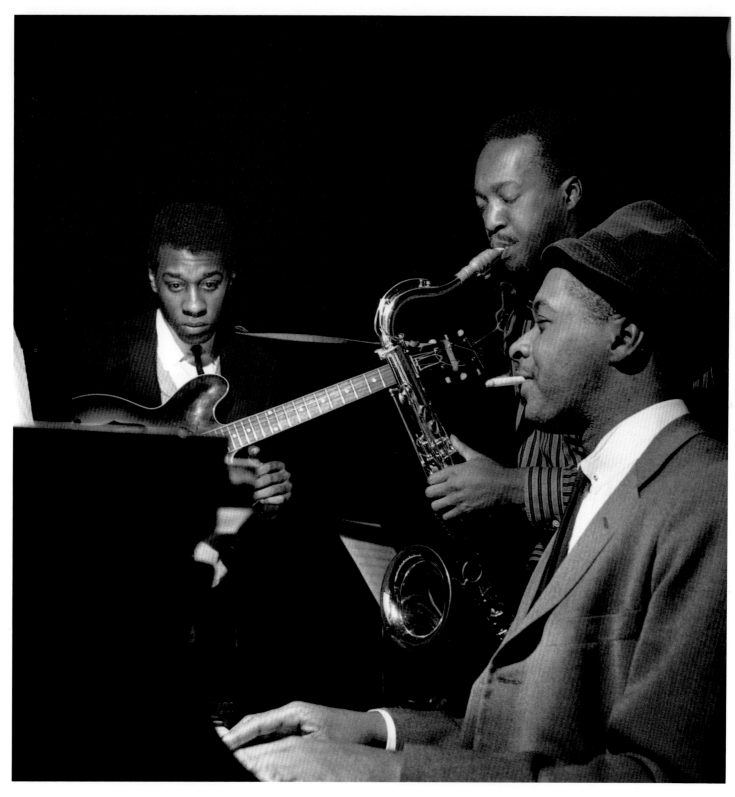

Grant Green, Hank Mobley, and
Wynton Kelly at a Blue Note
recording session in Englewood
Cliffs, New Jersey, 1961.

Photograph by Frank Wolff

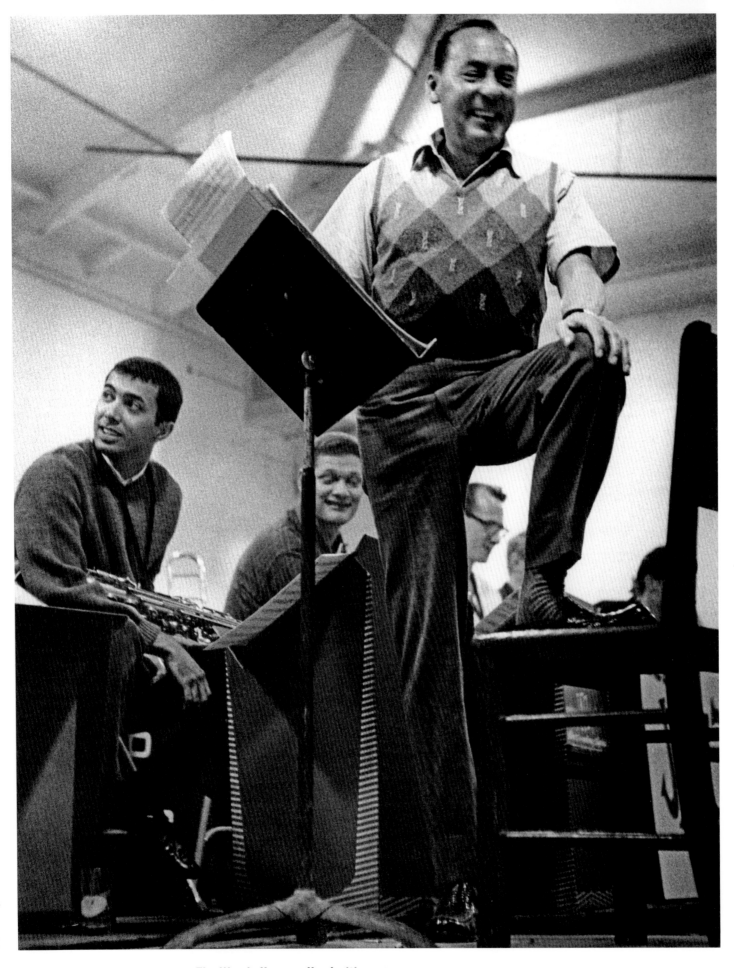

The Woody Herman Herd with
Richie Kamuca and **Zoot Sims**
at the Monterey Jazz Festival,
1959.

Photograph by Jerry Stoll

Zoot Sims and **Stan Getz,**
alumni of the Woody Herman
Four Brothers Band sax
section, in New York, 1963.
Photograph by Jim Marshall

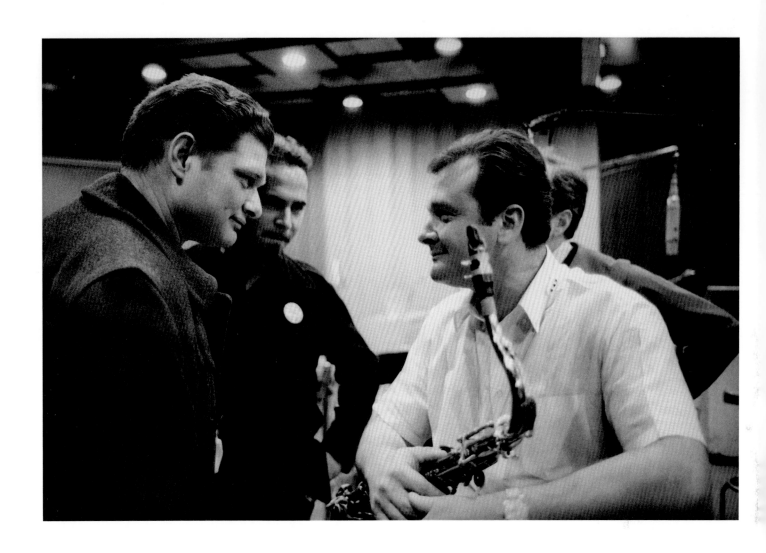

"I went with Woody Herman and became one of the Four
Brothers sax section. I loved that band! We were all young
and I found out: they were thinking the same thing I was."
Zoot Sims

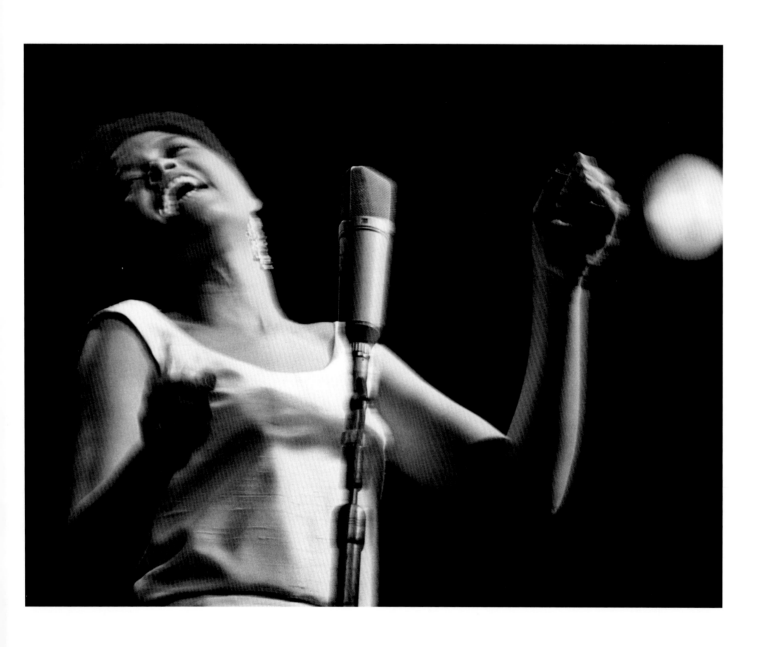

Abbey Lincoln performs the
"We Insist! Freedom Now Suite,"
by then-husband Max Roach,
at the Newport Jazz Festival, 1965.

Photograph by Lee Tanner

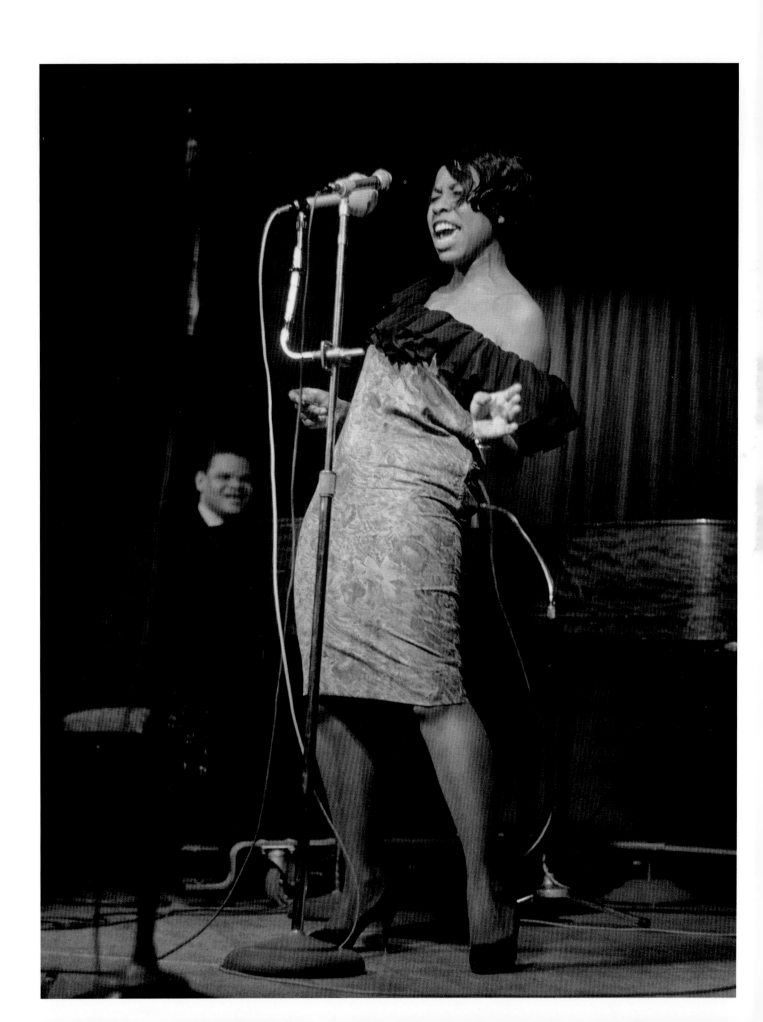

"Erroll Garner is his own rhythm section. He plays the piano
as an orchestra, with love and gusto, strutting humor and lush
romanticism, and, above all, with happy, confident originality."
Nat Hentoff

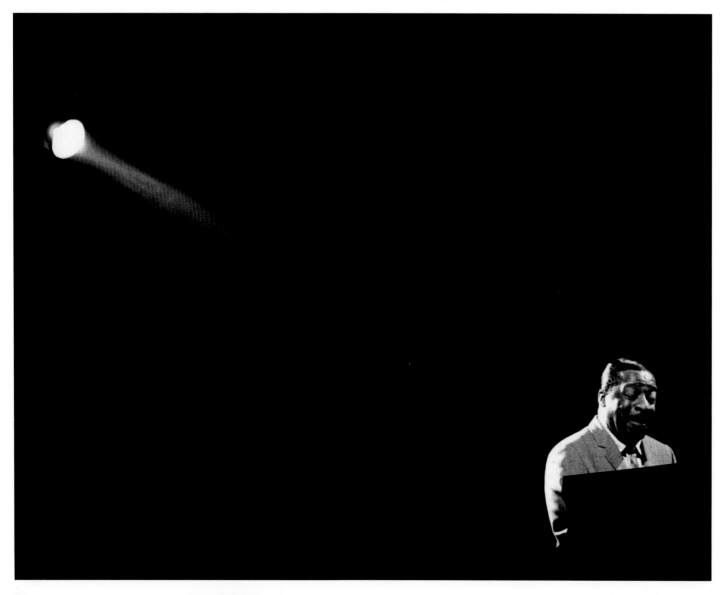

Erroll Garner, a unique hard-
swinging pianist, at the
Village Gate, New York, 1965.
Photograph by Don Schlitten

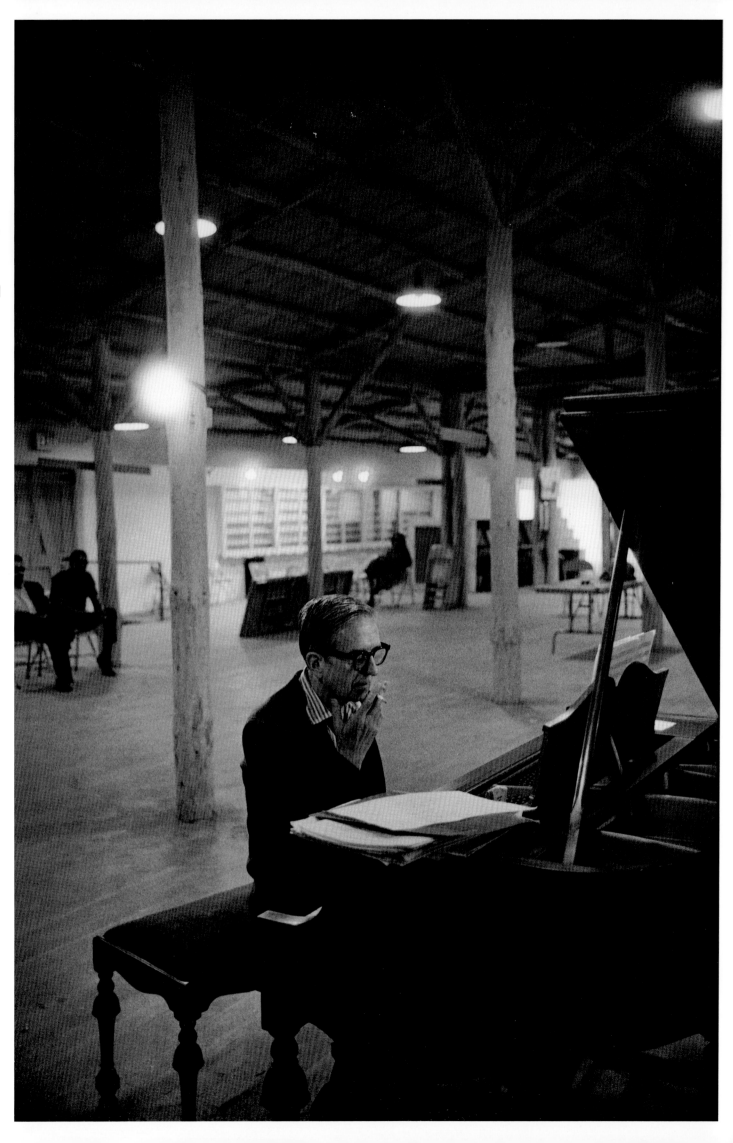

Arranger, composer, and pianist **Gil Evans** warms up before a performance at the Monterey Jazz Festival, 1966.

Photograph by Jim Marshall

"Duke Ellington had a band together continuously longer than anyone else in jazz. He needed an orchestra, he explained, because he was able to hear what he had written as soon as he'd written it."
Nat Hentoff

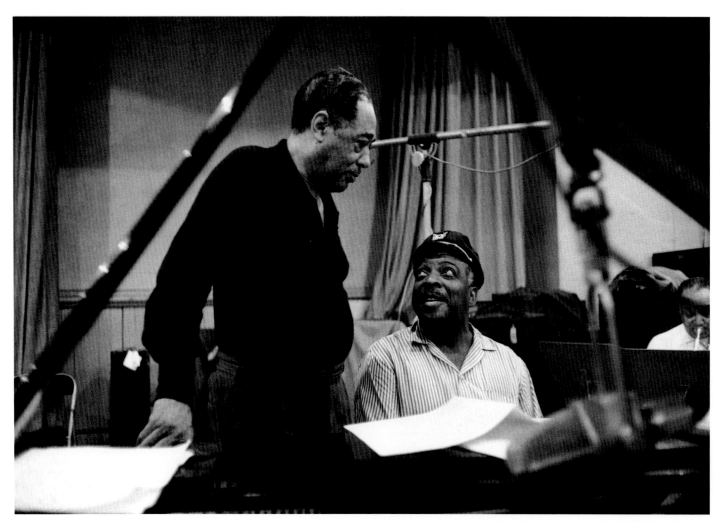

A joint recording session of
the **Ellington** and **Basie** bands
in New York, 1961.

Photograph by Don Hunstein

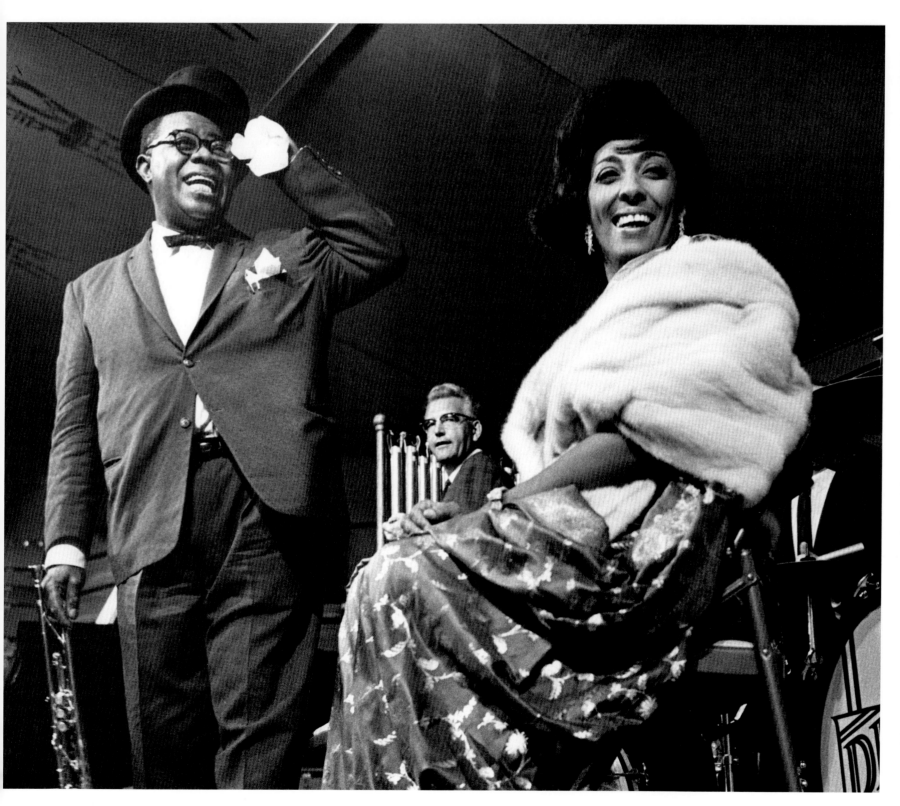

Louis Armstrong and **Carmen McRae,** with **Dave Brubeck** in the background, at the Monterey Jazz Festival, 1962.

Photograph by Jerry Stoll

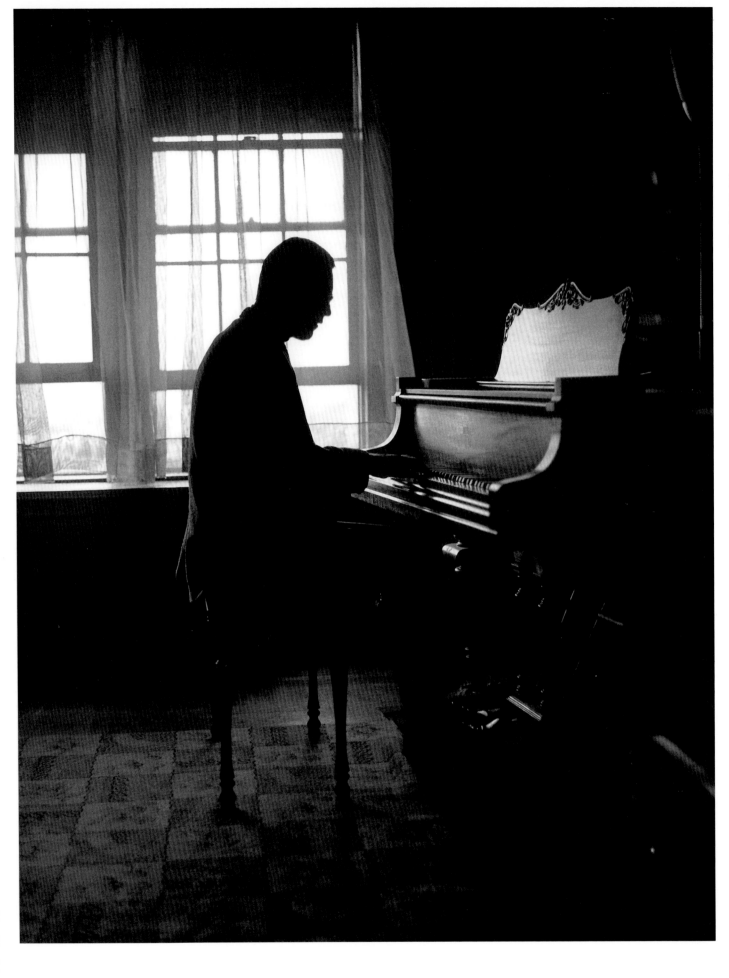

Bill Evans, a very important Miles Davis collaborator, in New York, 1960.

Photograph by Chuck Stewart

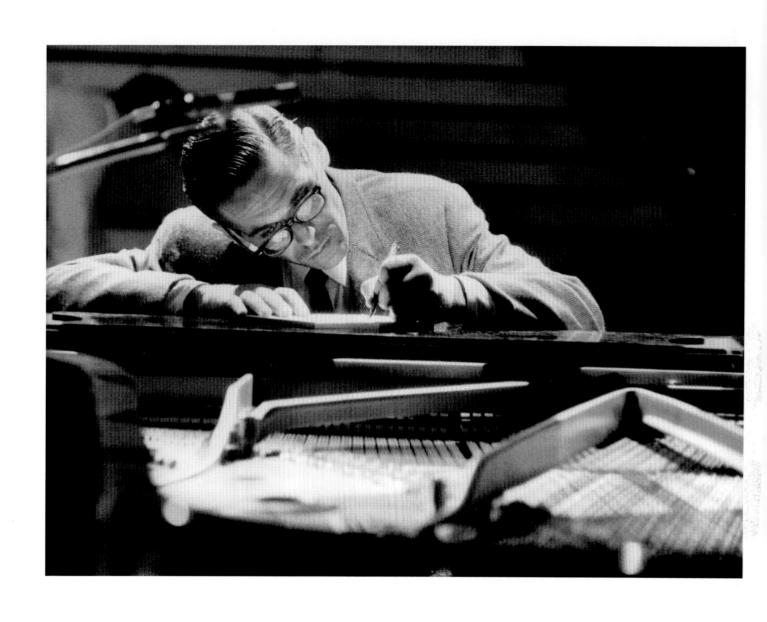

Bill Evans in Copenhagen, 1964.
His trios were sensational.
Photograph by Jan Persson

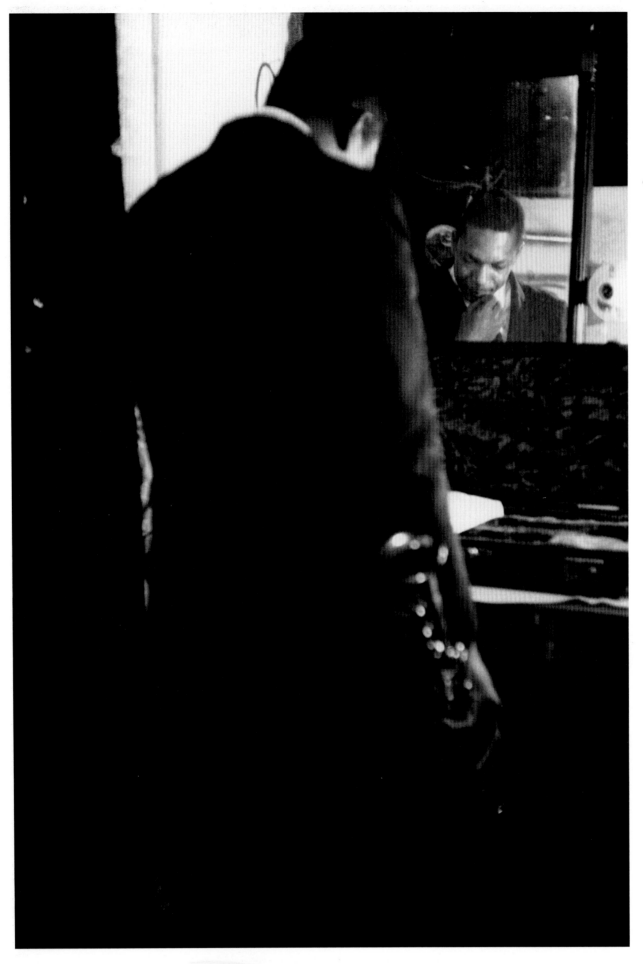

"The main thing a musician would like to do is to give a picture to the listener of the many wonderful things he knows of and senses in the universe."
John Coltrane

John Coltrane backstage at the Village Gate, New York, 1961.

Photograph by Herb Snitzer

John and Alice Coltrane in Englewood Cliffs, New Jersey 1966. The couple shared a remarkable bond.

Photograph by Chuck Stewart

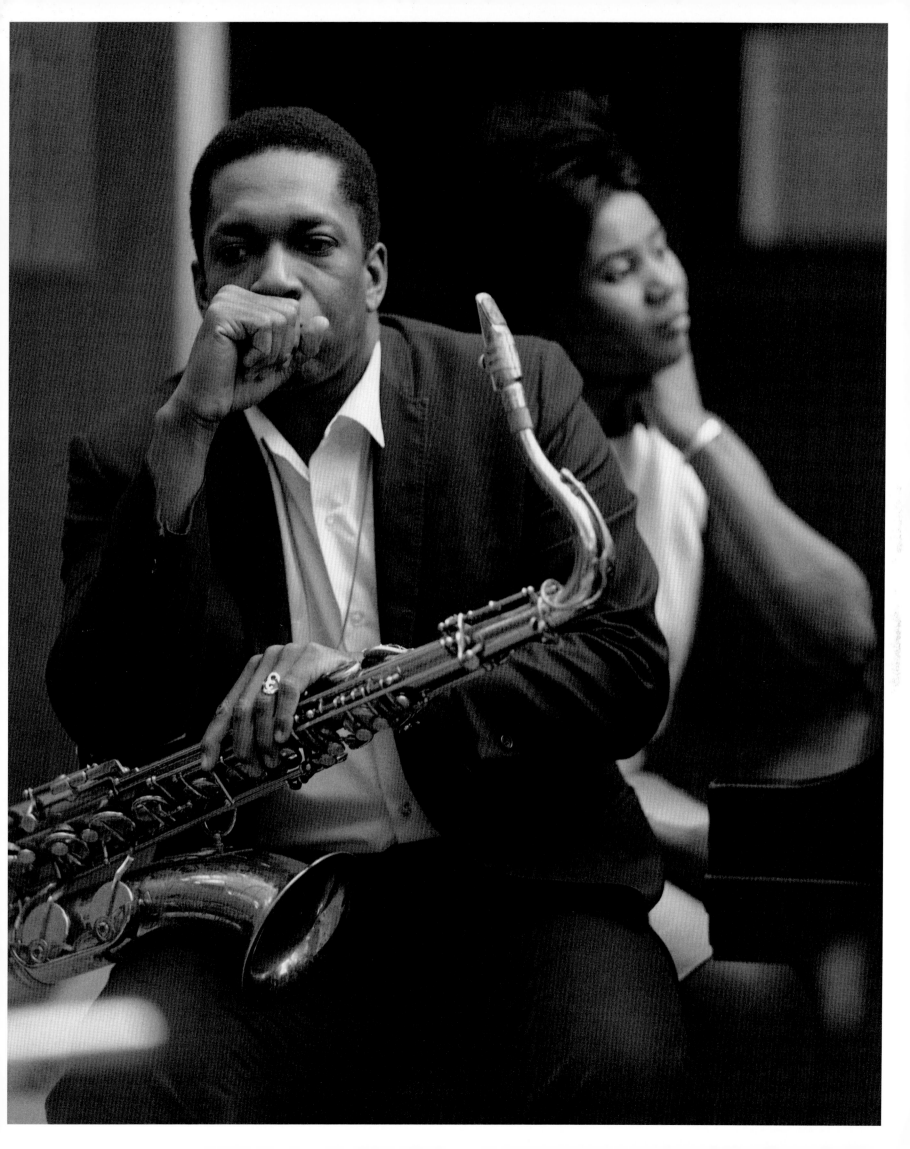

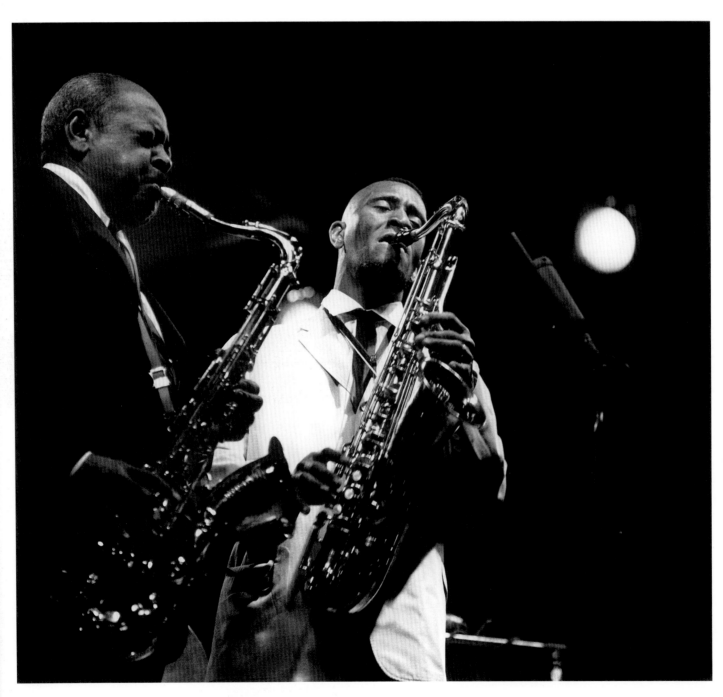

Sonny Rollins (right) and his idol **Coleman Hawkins** at the Newport Jazz Festival, 1963.

Photograph by Lee Tanner

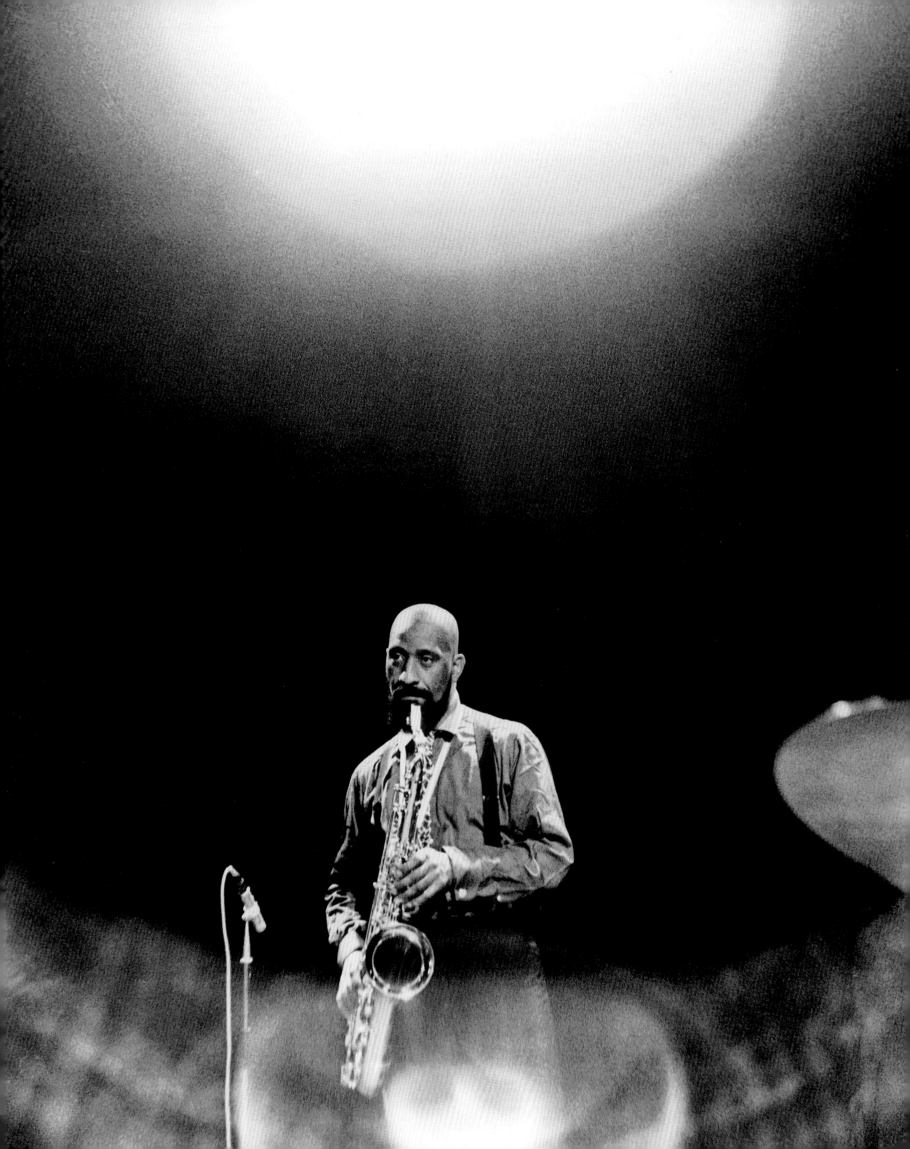

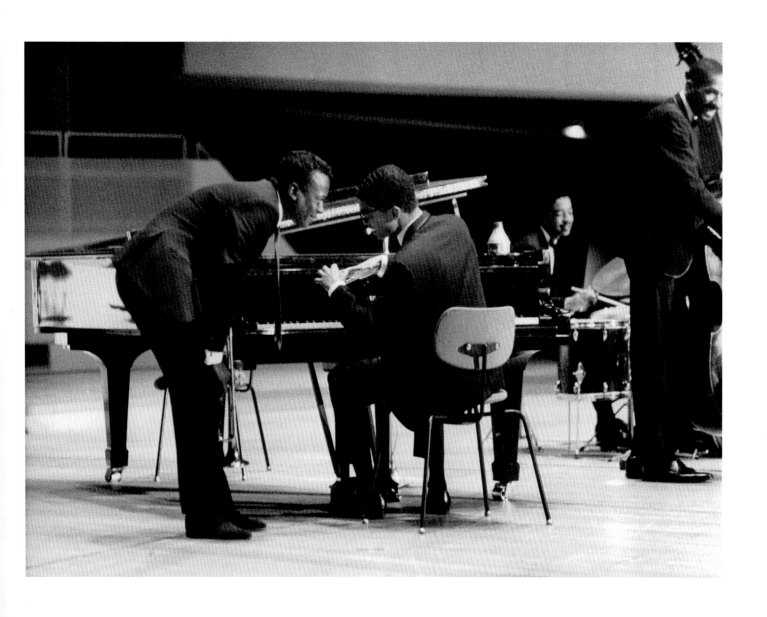

Miles Davis with pianist
Herbie Hancock, drummer
Tony Williams, and bassist
Ron Carter in Berlin, 1964.

Photograph by Jan Persson

"People thought Eric Dolphy avant-garde, but Charles Mingus
heard him crying as if trying to reach all the dead slaves."
Geoff Dyer

Eric Dolphy and **John Coltrane**
at the Village Gate, New York, 1961.
Photograph by Herb Snitzer

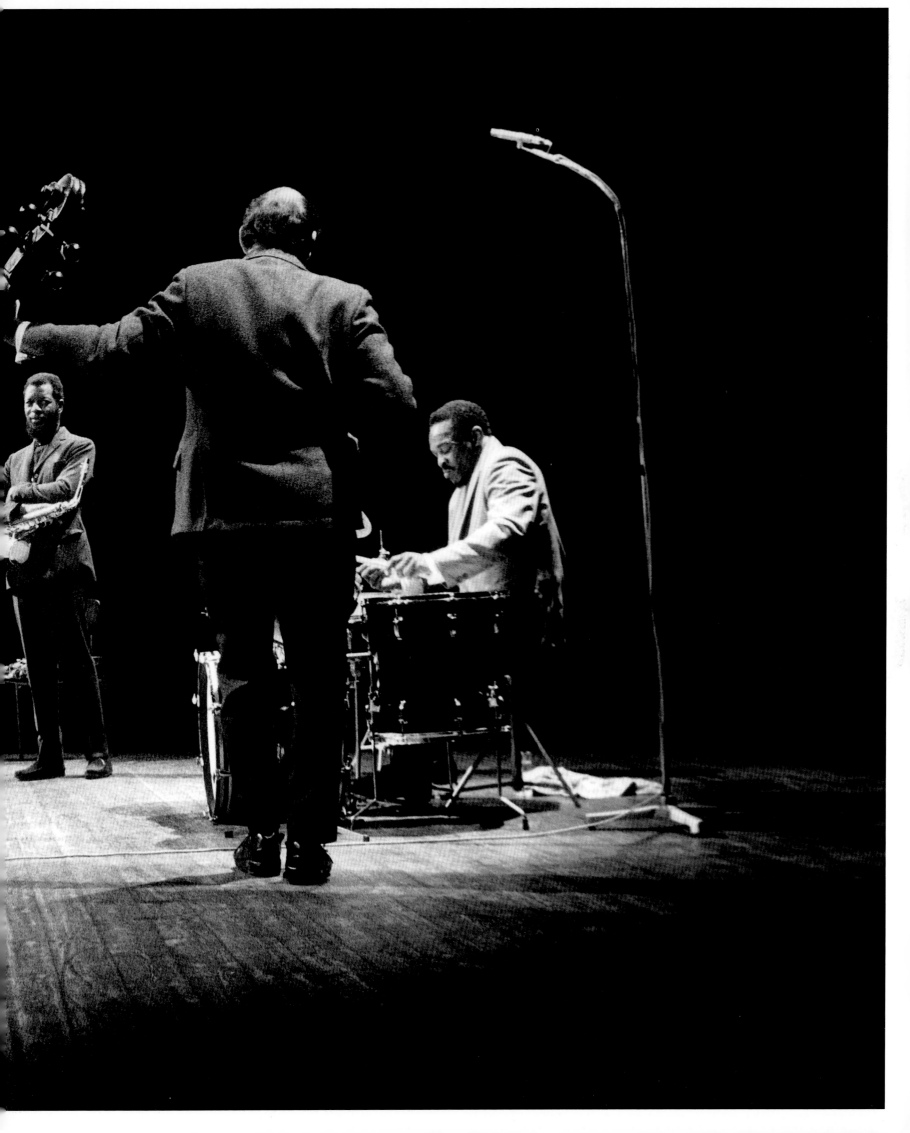

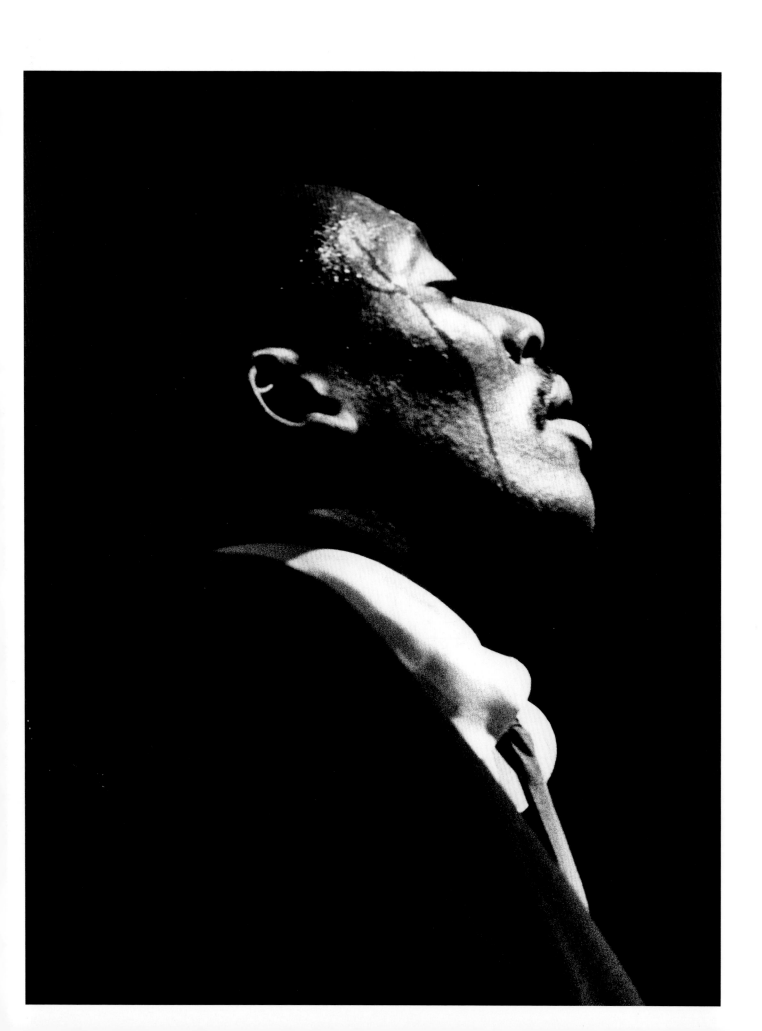

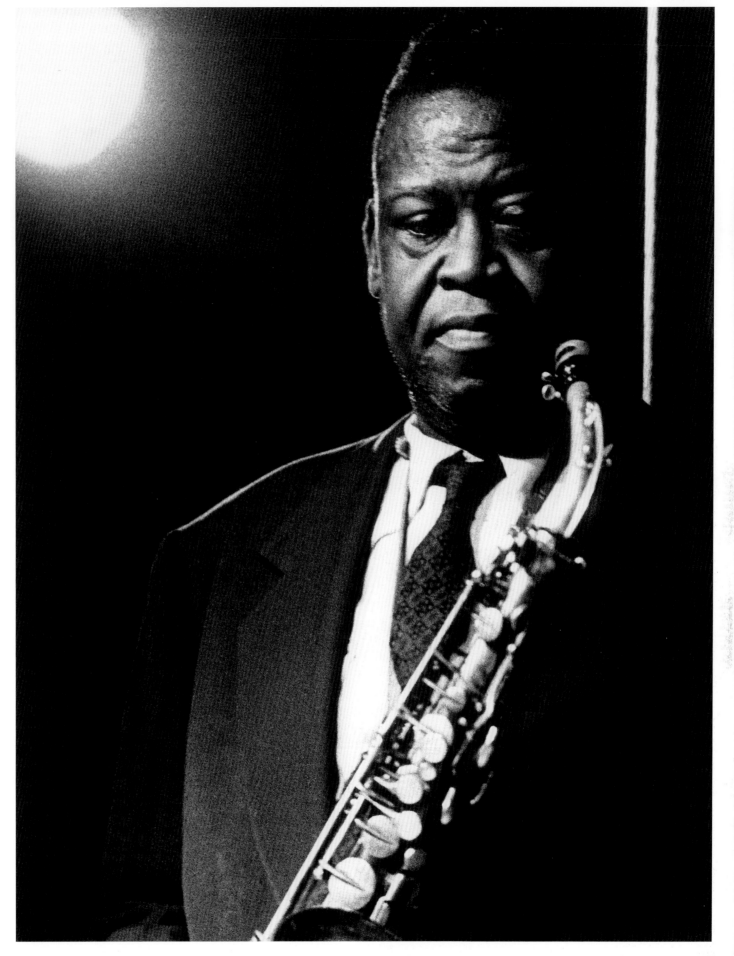

Pete Brown, an unsung
influence on modern alto sax
players, in New York, 1962.
Photograph by Don Schlitten

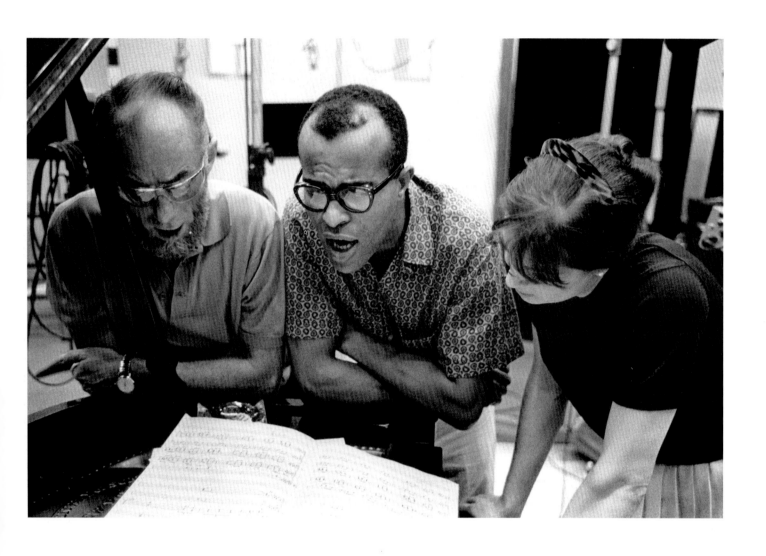

Scat singers **Lambert, Hendricks,
and Ross,** aka "the Metropolitan
Bopera Company," in New York, 1962.
Photograph by Ole Brask

Mel Torme, singer and composer, at a recording session in Hollywood, 1963.

Photograph by William Claxton

Super-drummer **Buddy Rich**
in Copenhagen, 1968.
Photograph by Jan Persson

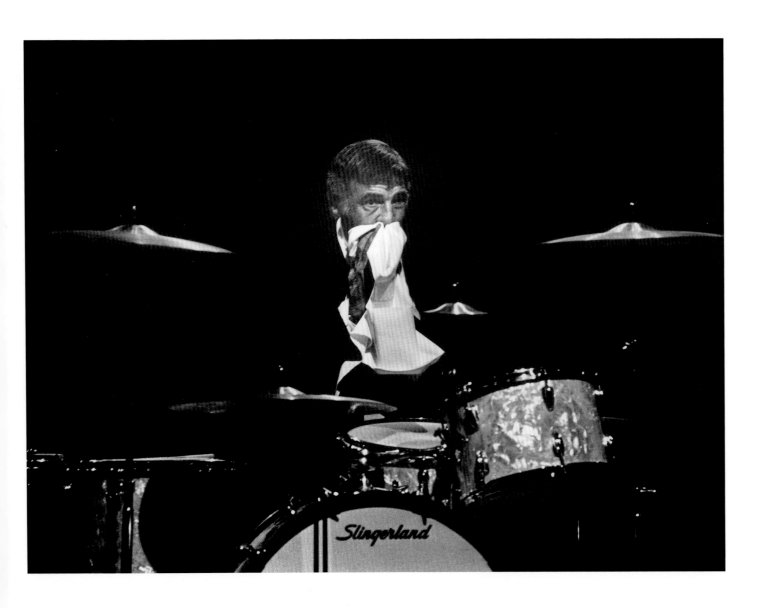

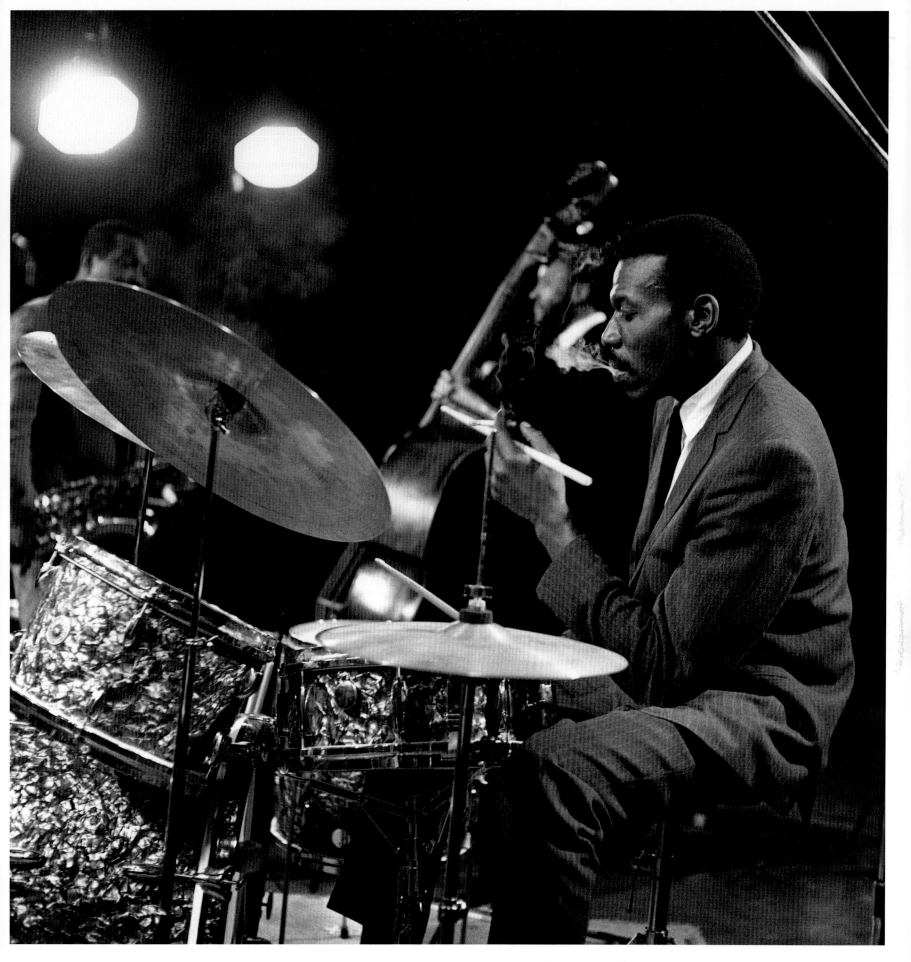

Elvin Jones, polyrhythmic
master and hard swinger,
at the WGBH-TV studio in
Boston, 1966.

Photograph by Lee Tanner

"Hodges says what he wants to say on his horn, and that is it. He says it in his language, which is specific, and you could say that he is pure artistry."
Duke Ellington

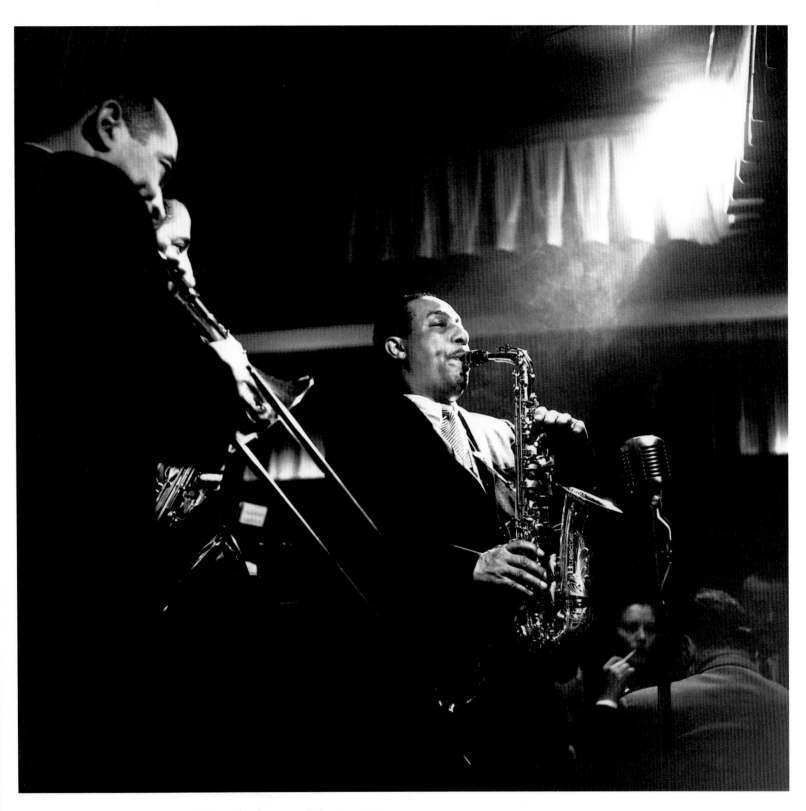

Johnny Hodges, an Ellington star,
at Connelly's, Boston, 1961.
Photograph by Lee Tanner

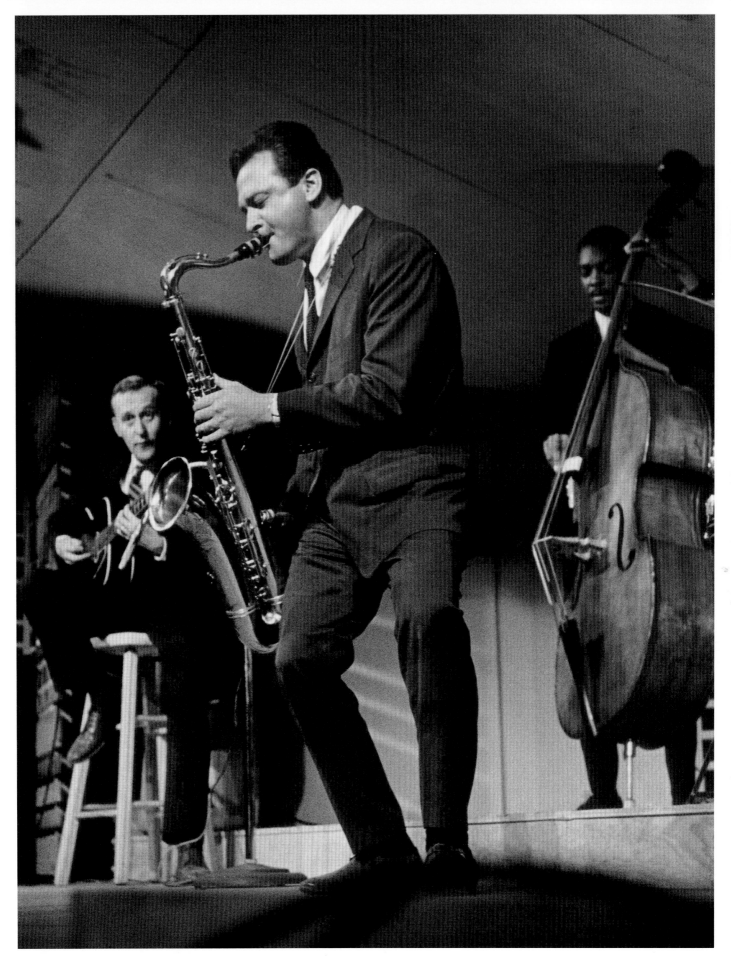

Stan Getz, romantic balladeer and
also hard swinger, with **Jimmy Raney**
on guitar and **Tommy Williams** on bass,
at the Monterey Jazz Festival, 1962.
Photograph by Jerry Stoll

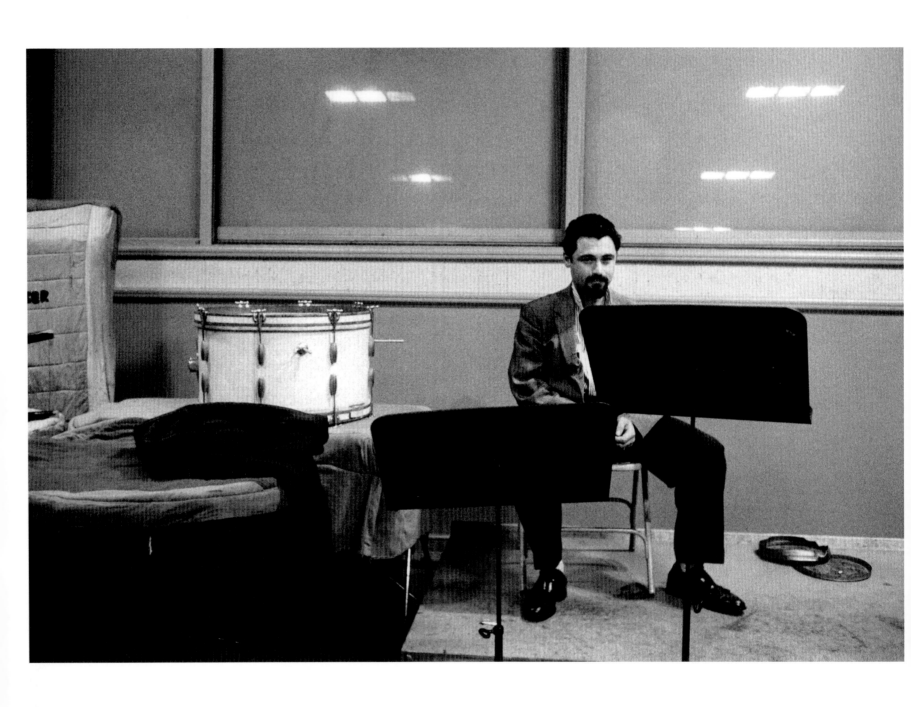

Shorty Rogers, trumpeter and
arranger, at a recording session
in Los Angeles, 1955.
Photograph by Bob Willoughby

"Pee Wee Russell was a man of seemingly infinite gentleness and love for music. He listened to musicians of every style . . . from traditional through to the likes of Mulligan and Monk."
Nat Hentoff

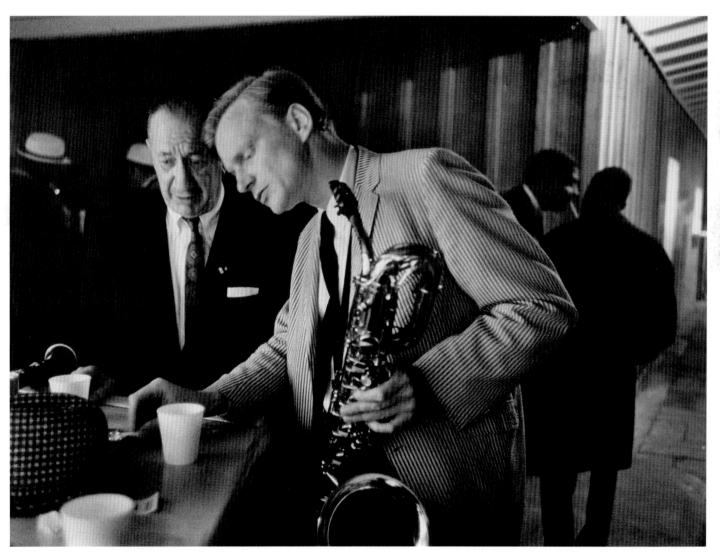

Traditionalist **Pee Wee Russell**
with modernist **Gerry Mulligan** at
the Monterey Jazz Festival, 1963.
Photograph by Jerry Stoll

Archie Shepp, Coltrane devotee,
in New York, 1967.

Photograph by Val Wilmer

"I was very fortunate.... I was among a number of
young people in whom Coltrane took an active interest."

Archie Shepp

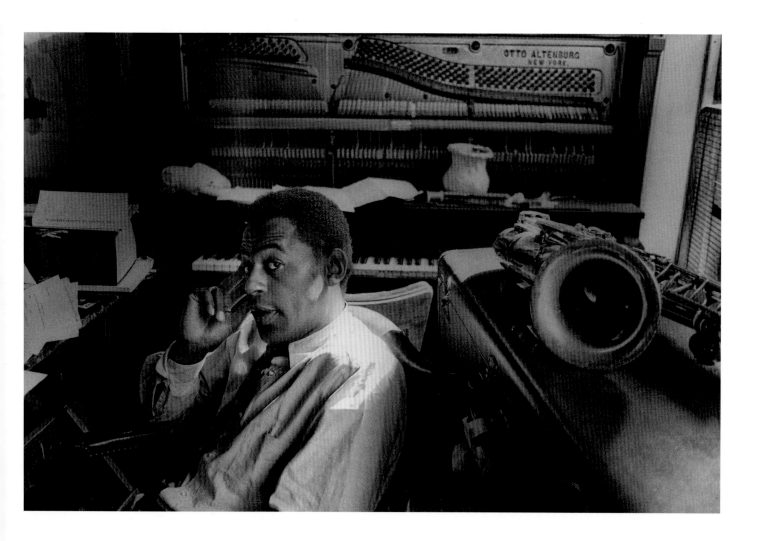

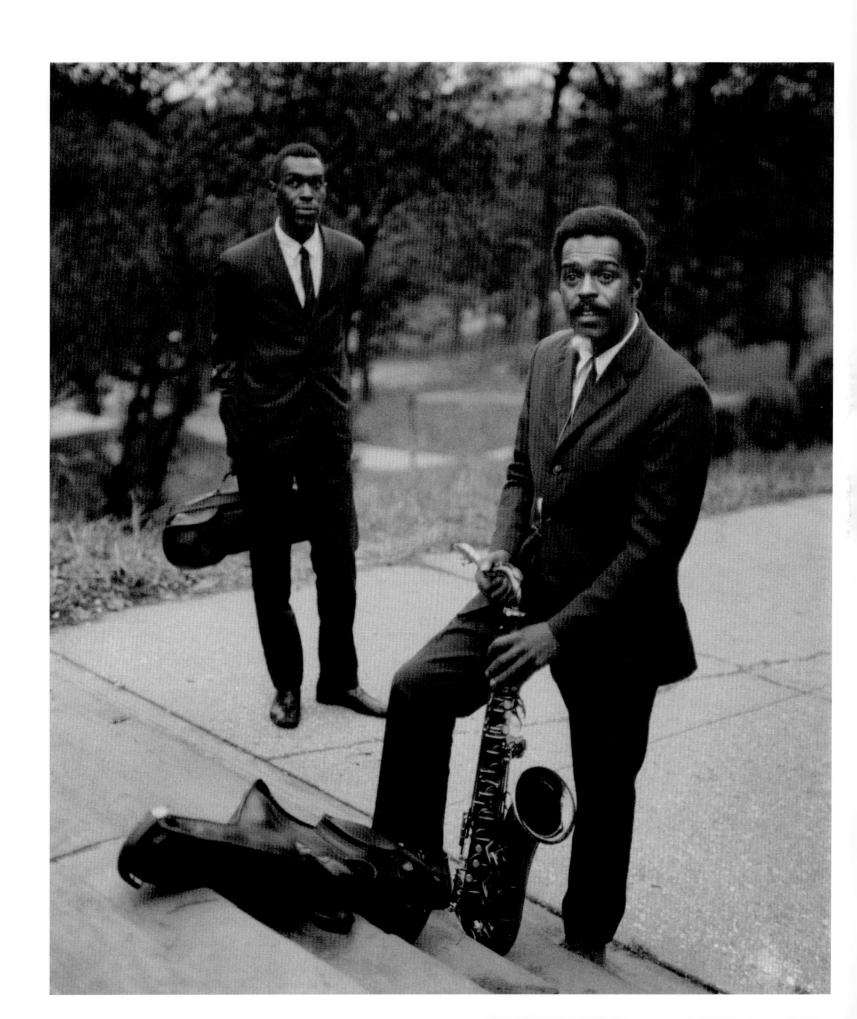

Illinois Jacquet and **John Lewis**
prepare to play at the Monterey
Jazz Festival, 1966.

Photograph by Jim Marshall

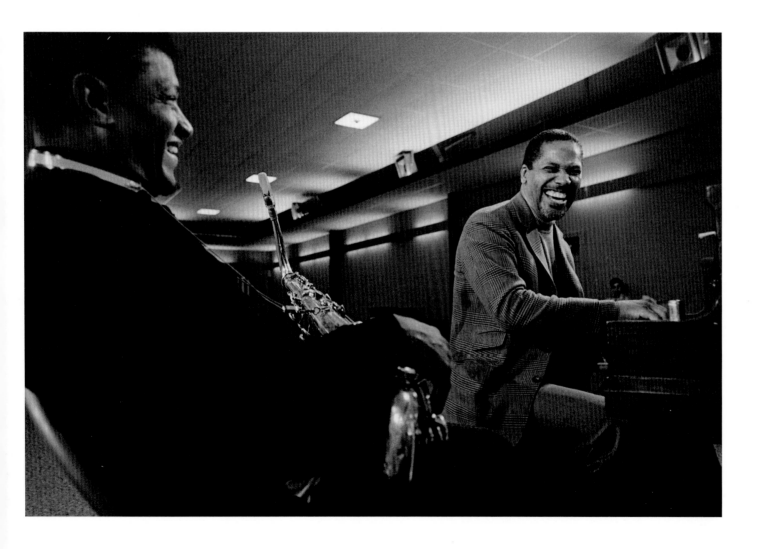

Nat King Cole, a remarkable
pianist, in Rochester,
New York, 1956.

Photograph by Paul Hoeffler

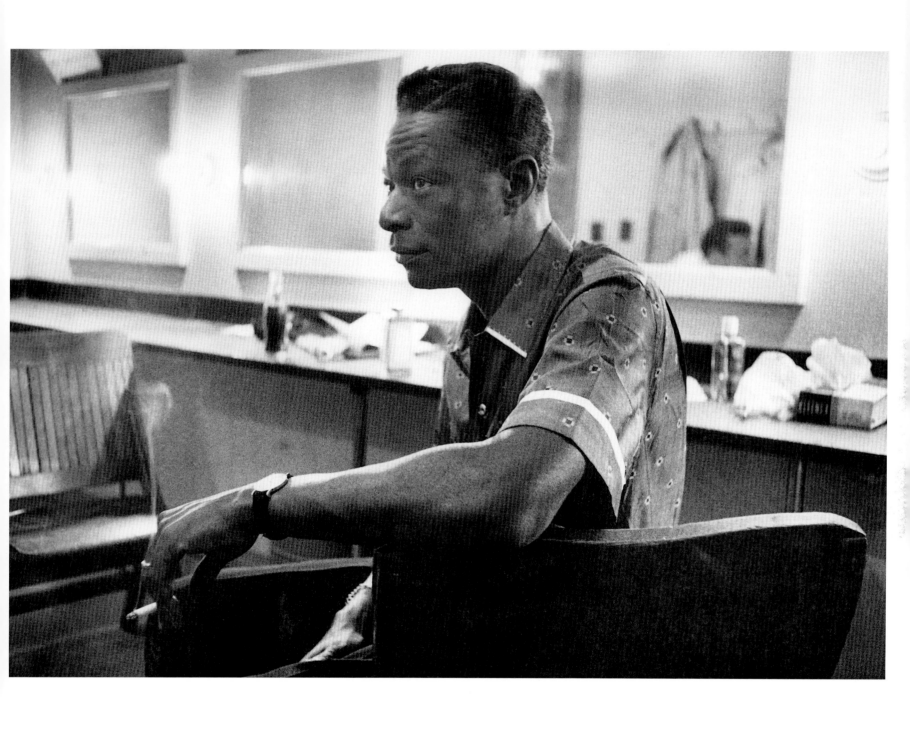

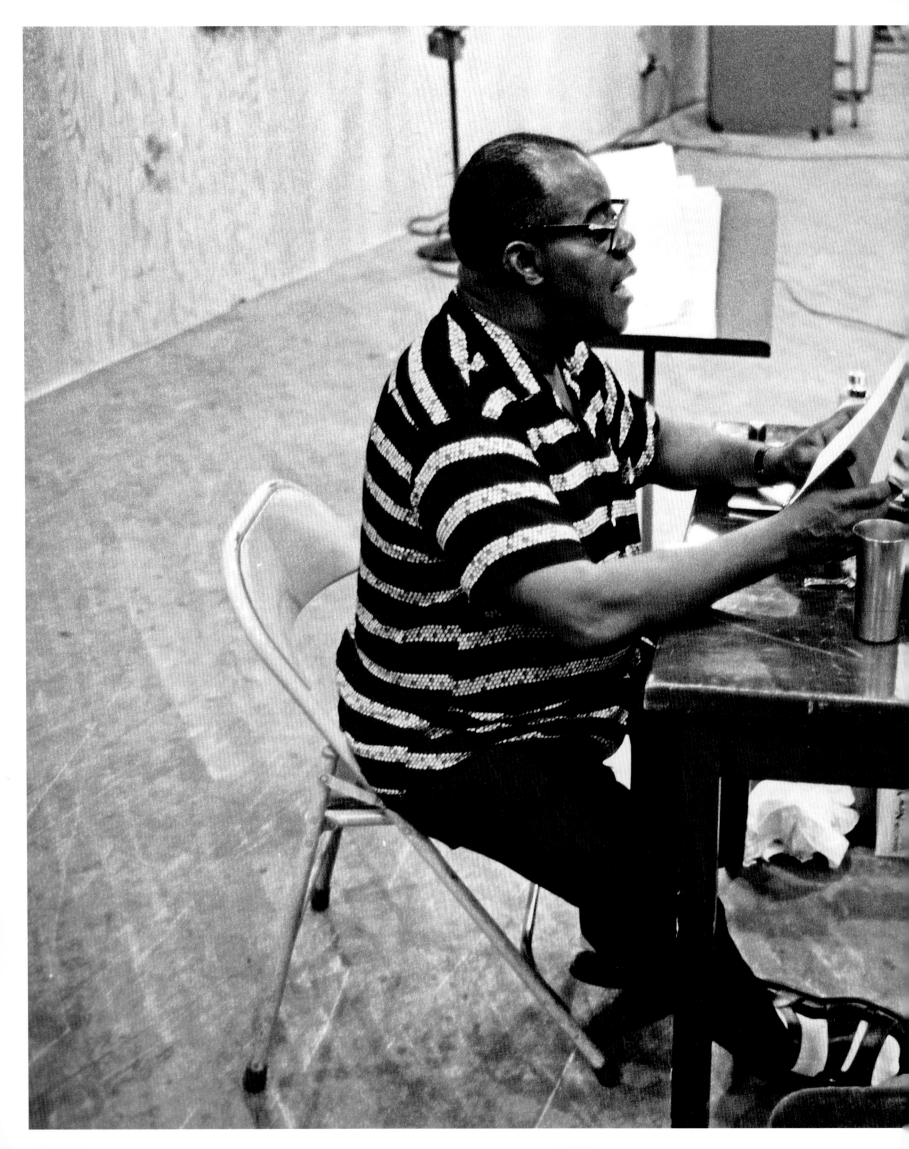

"At night before Louis goes to sleep he may read, sometimes rereading letters to friends that he's typed up. Louis loves to write, and he writes as he speaks."
Nat Hentoff

Louis Armstrong in New York, 1961. He loved writing to friends and keeping journals.
Photograph by Ole Brask

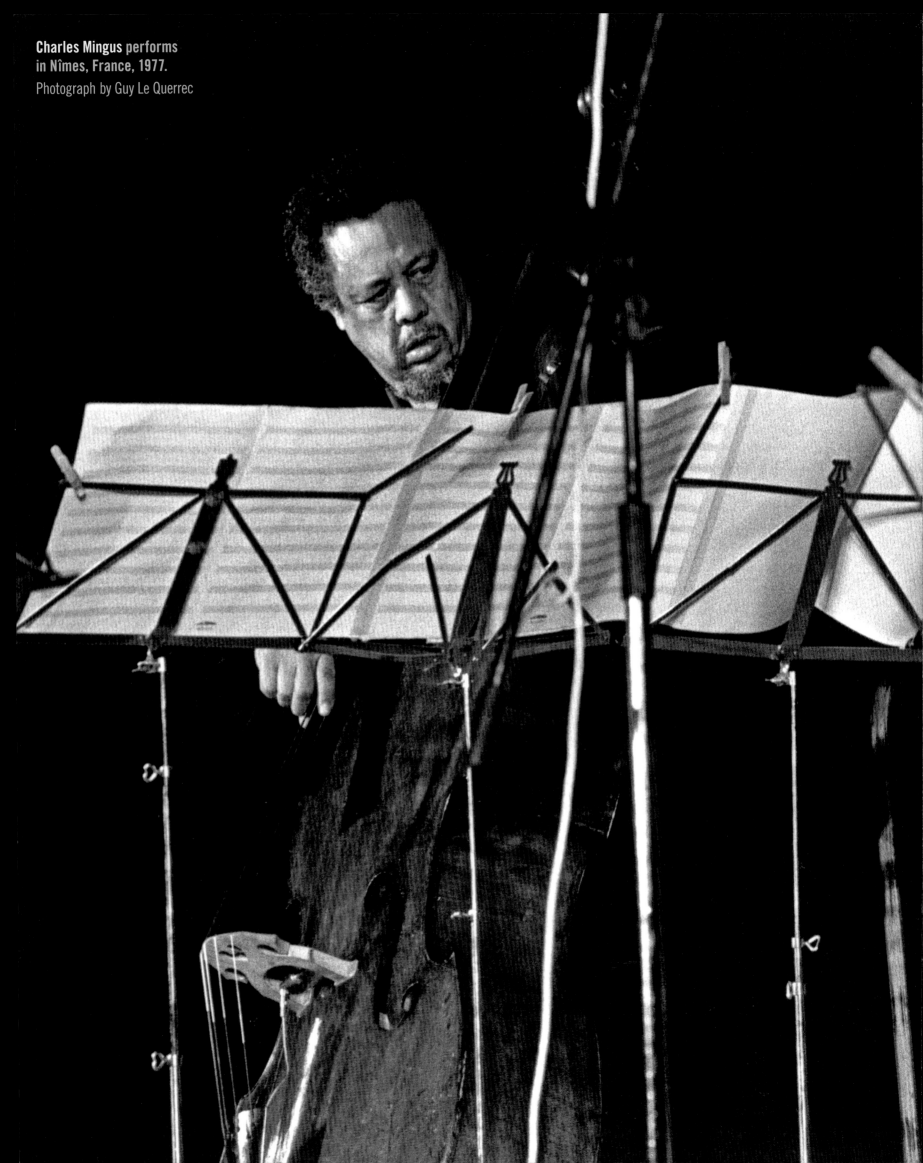

"Mingus packed his music so full of life, so full of noise of the city, that thirty years in the future someone listening wouldn't be sure whether that wail and scream was a horn on the record or the red-and-white siren of a prowl car shrieking past the window."
Geoff Dyer

1969–1992

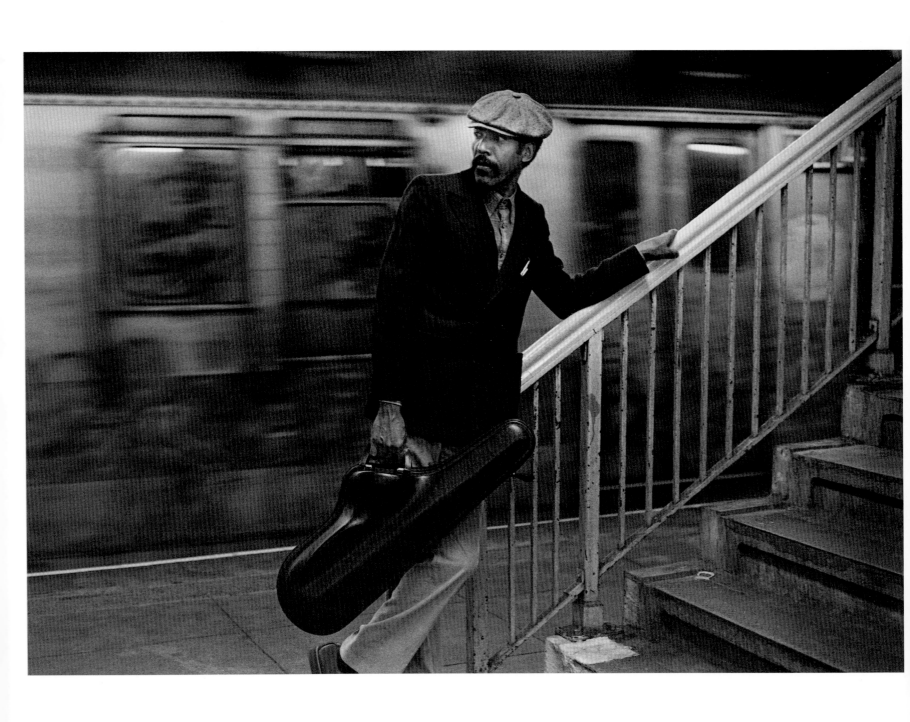

Frank Lowe, avant-garde
tenor saxist, in New York, 1982.
Photograph by Val Wilmer

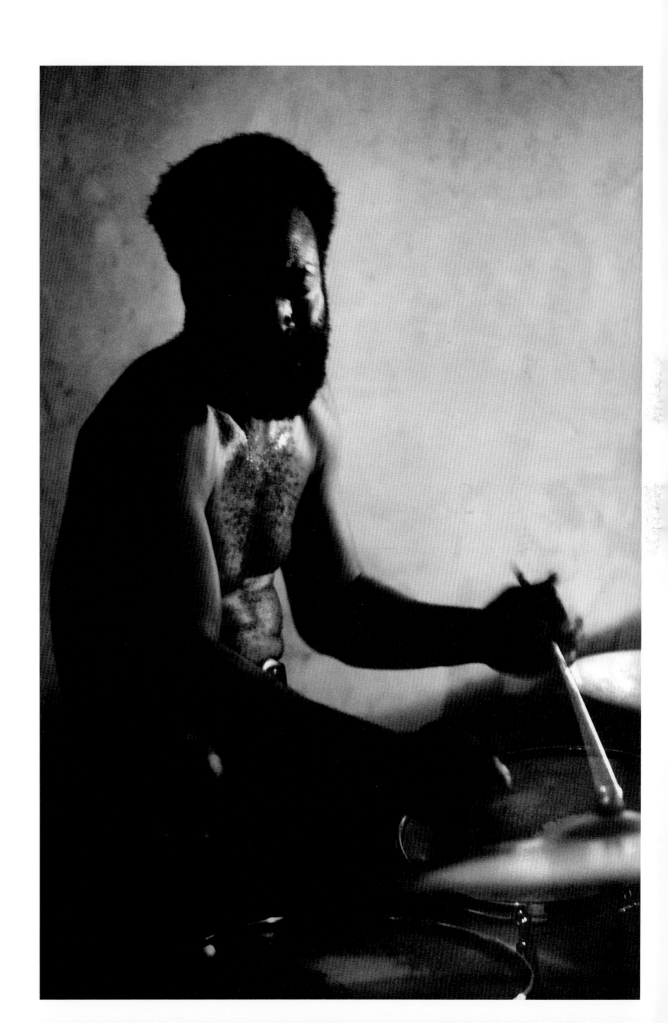

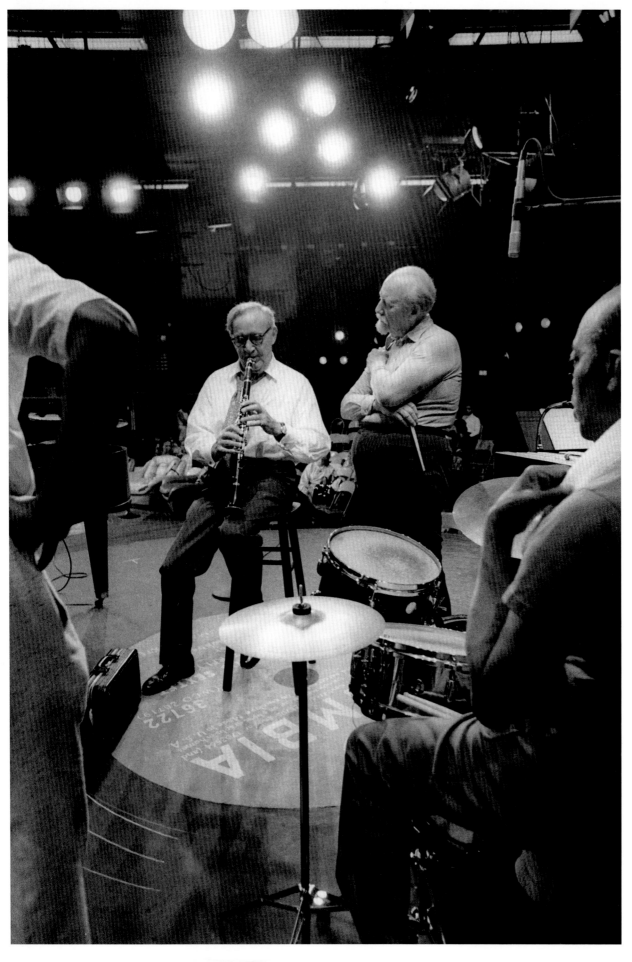

Benny Goodman tapes a television
show celebrating his music, with
vibist **Red Norvo** and drummer
Papa Jo Jones, Chicago, 1976.

Photograph by Ole Brask

140

"Gillespie, a great figure in American music, in world music, perhaps the greatest innovator in recent times."
Martin Williams

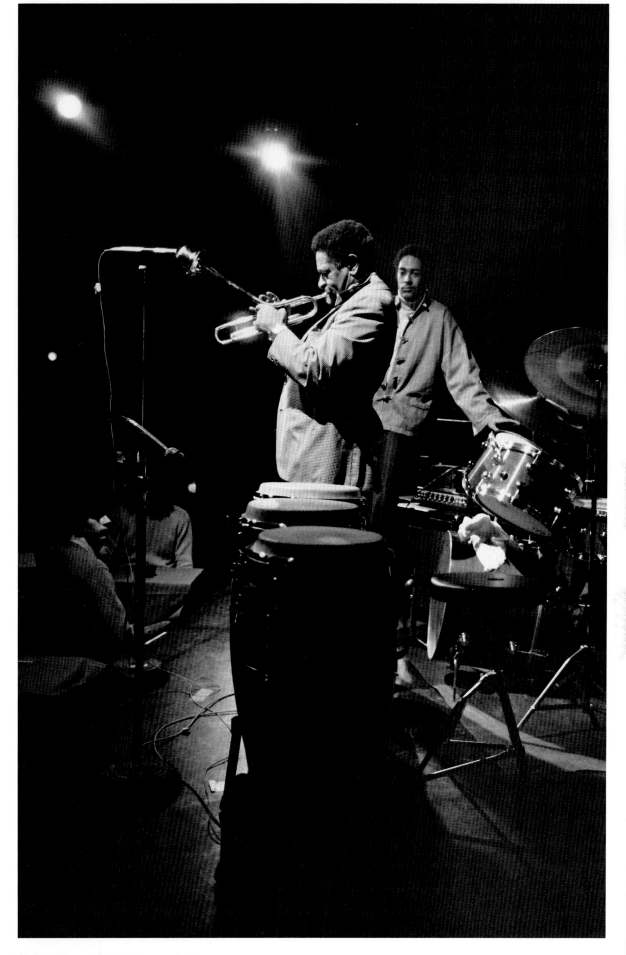

Dizzy Gillespie with his protégé
Jon Faddis in New York, 1976.
Photograph by Ole Brask

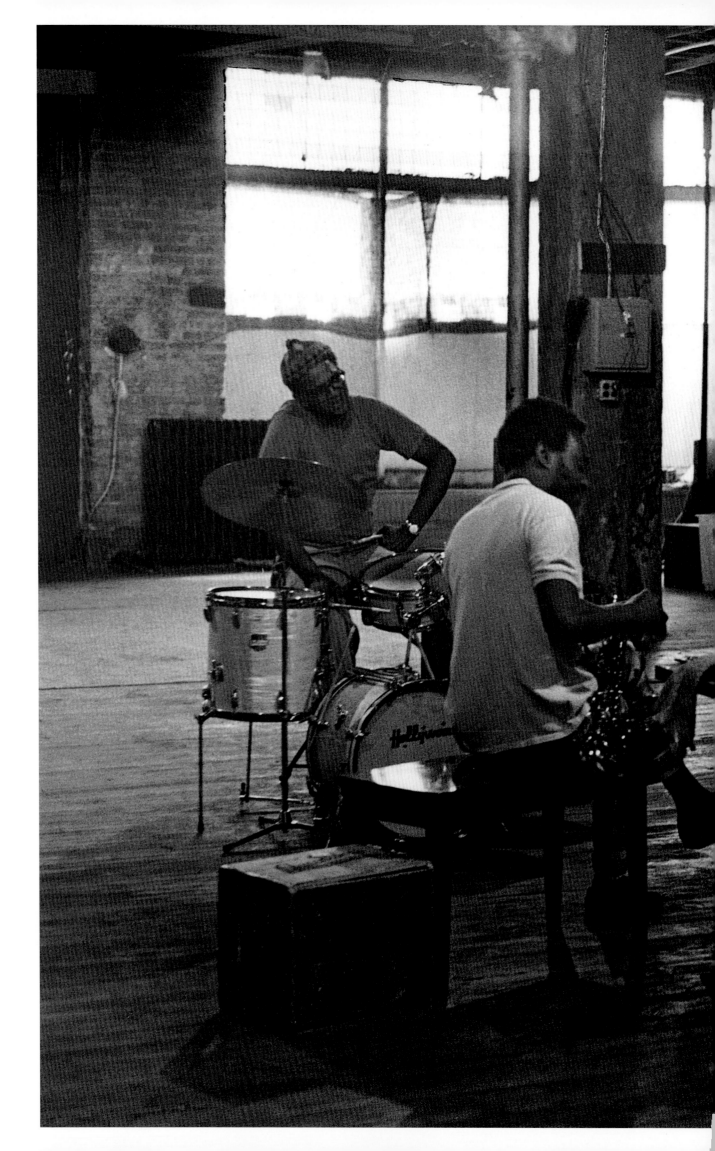

Ornette Coleman's group in rehearsal: **Ed Blackwell** on drums, **Dewey Redman** on tenor sax, **Coleman** on alto sax, and **Charlie Haden** on bass, in New York, 1971.

Photograph by Val Wilmer

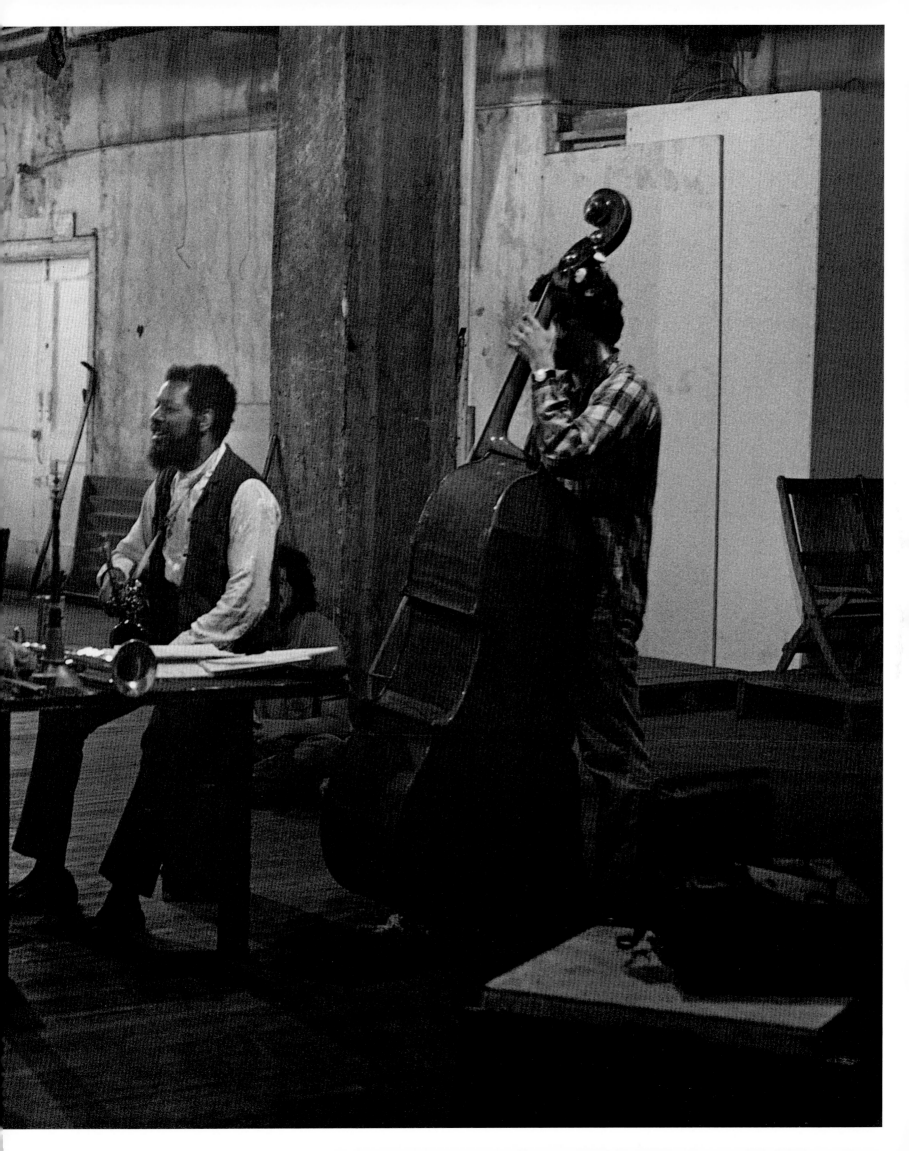

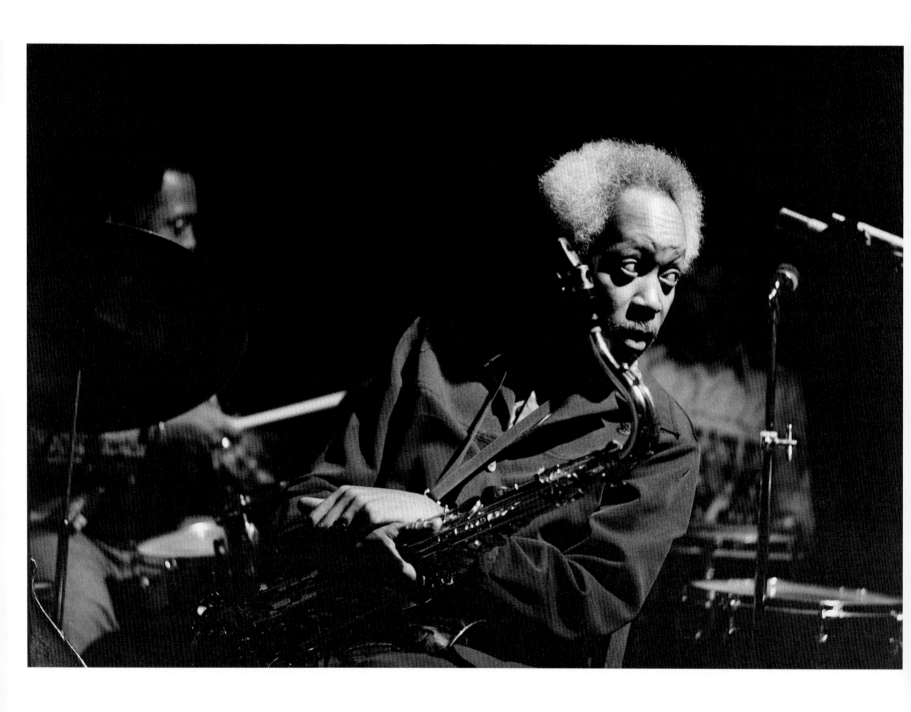

"Stitt . . . was the first and the best of
Charlie Parker's countless followers."
Whitney Balliet

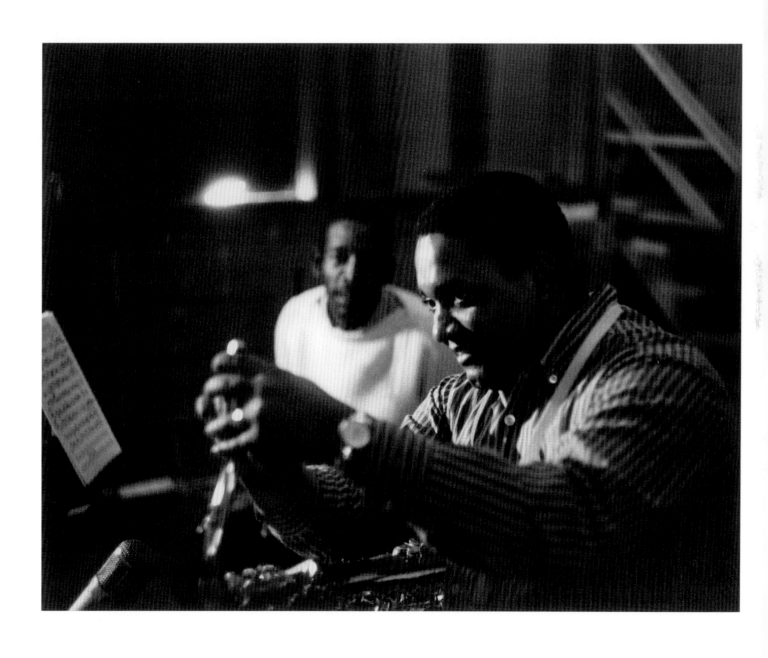

"Dizzy Gillespie had the vocation to teach, and he went about unraveling bebop's often convoluted harmonies as if the future depended on his ability to make the first and second generation boppers understand what they were doing."
Doug Ramsey

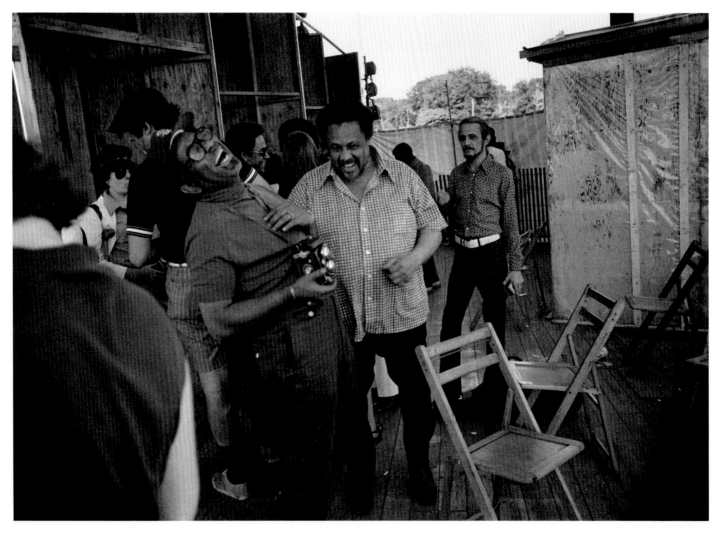

Dizzy Gillespie and **Charles Mingus**
share a joyful encounter at the
Newport Jazz Festival, 1971.
Photograph by Milt Hinton

French kids imitate
Dizzy Gillespie's cheeks
in Nice, France, 1981.
Photograph by Milt Hinton

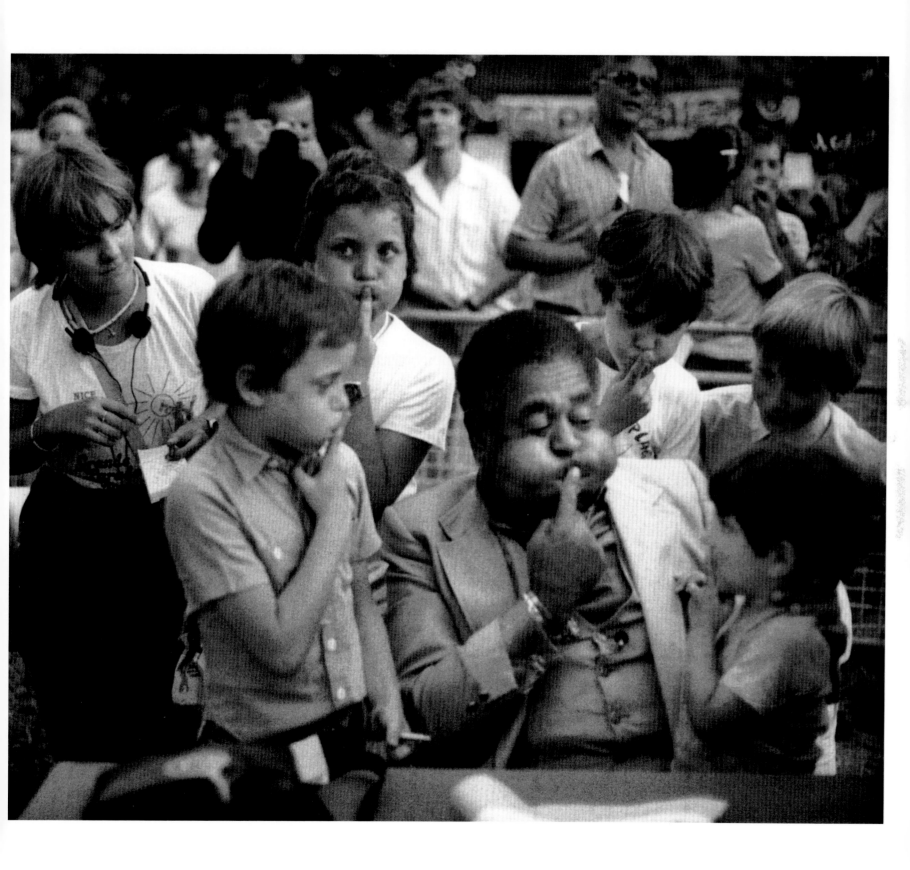

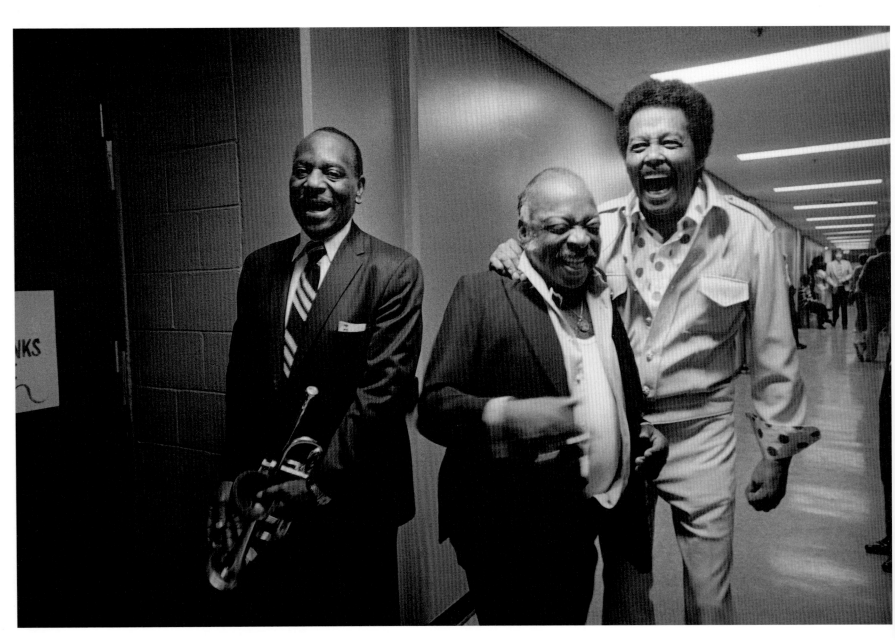

Cootie Williams, Count Basie, and singer **Billy Eckstine** at an Ellington tribute recorded at the CBS-TV studio in Los Angeles, 1972.

Photograph by Jim Marshall

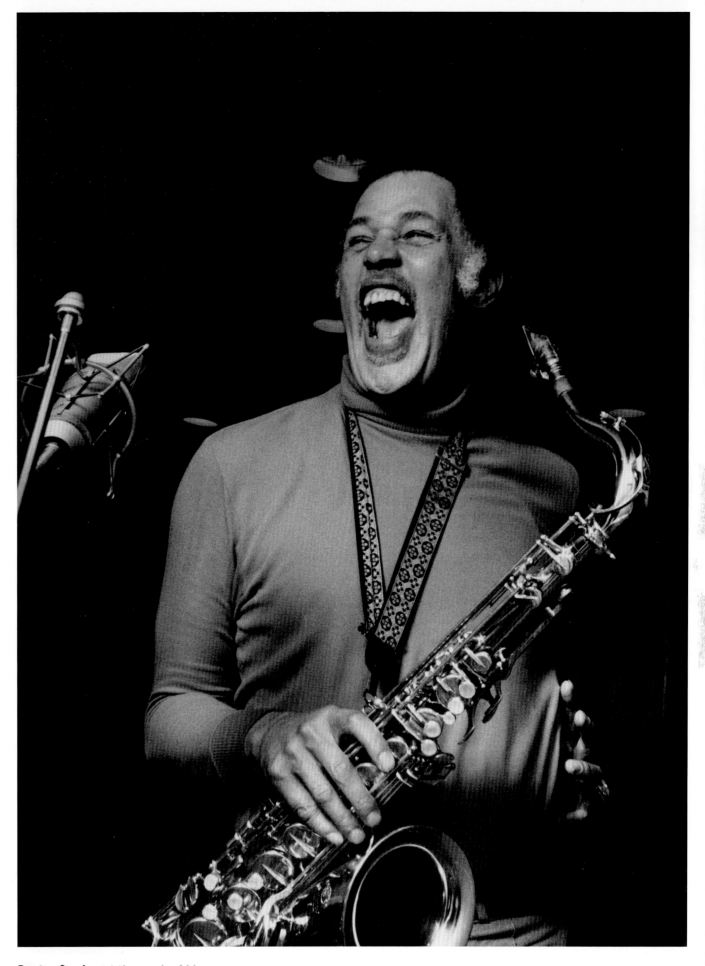

Dexter Gordon at the peak of his
career in Copenhagen, 1974.
Photograph by Jan Persson

The Modern Jazz Quartet greets
expatriate **Kenny Clarke,** the
group's first drummer, Paris, 1983.
Photograph by Guy Le Querrec

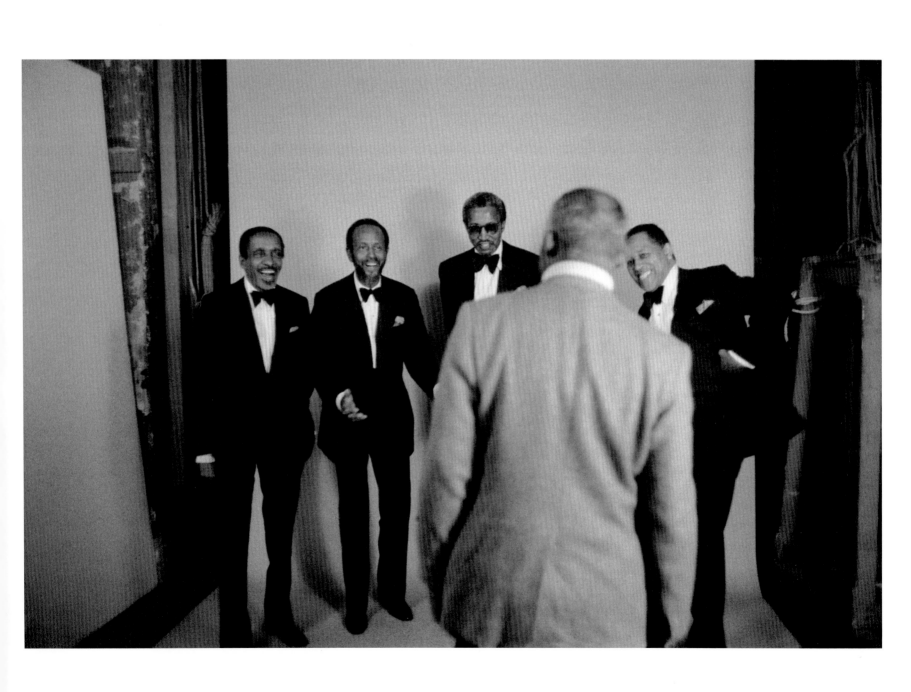

The musician's reliable friend and
producer **Norman Granz** with
Roy Eldridge in Los Angeles, 1976.
Photograph by Ole Brask

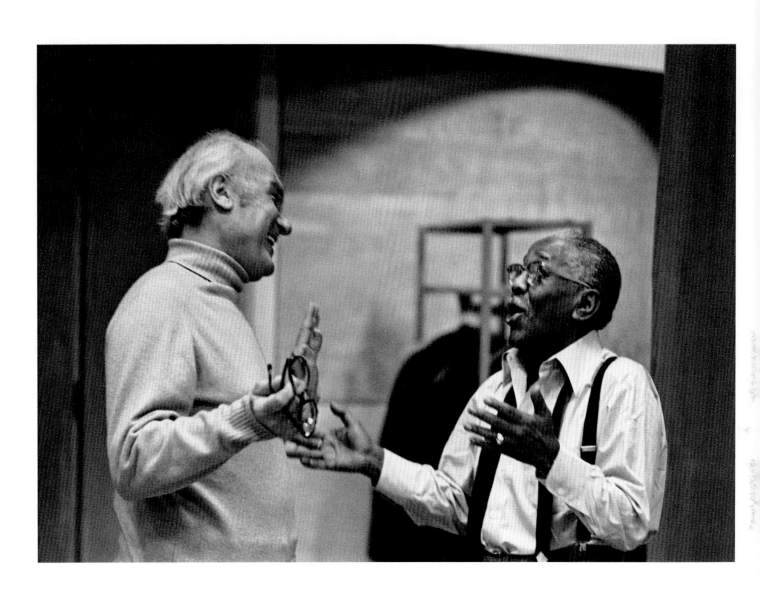

The musician's reliable friend and
producer **Norman Granz** with
Roy Eldridge in Los Angeles, 1976.
Photograph by Ole Brask

"Roy Eldridge most typified jazz. He's a musician for whom
it's far more important to dare. To try to reach a particular
peak even if he falls on his ass in the attempt."
Norman Granz

Art Blakey, guru of hard bop, in Stanford, Connecticut, 1989.
Photograph by Tad Hershorn

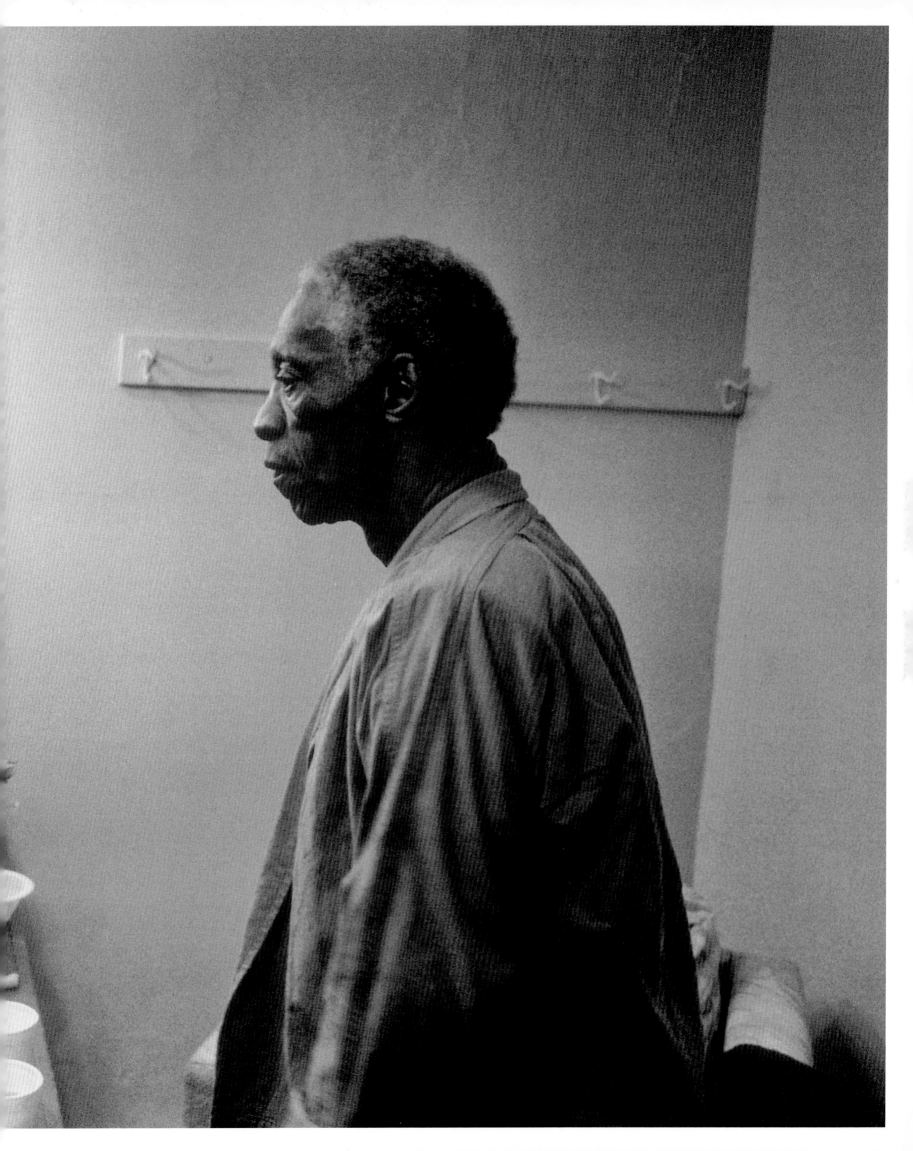

"Miles is Miles. You can't destroy that kind of musician.
He can't destroy himself. He's just there . . . always."
Sonny Rollins

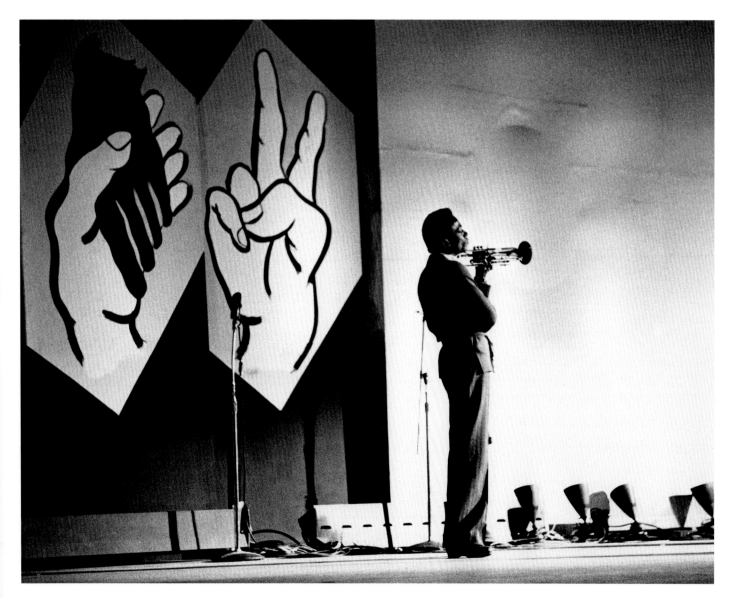

Miles Davis initiates his
jazz-fusion period at the
Monterey Jazz Festival, 1969.

Photograph by Ray Avery

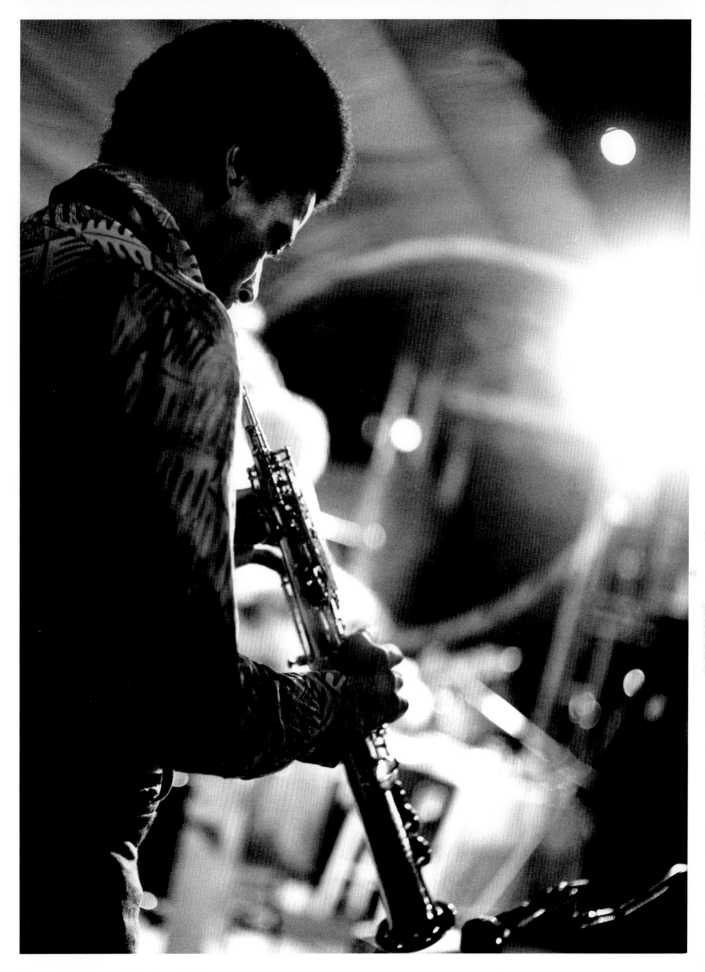

Wayne Shorter and the jazz-fusion group Weather Report peform on Boston Common, 1972. Shorter also starred with Art Blakey and Miles Davis.

Photograph by Lee Tanner

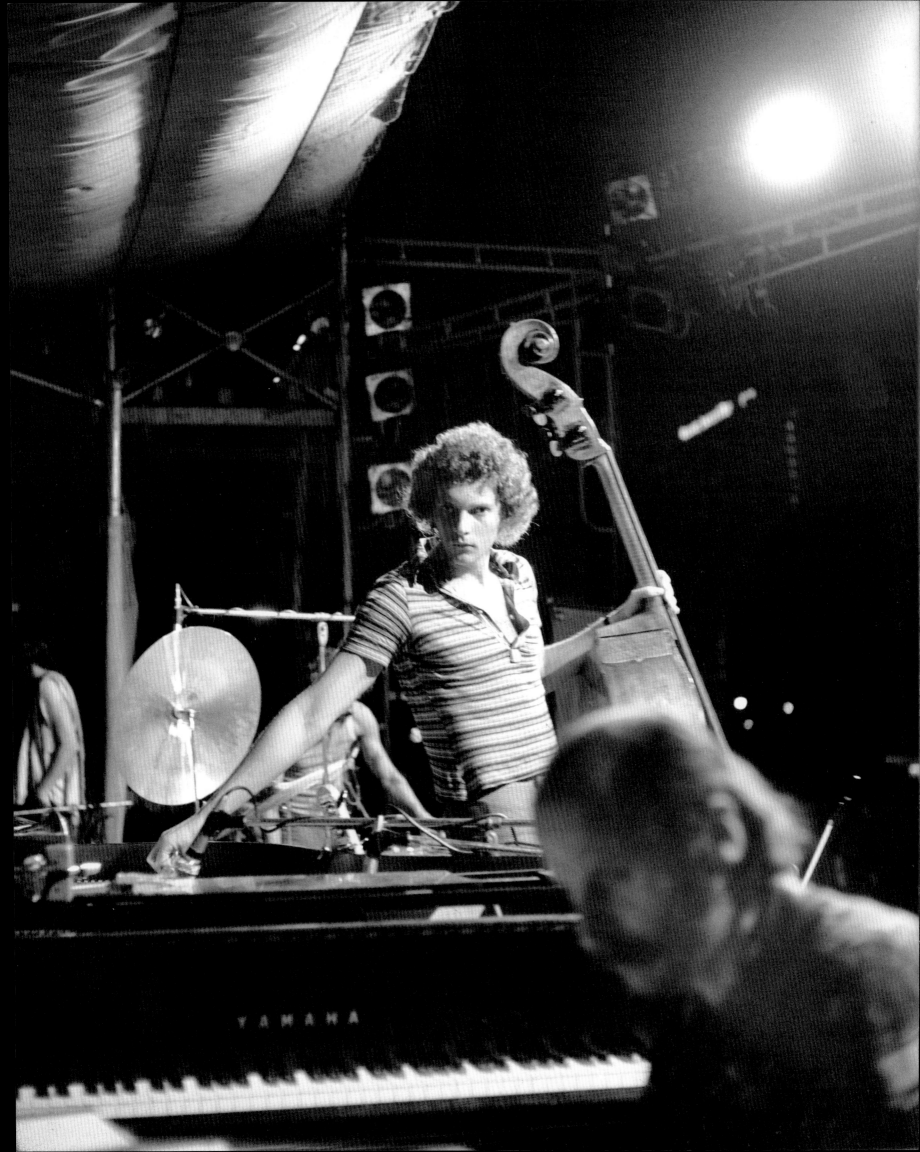

Weather Report on
Boston Common, 1972.

Photographs by Lee Tanner

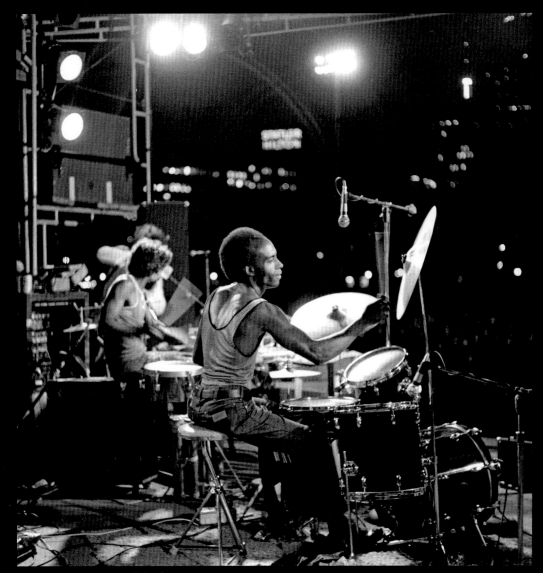

Dom Um Ramao and **Eric Gravatt**

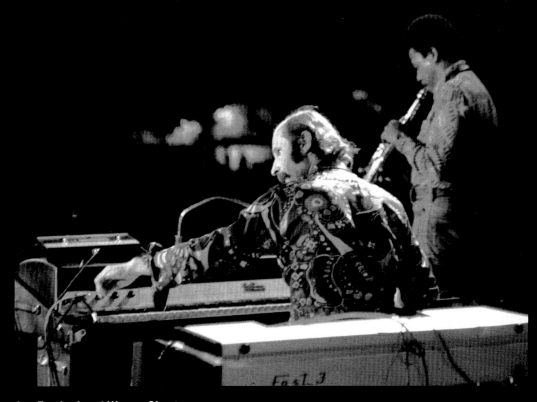

Miroslav Vitous

Joe Zawinul and **Wayne Shorter**

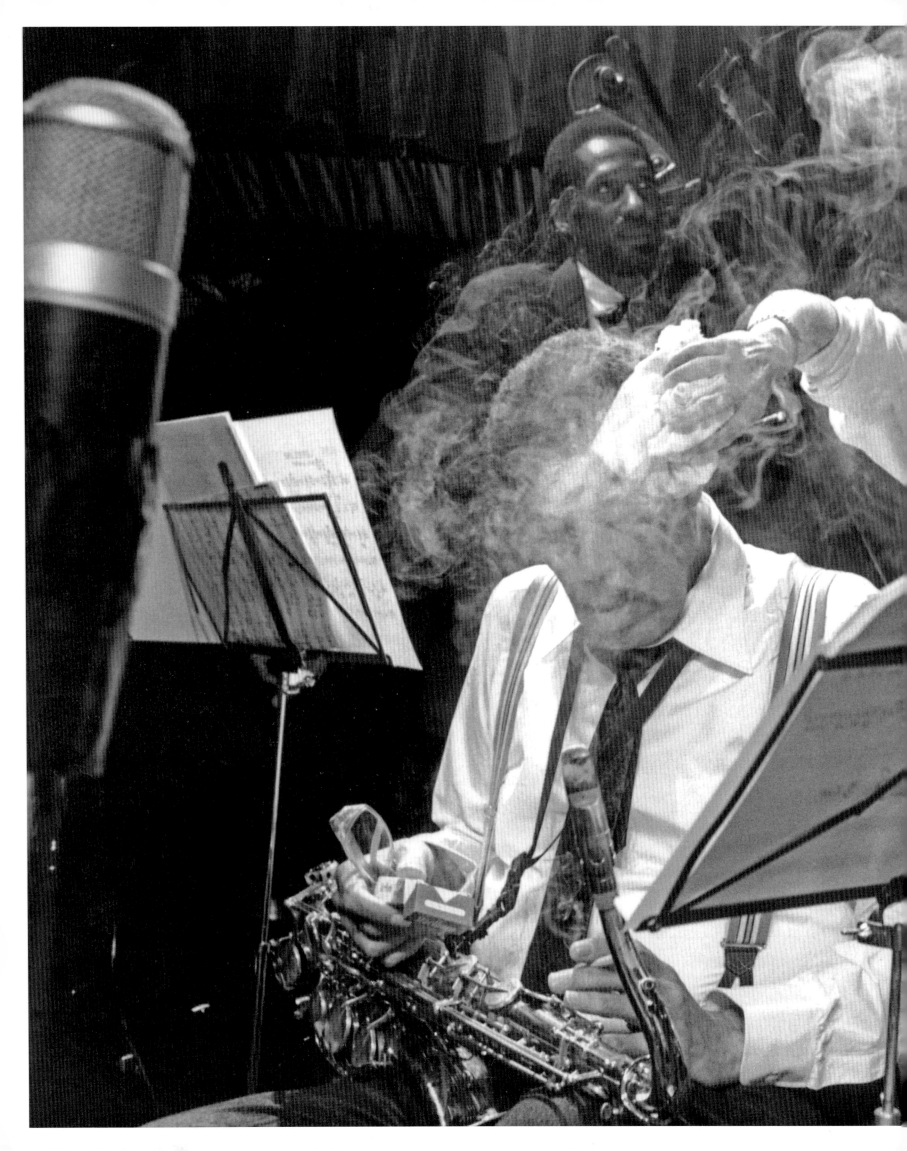

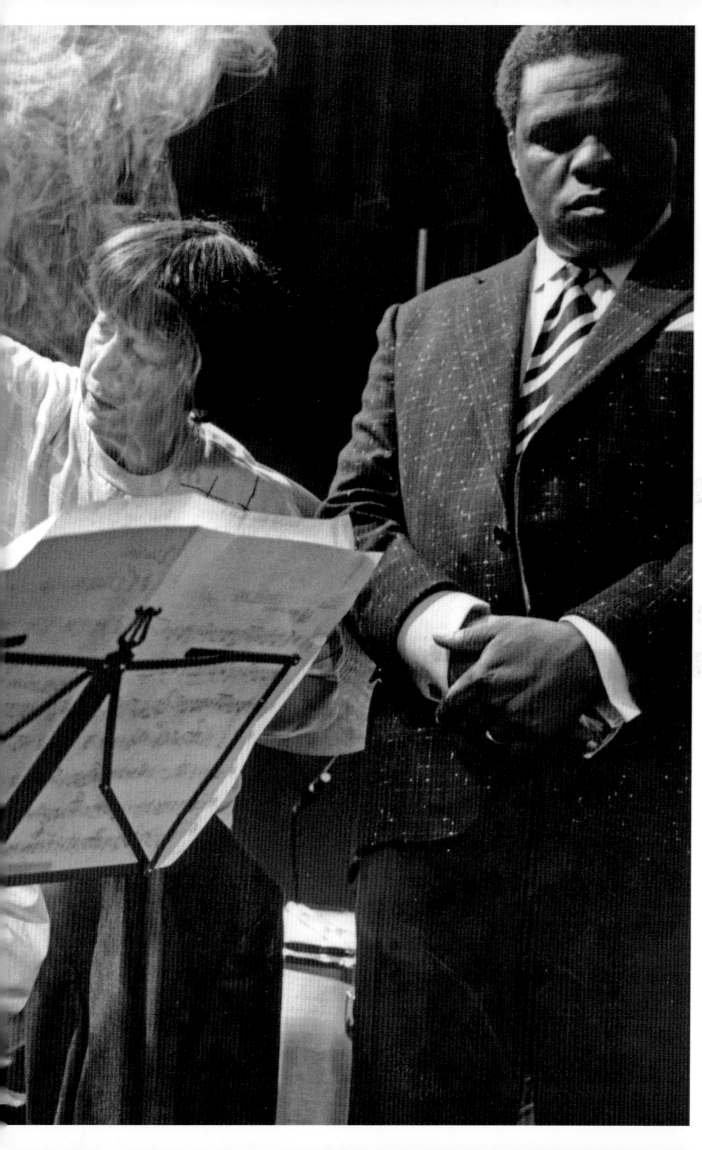

Dexter Gordon is made up during filming of *'Round Midnight* in France, 1985. He received an Academy Award nomination for his role. Bassist **Ron Carter** stands behind him, and trumpeter **Freddie Hubbard** is on the right.

Photograph by Guy Le Querrec

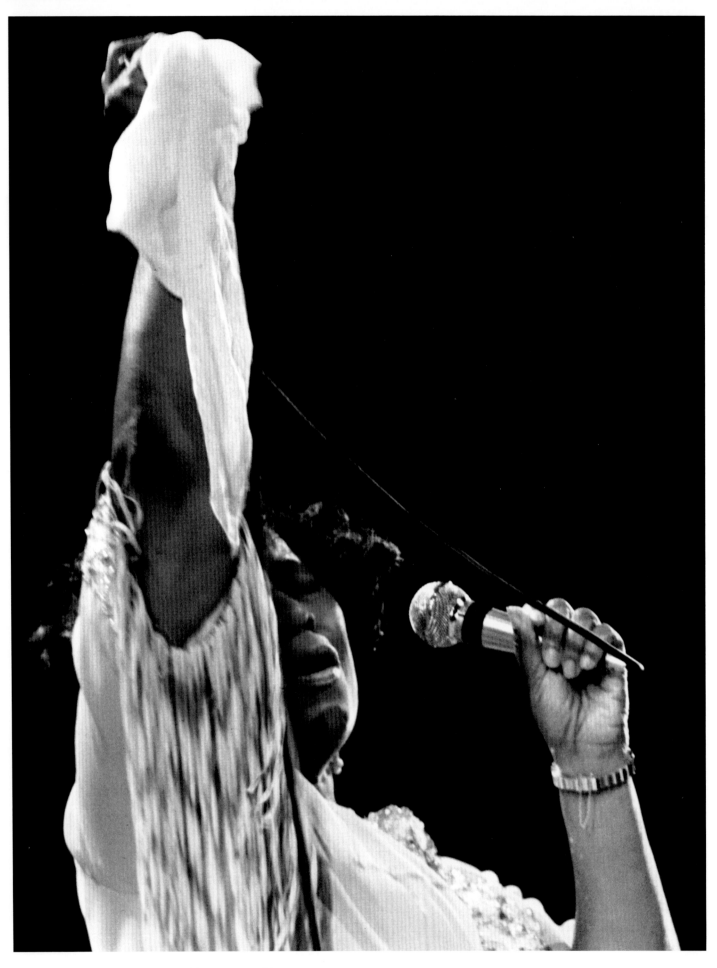

Ella Fitzgerald, the most
glorious jazz singer, at the
Newport Jazz Festival, 1970.

Photograph by Don Schlitten

Steve Lacy conducts a
jazz music seminar in the
Provence-Alpes-Côte d'Azur
region of France, 1976.
Photograph by Guy Le Querrec

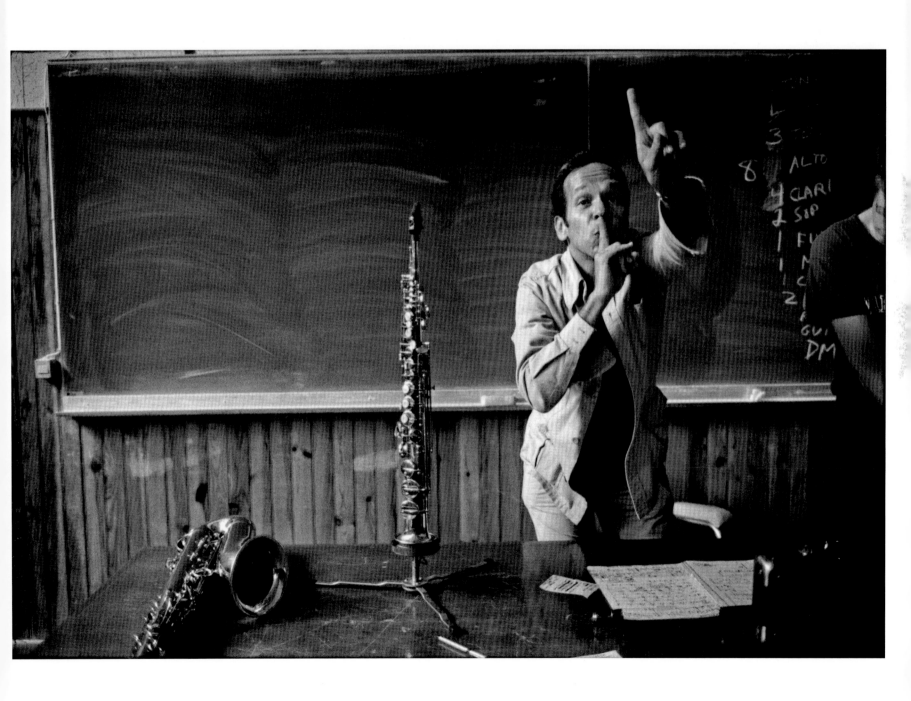

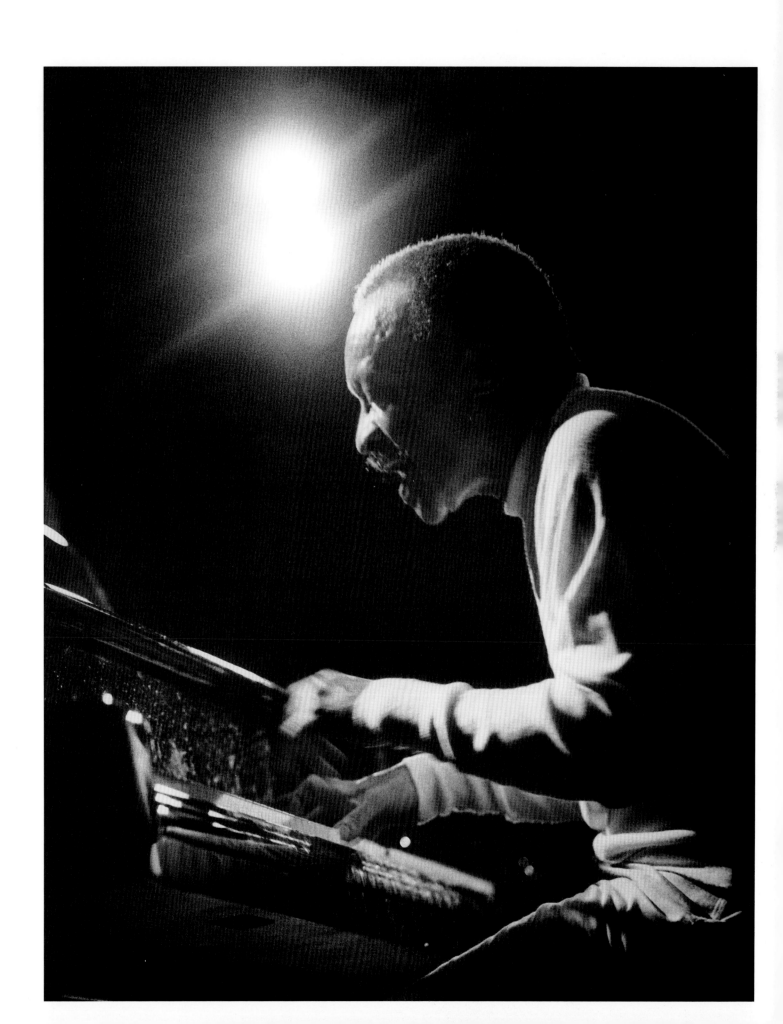

"Almost ninety, Benny Carter was still active and a remarkable soloist. Over his seven-plus-decade career he wrote and arranged hundreds of songs as well as writing several film scores. He is a true man for all seasons and a personification of the ageless inspiration in jazz."
Lee Tanner

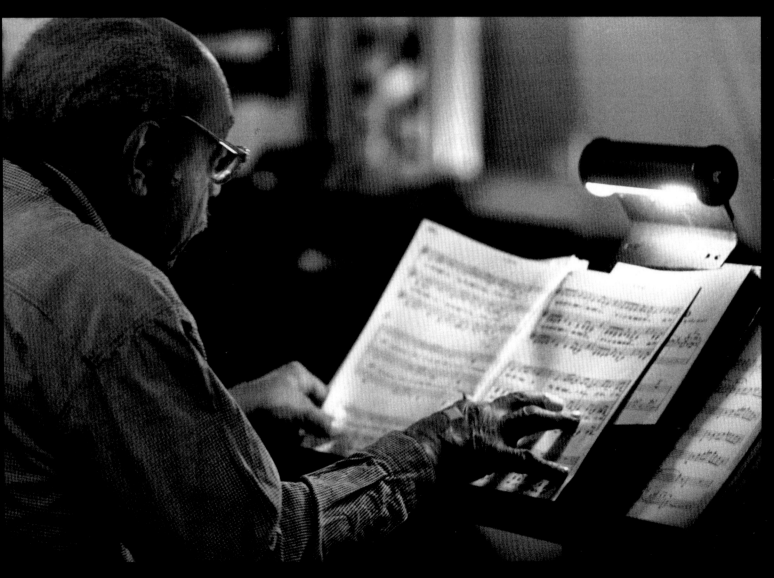

Benny Carter reviews his arrangement, New York, 1990.
Photograph by Tad Hershorn

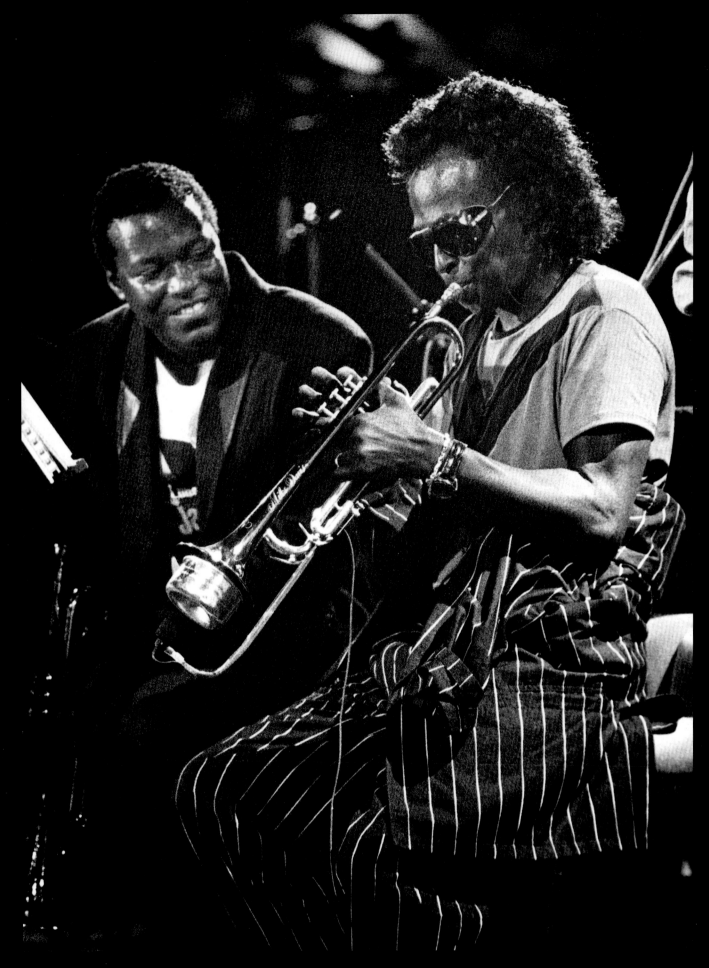

Wallace Roney and **Miles Davis**
at the Montreux Jazz Festival, 1991.

Photograph by Herman Leonard

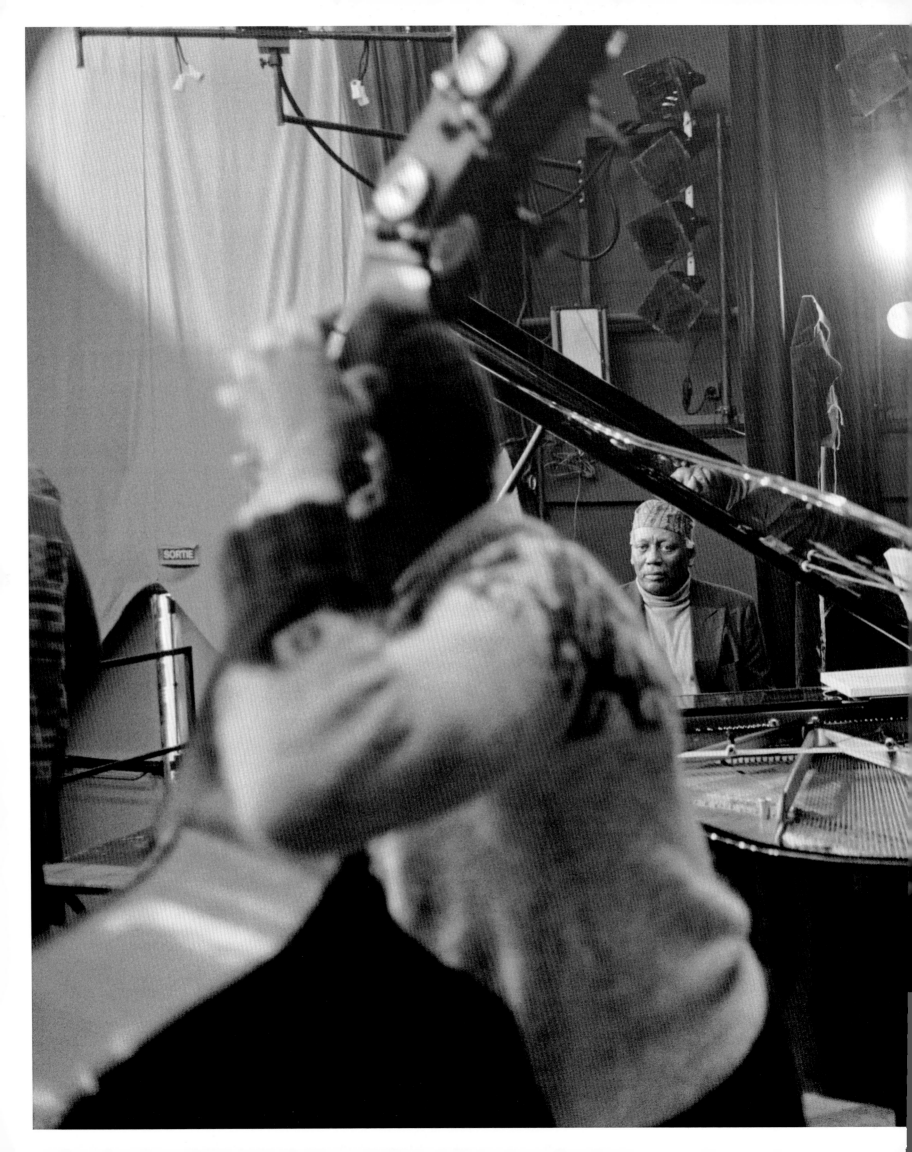

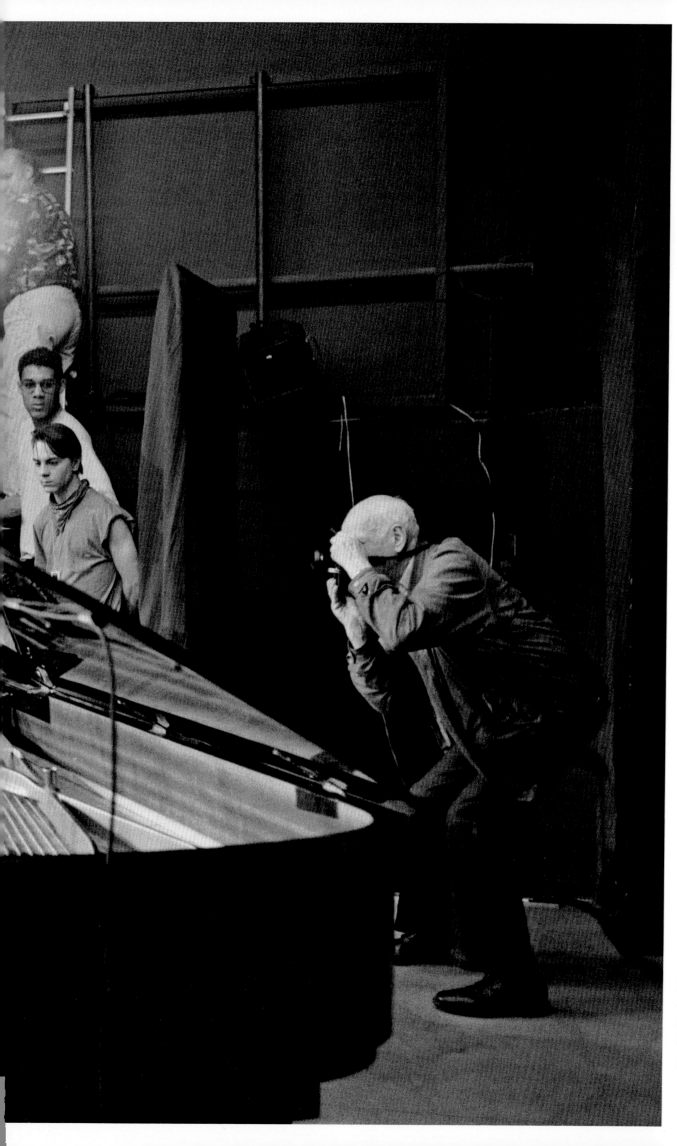

"The decisive moment . . . waiting for the moment it wells up and up and it explodes, it's a physical joy, dance, and space all combined. Yes. Yes. Yes."
Henri Cartier-Bresson

Randy Weston rehearses as Henri Cartier-Bresson photographs him, Drancy, France, 1992.

Photograph by Guy Le Querrec

AFTERWORD By Peter Fetterman

Jazz and photography have been two of the major influences in my life. Jazz came first. I grew up in a poor neighborhood in London during the 1950s and was fueled by visions of another life in another place. I discovered jazz at the age of eleven. The music evoked energy and hope in a far-off land called America. The probability of actually living there was about equal to living on the moon. But I did the next best thing: I saved my pennies and journeyed to a large old converted cinema, the Hammersmith Odeon, where the legendary jazz impresario Norman Granz promoted a series of concerts called "Jazz at the Philharmonic." These were the most magical moments of my youth. Being a skinny kid in an era before intense celebrity security, I managed somehow to always sneak backstage to advance my autograph collection. There I actually got to meet my heroes: Duke Ellington, Ella Fitzgerald, Dave Brubeck, The Modern Jazz Quartet, Gerry Mulligan, and Sarah Vaughan. I had my picture taken with Jimmy Rushing and got to have tea with Count Basie.

The years passed, and the dreams flowed. I knew that I belonged in the land of jazz, the United States. I wanted to be in a place where there was unrestricted hope and energy and the possibility of triumph and reward and friendship with the kind of people who were onstage thousands of miles away.

I arrived in the States in 1979 and immediately discovered the power of photography. I soon learned that great photographs change the way we see the world. I started to collect images that inspired and moved me the way jazz did. The collecting took over me, and I managed to find a way to turn this other passion into a new way of life.

When I look at this book I don't just see portraits of jazz musicians. I see stories of lives lived. I see stories of hopes and dreams and struggles and triumphs. I see the spirit and energy of a great art form and the American people who created it.

I have never liked the term "jazz photographer," which is often accorded to those whose most celebrated images happen to have been taken in the musical arena. I think it belittles their talent. They are great photographers in the tradition of important twentieth-century masters such as Walker Evans, Robert Frank, and Dorothea Lange. They are storytellers. And the history of jazz is the story of the geniuses all brilliantly shown here. Herman Leonard's magical Duke Ellington (page 41); Chuck Stewart's haunting John Coltrane (page 113); Bob Willoughby's tender Billie Holiday (pages 48–49); Don Hunstein's glorious Miles Davis (pages 60–61); William Gottlieb's magical Ella Fitzgerald and Dizzy Gillespie (page 50); William Claxton's energetic Dinah Washington (page 51); Carole Reiff's soulful Gerry Mulligan (page 73); Dennis Stock's poignant Lester Young (page 58); and Lee Tanner's insightful Johnny Hodges (page 126) and Milt Jackson (page 96). When I look at one of Gjon Mili's famous images shot in his loft (page 14), I see a Balanchine with a camera. I am there in the room with him, witnessing a historic session. Milt Hinton's "For Colored Only" (page 29) tells me the story of racism, an integral issue in jazz's development.

I am fortunate to know and work with many of the photographers whose work is included in this book. They all have something in common: A dedication to truth and a sensitivity and respect for the artists they are portraying. Lee Tanner has lovingly composed a symphony of great beauty. Linger with the images, and then close your eyes. You will hear the music.

Peter Fetterman is a fine-art photography dealer and collector based in Santa Monica, California. He edited and published a book on the work of the photographer Cornell Capa and is the editor of *Woman: A Celebration.* His new book, *Child: A Celebration,* will be published in 2007. His Web site is www.peterfetterman.com.

THE PHOTOGRAPHERS

RAY AVERY was born in Winnipeg, Canada, in 1920. His family moved to California when he was six, to an isolated rural area outside of Los Angeles. His first contact with jazz was on the radio in the early mornings. Avery studied at UCLA, then entered the Air Force in World War II, photographing in India with an Argus C3 camera. After discharge, Avery went into his father's fur-farming business for a while. In 1947 Avery opened the first of a series of Los Angeles record shops. The stores became a center for serious record collectors and music professionals. He was invited to many jazz events, and Avery brought his Nikon cameras everywhere, documenting the West Coast jazz scene from its beginnings: all the Monterey Festivals, the *Stars of Jazz* television series, and the busy nightclub scene. He retired in 1986 and devoted more time to photography; his book *Stars of Jazz* was published in 1998. Avery passed away in 2003. His work can be found online at www.ctsimages.com.

HUGH BELL was born in New York City in 1927. He graduated from New York University in 1950. Long interested in jazz, he started shooting the music scene in Greenwich Village while during the day he pursued a career in advertising and fashion photography. A background in documentary films led him to focus on picture stories, capturing passionate images of boxers, dancers, and actors, as well as travel spreads. His jazz pictures have been included in several shows and books, including the monumental 1955 photography exhibition *The Family of Man*, curated by Edward Steichen, at New York's Museum of Modern Art. His work is also featured in K. Abe's classic book of photographs, *Jazz Giants: A Visual Retrospective*.

OLE BRASK was born in Denmark in 1935 and grew up during the German occupation. He was introduced to jazz after the war: "It all started with my father's old gramophone and a record by Louis Armstrong and His All-Stars." The few available recordings were from American soldiers stationed in Germany. Brask became a professional photojournalist in his early twenties. At age twenty-four he decided to find work in New York to be closer to the center of jazz. He worked as an assistant to Richard Avedon, for Magnum, and for TV programs, and his photos were published in various magazines. He found his way into the jazz world when he met the producers John Hammond and George Avakian. They gave him access to recording sessions and a great deal of encouragement, and he became close friends with many of the musicians, in particular Milt Hinton. Brask returned to Denmark in 1976. The same year he published a book of prints, *Jazz People*.

WILLIAM CLAXTON grew up in the 1940s and 1950s in the Pasadena-Glendale area of southern California. He started collecting jazz records at a very early age, and photography helped pay his way through UCLA. He recalled his first big break: "While shooting Gerry Mulligan and Chet Baker playing at the Haig, I met record producer Dick Bock. He liked my pictures, appointed me art director/photographer for Pacific Jazz Records." Claxton's active period of jazz photography lasted about ten years, during which time he photographed for nearly all the record companies and won many awards. Claxton found that "most musicians possess a wonderful combination of being disciplined, well-trained performers who can take direction instantly . . . and at the same time remain almost totally ingenuous . . . that beautiful innocence of an artist." By the early 1960s he had expanded his reach into general photojournalism, advertising, and the movie industry. In the late 1980s several books of his jazz photography were published. His most recent book is *Jazz Life*. His work can be found online at www.williamclaxton.com.

ESMOND EDWARDS, a native of Nassau, the Bahamas, moved to New York City's Harlem in 1932 at age five. As a teenager, he developed avid interests in jazz and photography. He pursued a career as an X-ray technician until 1957, when he quit to be a freelance photographer. About that time he went to a Prestige recording session with a friend, drummer Arthur Taylor, where he took some photographs; the producer later bought a print for the album cover. Edwards took an office job at Prestige and attended recording sessions, learning music-production techniques, and he rose to become A&R director. Edwards recalled, "I got to sign and work with exciting new artists like Eric Dolphy and Oliver Nelson, as well as old favorites like Buck Clayton and Coleman Hawkins. I was supervising the recordings, shooting pictures during the rundowns and playbacks, and then I would hurry home to process the film and print and design the LP cover." Edwards left in 1962 and went on to A&R positions at several other labels, including Cadet, Verve, and Impulse, where he recorded Ramsey Lewis, John Handy, and rock-and-roll legend Chuck Berry. Now living in Golita, California, Edwards continues to work as an independent record producer.

WILLIAM GOTTLIEB was born in Brooklyn in 1917. A teenage friend who was an ardent jazz fan introduced him to the music. While a student at Lehigh University, Gottlieb was editor of the campus monthly magazine, and he included at least one piece on jazz in every issue. After graduation he landed a job at the *Washington Post,* where he soon convinced the editor to have a weekly column on jazz. Told to take the photographs himself, Gottlieb bought a Speed Graphic camera. He served as a photo officer in the Air Force during World War II, and after the war he returned to writing about and photographing jazz for *Down Beat* magazine. Gottlieb said, "With few exceptions, my jazz photographs, all taken on location instead of in photo studios, were made only to illustrate my articles." Gottlieb left the jazz world in 1948 to become a producer of educational filmstrips. His photographs are collected in the extremely popular book *The Golden Age of Jazz*. In 1995 his work joined the permanent collection of the Library of Congress. His photographs are found online at his Web site, www.jazzphotos.com.

TAD HERSHORN, an archivist at Rutgers University's Institute of Jazz Studies, began photographing jazz in Dallas in 1969 when he was fifteen years old. "Miles Davis was in the first frame of jazz I ever shot," he recalled, "I arrived late, didn't hear him introduced, and was not exactly sure who it was. My musical education was just beginning." During his career as a journalist for Texas newspapers, Hershorn also took photography and writing assignments for music publications. His photographs have also appeared on album covers for major record labels. Hershorn earned master's degrees in American history and library and archives. He joined IJS in 1999, where he produces an award-winning series of Web documentaries on jazz artists, the "Jazz Greats Digital Exhibits," which can be viewed online at http://newarkwww.rutgers.edu/ijs/main.htm.

MILT HINTON has been described by the historian Dan Morgenstern as "jazz history personified." Hinton began playing bass in the late 1920s, and he performed with nearly every prominent jazz musician, from Louis Armstrong, Benny Goodman, and Lionel Hampton to Dizzy Gillespie, John Coltrane, and Branford Marsalis, just to name a few. Hinton's introduction to jazz came in Chicago, where his family moved in 1919 from Mississippi. Cab Calloway hired Hinton for his big band in 1936; he stayed with him for fifteen years. Hinton started photographing with an Argus C3 while on the road with Calloway. Hinton settled in New York City in the 1950s, playing for CBS radio in a variety of musical productions. He always took along his Leica and Nikon cameras, capturing intimate, informal moments that were unavailable to other jazz photographers. A highlight of his work is the still and film footage that he and his wife, Mona, shot during Art Kane's 1958 photo shoot of more than fifty jazz musicians on a Harlem street. This became part of the 1994 documentary film about the event, *A Great Day in Harlem*. Hinton received many honors over the years, including membership in the Duke Ellington Fellowship at Yale University. In 1993 he was awarded the highly prestigious American Jazz Master Fellowship from the NEA. The best of his photos are featured in *Bass Line* and *Overtime*. He died in 2000 at age ninety. More information about him can be found online at www.milthinton.com.

PAUL HOEFFLER was born in 1937, grew up in New England, and studied photography at the Rochester Institute of Technology. After graduating in 1959, he worked for several major New York photographers before opening his own studio in 1963. After moving to Toronto, Hoeffler was more active than ever, and his work continued to appear on many record covers and in magazines. He taught at Parsons School of Design in New York and at Ryerson University in Toronto. He photographed not only jazz but classical musicians as well. His work is represented by several galleries, including the Stephen Bulger Gallery in Toronto. Hoeffler died in 2005 at age sixty-eight. His work is found online at www.ctsimages.com.

DON HUNSTEIN was born in St. Louis in 1928. When he was quite young, an uncle introduced him to the music of the Benny Goodman and Cab Calloway bands. Hunstein graduated from Washington University in 1950 and served three years in the Air Force, stationed in England. There he purchased a book of prints by the French photographer Henri Cartier-Bresson, inspiring him to purchase a Leica IIIG and pursue photography. Hunstein settled in New York City and was hired by the Columbia Records publicity department. In 1965 he became head of the CBS Records Photo Studio, photographing all of the music made in the Columbia studios during the vibrant period of 1956 to 1986: the historic Miles Davis, Gil Evans, Thelonious Monk, Charles Mingus, and Duke Ellington recording sessions, and much more. His black-and-white style is distinctive: The awful flat lighting typical of sound studios somehow sparkles in his prints. In 1986 Hunstein opened a studio, and he now specializes in portraiture of musicians and corporate executives. The Peter Fetterman Gallery in Santa Monica, California, displays his work.

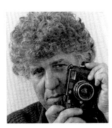

GUY LE QUERREC was born in 1941 in Brittany, France. In the late 1950s he shot his first pictures of jazz musicians in London. Following a tour in the military, Le Querrec became a professional photographer in 1967. Two years later he was hired by the weekly publication *Jeune Afrique* as a staff photographer. After working in Africa, he began covering Europe. As with many of the photographers of his era, he was strongly influenced by Henri Cartier-Bresson. Le Querrec's pictures reveal chance encounters and moments of recognition. He joined Magnum in 1976, where his many diverse assignments took him to China, Africa, and North America. However, he made sure to attend all the important jazz shows no matter where he was located. He has published several books of his jazz images, including *Jazz comme une image* and *Jazz de Jazz*. His work can be found online at www.magnumphotos.com.

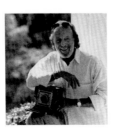

HERMAN LEONARD became hooked on jazz in 1941, when Benny Goodman's band played at Ohio University while he was a student. After serving in the army and graduating from college, Leonard apprenticed for a year with the photographer Yousuf Karsh. He moved to New York in 1948, where he took portraits and worked for magazines, but he was drawn back to the music scene. Too poor to pay the entrance fee to the jazz clubs, he begged the owners to let him shoot during the rehearsals in exchange for photos for their publicity windows, and he sold the occasional photo to the magazines *Down Beat* and *Metronome*. In the 1950s Leonard joined the French company Barclay Records, leaving to open his own studio in Paris in 1960. Twenty years later, while moving to Ibiza, Leonard found long-forgotten negatives of jazz photographs. These were subsequently published in two books, *The Eye of Jazz* and *Jazz Memories*, and exhibited around the world; the Smithsonian Institution in Washington, D.C., acquired the entire collection. Leonard moved to New Orleans in the early 1990s. He and his family left before Hurricane Katrina hit in 2005, taking his negatives with them, but his home, studio, and vast archive of prints were destroyed. He now makes his temporary home in Los Angeles. His website is www.hermanleonard.com.

JIM MARSHALL was born in San Francisco and began taking pictures as a teen. In 1961, at the end of a tour in the Air Force, he moved to New York City to be part of its flourishing jazz and folk-music scene. He contributed photographs to several major record companies and magazines. The Newport Jazz Festival incorporated a Folk Festival in the 1960s, and the two festivals were his photographic playgrounds. Several years later Marshall returned to the Bay Area, where he found yet another new musical love: electrified rock and roll. He jumped right into the hippie scene, but he was still involved with jazz, going to the San Francisco clubs and the Monterey Jazz Festival. Now seventy, Marshall is associated with several galleries, including the prestigious Fahey-Kline Gallery in Los Angeles. Some of his best work can be found in the books *Not Fade Away*, *Jim Marshall: Proof*, and *Jim Marshall: Jazz*. His images can be seen online at www.jimmarshallvault.com.

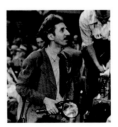

GJON MILI came to the United States from Romania in 1923 to study electrical engineering at the Massachusetts Institute of Technology. After graduation he joined the Westinghouse Company to conduct lighting research. Photoflash lamps, invented in 1931, had just arrived in the US, and he began experimenting with lighting and shutter synchronization. He later opened his own studio in New York City and started photographing for *Life* magazine. Mili's work over the next decades featured great personalities in the worlds of sports, theater, dance, and music. Mili became friends with many of his subjects, who would

return to his studio after hours for parties, poker games, and jam sessions. In 1944 *Life* produced a photo-essay on one such session, titled "*Life* Goes to a Party." That year Mili made his first short film, *Jammin' the Blues*, in collaboration with Norman Granz, a film editor who was just starting to produce the Jazz at the Philharmonic concert series. This short of a jam session is one of the finest presentations of jazz in film. In 1966 a fire destroyed Mili's studio, wiping out most of his prints and negatives. Fortunately, his work for *Life* was safe in the magazine's archives. Mili's vintage prints are available at the Howard Greenberg Gallery in New York, and new prints can be obtained from Getty Images, www.gettyimages.com.

ROBERT PARENT was born in 1923 in a suburb of Boston. He became involved in the Boston jazz scene while he worked as a draftsman and studied mechanical engineering at night. It was not until 1945 that Parent began to take photography seriously. His first camera was a 4x5 Speed Graphic used with a flash held at arm's length to simulate club lighting. In 1951, after a tour in the army, he moved to New York to attend art school, determined to make it as a painter. But he never gave up his love affair with jazz and jazz photography. His pictures were regular features in *Down Beat* and *Metronome*, and he designed LP jackets for small independent recording companies. During the 1960s Parent turned to social and political photojournalism. He was still active in 1987, when he died at age sixty-three. His nephew, Dale Parent, serves as his archivist and is planning a book of the photographer's best images. He also maintains a website of Parent's photography, www.jazzpix.com.

JAN PERSSON grew up in Copenhagen, which was full of thriving jazz clubs, and big jazz tours such as Jazz at the Philharmonic came through town. A number of prominent American musicians even preferred to live in Denmark. Persson started photographing musicians for himself, because he couldn't afford to buy publicity photos. This led to general freelance work and ultimately to a full-time career in photojournalism. Persson's favorite venue was the Montmartre jazz club that established Copenhagen as an important jazz city. Countless artists and bands played in that small room, including Stan Getz, Oscar Pettiford, Dexter Gordon, and Ben Webster. Many of Persson's photographs are included in his book, *Jazz Portraits*. Some of his photographs are found online at www.deote.com/sites/jp/show.asp.

CHARLES PETERSON was born at the turn of the century to Swedish immigrants in northern Minnesota. In high school he bought a banjo, and during his college years he played in local dance halls and resort hotels. In 1926 he headed for New York, where he played regularly at Brooklyn's Rosemont Ballroom with people such as trumpeter Wingy Manone. In 1928 he joined the Rudy Vallee Orchestra for four years. He quit the road and attended New York's Clarence White School to study photography. He followed a typical career in the 1930s, including ad agency work and entertainment coverage for various magazines. Peterson took rooms above the Onyx club on 52nd Street and made nightly forays into all the clubs. He was perhaps the first dedicated photographer of the New York jazz scene in the mid-1930s. By 1939 he had photographed the classic Commodore and Decca recording sessions and had several spreads in *Life* magazine. After a tour in the Coast Guard during World War II, Peterson changed course again, becoming an industrial photographer and writer in Pennsylvania. On occasion, he would return to New York to photograph the music scene. Peterson died in 1976. His son, Don, compiled his work in the book *Swing Era New York*.

CAROLE REIFF was born in New York City in 1934, the daughter of illustrator and photographer Hal Reiff. She graduated from the High School of Music and Art and studied at the Art Students League. Reiff began photographing while still in her teens. She discovered jazz and quickly found it the ideal subject to photograph. Using the twin-lens Rolleiflex camera her father gave her, she gained remarkable access to jazz clubs and concert halls as well as recording studios, rehearsal lofts, and all-night jam sessions. Her style was unique: Sharp focus was often sacrificed for the perfectly captured moment. Reiff freelanced for many recording companies and magazines. Beginning in the 1960s, Reiff worked almost exclusively in advertising. She died in 1984 at age fifty; the following year a compilation of her photography, *Nights in Birdland*, was published.

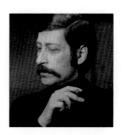

DON SCHLITTEN was born in 1932 and grew up in New York City. By the time he entered the High School of Music and Art, he had discovered jazz and the tenor saxophone. He first went to art school, then studied at the New York Conservatory of Modern Music, determined to be a jazz musician. One night in 1949 Schlitten walked down the stairs to the Royal Roost club on Broadway and encountered Herman Leonard's jazz portraits. Schlitten was inspired to turn to photography, and his jazz photographs were first published in 1957. He also produced jazz recordings for a variety of record labels and designed the jackets. In 1975 Schlitten formed his own company, Xanadu Records. "Having put my saxophone and my easel in the closet, I would spend my spare time, as do all photographers, wandering around looking for 'that shot,'" Schlitten said, "but it was always my serious portraits of jazz musicians that were most important to me. . . . I shoot sparingly, always looking for the moment in time that expresses all time."

HERB SNITZER was born in 1932 and grew up in Philadelphia. After graduating from the Philadelphia College of Art in 1957, he moved to New York City, where he quickly established himself as a busy photojournalist. In 1959 Snitzer became the photography editor of *Metronome*, then associate editor until 1961. During what proved to be a twenty-year break in his photography career, he earned a master's degree in education and worked in that field. The jazz world beckoned once again in 1986, when Snitzer's friend of many years, singer-pianist Nina Simone, asked him to accompany her to Switzerland and document several of her concerts. In the 1990s Snitzer moved to St. Petersburg, Florida, and opened a studio for fine-art photography. His work is displayed in galleries and museums throughout the country, and he has authored five books on music and education. His most recent book, *Jazz: A Visual Journey*, contains the best of his jazz photography. His work is found online at www.herbsnitzer.com.

CHUCK STEWART was born in 1927 in Texas, but soon moved to Tucson, Arizona. Music was an interest from an early age, but he was not naturally talented. "Since I could not be a great musician," Stewart explained, "I became a photographer." He received a BFA in photography from Ohio University, where Herman Leonard was a fellow classmate;

Stewart has described Leonard as his greatest photographic influence. Leonard already had a studio in New York when Stewart graduated in 1949, and Stewart worked as Leonard's assistant until he was drafted into the army in 1951 for a two-year tour as a combat photographer in Korea. Stewart returned to New York in 1953 and became a staff photographer for the magazine *Our World.* Then in 1955 Leonard called from Paris to say he was staying in Europe—and offered his studio and business to Stewart. Stewart has since retired from day-to-day business. His book *Chuck Stewart's Jazz Files* spans three decades of the jazz scene.

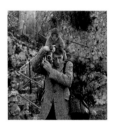

DENNIS STOCK was born in 1928 and grew up in New York City. He joined the Navy in 1944 when he turned sixteen, and after the war he studied photography at the New School. This proved too restrictive, and he left to gain hands-on experience as a photojournalist's assistant. He briefly worked for W. Eugene Smith, then apprenticed with Gjon Mili for four years. During this time Stock won first prize in *Life's* Young Photographers Contest, which led to an associate membership at Magnum. Soon he was a full member and became Magnum's man in Hollywood. Between 1957 and 1960 Stock dedicated himself to covering the jazz scene. This body of work was published in the book *Jazz Street,* with text by Nat Hentoff. His photographs are found online at www.magnumphotos.com.

JERRY STOLL was born in 1923, the son of tenant farmers on the shores of Lake Minnetonka, in Minnesota. Stoll's older sister was a jazz vocalist, and she introduced him to the music. He was the resident photographer at the Monterey Jazz Festival, creating a visual document of the years 1958 to 1964. Rupert Jenkins, the director of the San Francisco Art Commission Gallery, wrote, "Stoll was for many years one of several prominent Bay Area post-war photographers to document the changing face, economics, and politics of the city. His early works were influenced by sources as varied as Edward Steichen's *Family of Man* exhibition, Cubism, and the Soviet films of Sergei Eisenstein. . . . His change of style coincided with the emerging art renaissance in San Francisco, led by the Beats—'a non-revolutionary cultural revolution,' in Stoll's words." Working out of San Francisco, New York, and Washington, DC, Stoll has authored books and pictorial essays and has produced and directed several documentary films, including *Sons and Daughters, The Years Yet to Come, The Pentagon Papers,* and

The War Economy. In 1955 he helped create the artists' group Bay Area Photographers, and in 1965 he founded American Documentary Films. Stoll died in 2004.

LEE TANNER discovered jazz on Boston radio in 1938, at age seven. When he was older, on Saturdays he would pack lunch and travel downtown to spend the whole day at the RKO theater. He would hear the big bands live—Basie, Ellington, Herman, Cootie Williams, Benny Carter, Kenton, Goodman— a new one every week. His family moved to New York City in the mid-1940s, and he started hanging out at the jazz clubs on 52nd Street and in Greenwich Village. The son of an artist, Tanner had always sketched and painted; now he turned to photography to capture the immediacy of the performances. He studied at New York University and the University of Pennsylvania and served a two-year tour in the army in the 1950s. He pursued a forty-year career in scientific research, but jazz photography, like the music itself, was a constant in his life. While living in Boston again, he photographed the weekly live music show *JAZZ* for WGBH-TV; in the late 1960s he produced this series as *Mixed Bag,* with an expanded format to include blues and the first jazz-rock fusion bands. Tanner retired from science in the early 1990s. He has organized group photography exhibitions across the country. His own photographs make up *Images of Jazz* and *Images of the Blues.* Tanner now lives in Sonora, California, near Yosemite National Park, with his wife, Linda. His Web site is www.jazzimage.com.

BOB WILLOUGHBY was born and raised in Hollywood, and he began his career apprenticing with several Los Angeles photographers. His passion for jazz and dance led him to photograph backstage at nightclubs and theaters. Willoughby covered the early 1950s West Coast jazz scene, but he rarely sold these prints. He did, however, exhibit them, catching the attention of the Globe Picture Agency and leading to assignments for the fashion magazine *Harper's Bazaar.* These photographs were also seen by Edward Steichen, who included several of Willoughby's jazz pictures in his 1955 exhibition *The Family of Man* at the Museum of Modern Art, New York. Willoughby started working for film production companies in Hollywood, creating marvelously vibrant picture stories that replaced the old, stiff movie stills. By the 1970s, however, the excitement of Hollywood had worn off, and Willoughby and his family moved to Ireland, where he worked on photographic art and cultural

projects. The Willoughbys now live in the foothills of the Alpes-Maritimes in France. The best of Willoughby's jazz photography is included in *Jazz in LA.* His work is available from the Staley-Wise Gallery in New York and can be seen online at www.globalgallery.com.

VAL WILMER was born in Yorkshire, England, in 1941. She grew up in the austerity of postwar London, and at age twelve she first heard jazz on the radio. In 1956 she took her first photographs of a musician—Louis Armstrong— using her mother's Kodak Brownie box camera. Wilmer recalled, "He gave me his autograph and that 'Satchmo smile.' I 'clunk-clicked' a couple of snapshots and launched my career." She studied photography at the Regent Street Polytechnic in London and embarked on the twin careers of jazz photography and writing. Over the years she has illustrated countless books and magazines and has written extensively on music and other topics; her books include *The Face of Black Music* and *Jazz People.* Her prints have been exhibited in many galleries and museums throughout Europe and the United States. In 1983 she co-founded Format, Britain's first all-women photographic agency.

FRANK WOLFF met Alfred Lion in 1924, when both were teenagers in Berlin with a passion for jazz. Lion moved to New York in 1928, while Wolff remained in Germany to study photography. When Lion created Blue Note Records in 1939, he sent for Wolff. Their early recordings were of traditionalists such as Sidney Bechet and Frankie Newton. The early 1940s saw the advent of bebop and significant changes in jazz. Ike Quebec, Blue Note's star tenor sax performer, introduced them to the new music. A year later the label was releasing beautifully crafted modern records, including the debuts of Thelonious Monk, Tadd Dameron, Bud Powell, and Art Blakey. Wolff photographed at the studios, documenting two decades of historic recording sessions. His images became the signature look of the Blue Note packaging. When Lion retired in 1967, Wolff became producer, until his death in 1971. Wolff's prints have been exhibited in galleries and published in several books on Blue Note. His photographic archive is owned by Mosaic Records; prints are available at www.mosaicrecords.com.

FURTHER READING

Abe, K., ed. *Jazz Giants: A Visual Perspective.* New York: Billboard Publications, 1988.

———. *Fifty Jazz Greats.* Tokyo: Shinka Music Publishing Co., 1995.

Arbaizar, Philippe, Peter Galassi, Robert Delpire, et al. *Henri Cartier-Bresson: The Man, The Image and the World.* London: Thames & Hudson, 2003.

Avery, Ray. *Stars of Jazz.* Copenhagen: JazzMedia ApS, 1998.

Brask, Ole, text by Dan Morgenstern. *Jazz People.* New York: Da Capo Press, 1993.

———, text by Milt Hinton. *Photographs Jazz.* Kiel, Germany: Nieswand, 1995.

Bubley, Esther, text by Hank O'Neal. *Charlie Parker.* Paris: Editions Filipacchi, 1995.

Claxton, William. *Jazz.* San Francisco: Chronicle Books, 1996.

———. *Young Chet.* Munich: Schirmer/Mosel, 2006.

———. *Claxography: The Art of Jazz Photography.* Kiel, Germany: Nieswand, 1996.

———. *Jazz Seen.* Cologne: Taschen, 1999.

———. *Jazz Life* Cologne: Taschen, 2005.

DeCarava, Roy. *The Sound I Saw.* London and New York: Phaidon, 2001.

Driggs, Frank, and Harris Lewine. *Black Beauty, White Heat: A Pictorial History of Classic Jazz, 1920–1950.* New York: Da Capo Press, 1996.

Van der Elsken, Ed. *Jazz.* Amsterdam: Fragment, 1991.

Friedman, Carol. *A Moment's Notice: Portraits of American Jazz Musicians.* New York: Schirmer Books, 1984.

Gignoux, Dany. *Dizzy Gillespie: Photographs.* Kiel, Germany: Nieswand, 1994.

Gottlieb, William. *The Golden Age of Jazz: Text and Photographs.* San Francisco: Pomegranate Artbooks, 1995.

Graham, Charles. *The Great Jazz Day.* New York: Da Capo Press, 2000.

Hentoff, Nat, and Robert Parent. *Jazz Is.* New York: Limelight Editions, 1984.

Hinton, Milt, and David G. Berger. *Bass Line: The Stories and Photographs of Milt Hinton.* Philadelphia: Temple University Press, 1991.

———, David G. Berger, and Holly Maxson. *Overtime: The Jazz Photographs of Milt Hinton.* San Francisco: Pomegranate Artbooks, 1991.

Leonard, Herman. *The Eye of Jazz.* New York: Viking Penguin, 1985.

———. *Jazz Memories.* Paris: Editions Filipacchi, 1995.

Lyons, Jimmy, ed. *Dizzy, Duke, The Count and Me: The Story of the Monterey Jazz Festival.* San Francisco: San Francisco Examiner Division of the Hearst Corp., 1978.

Le Querrec, Guy. *Jazz comme une image.* Paris: Scandéditions, 1993.

———. *Jazz de Jazz: Photographie le jazz.* Paris: Marval, 1996.

Minor, William, and Bill Wishner, eds. *Monterey Jazz Festival: Forty Legendary Years.* Santa Monica: Angel City Press, 1997.

Persson, Jan. *Jazz Portraits.* Copenhagen: Tiderne Skifter, 1996.

Polonsky, Bruce. *Hearing Music.* San Francisco: Private Books, 1981.

Quinke, Ralph. *Jazz + More: Photographs.* Kiel, Germany: Nieswand, 1992.

Redfern, David. *The Unclosed Eye: The Music Photography of David Redfern.* London: Sanctuary Publishing, 1999.

Reiff, Carole. *Nights in Birdland: Jazz Photographs, 1954–1960.* New York: Simon & Schuster, 1987.

Sidran, Ben, and Lee Tanner. *Talking Jazz: An Oral History.* New York: Da Capo Press, 1995.

Snitzer, Herb. *Jazz: A Visual Journey.* Clearwater, Florida: Notables, 1999.

Sol, Ydo. *Faces of Jazz.* Kiel, Germany: Nieswand, 1991.

Stewart, Charles. *Chuck Stewart's Jazz Files.* Boston: Little, Brown, 1985.

Stock, Dennis. *Jazz Street.* Garden City, New York: Doubleday & Co., 1960.

Stokes, W. Royal. *Swing Era New York: The Jazz Photographs of Charles Peterson.* Philadelphia: Temple University Press, 1994.

Stoll, Jerry, and Michael Ehlers. *Jazz Memories.* San Francisco: Pomegranate Artbooks, 1987.

Tanner, Lee, ed. *Dizzy: John Birks Gillespie in His 75th Year.* San Francisco: Pomegranate Artbooks, 1993.

———. *Images of Jazz.* New York: Friedman/Fairfax Publishers, 1998.

———, and Lee Hildebrand. *Images of the Blues.* New York: Friedman/Fairfax Publishers, 1998.

Williams, Richard. *Miles Davis: The Man in the Green Shirt.* New York: Henry Holt, 1993.

———. *Jazz: A Photographic Documentary.* New York: Crescent Books, 1994.

Willoughby, Bob. *Jazz in LA.* Kiel, Germany: Nieswand, 1990.

Wilmer, Valerie. *The Face of Black Music.* New York: Da Capo Press, 1976.

Wolff, Francis. *Blue Note Jazz: Photography of Francis Wolff.* New York: Universe, 2000.

———. *The Jazz Photography of Francis Wolff: The Blue Note Years.* New York: Rizzoli, 1995.

MUSICIANS

PHOTOGRAPHERS

PHOTOGRAPH CREDITS

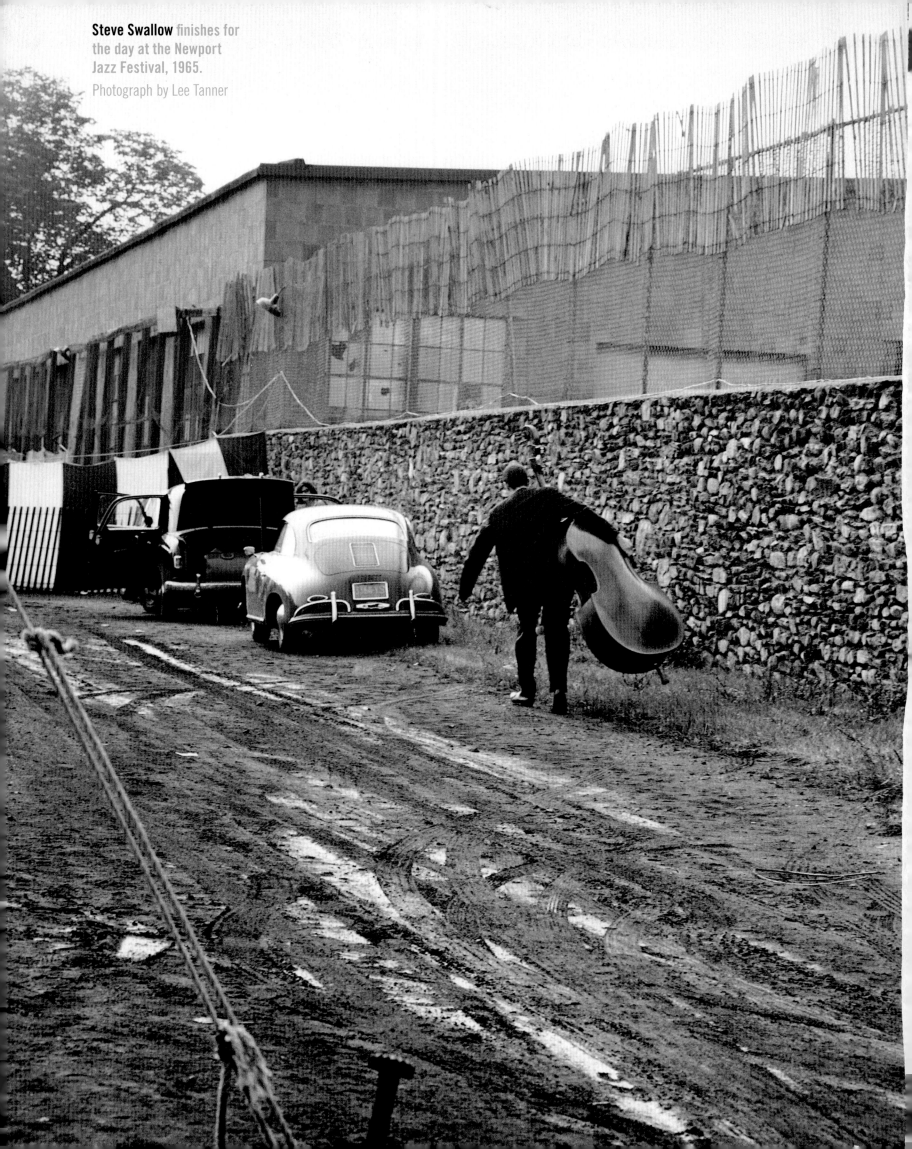

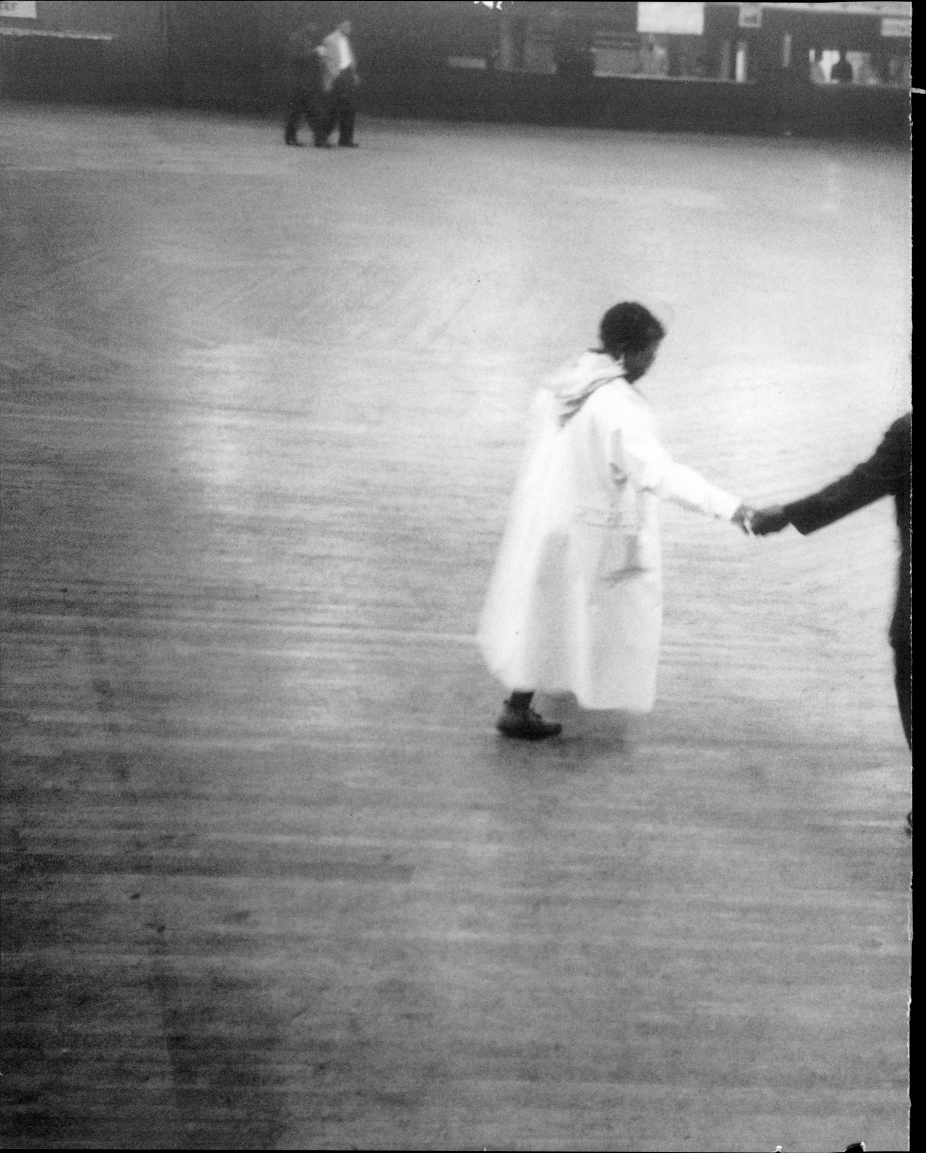